ART AND HIS
BARCELONA
THE CITY OF GAUDÍ

THE CITY OF THE BARRI GÒTIC AND MODERNISTA ARCHITECTURE

BONECHI

© Copyright by Casa Editrice Bonechi - Florence - Italy
E-mail:bonechi@bonechi.it - Internet:www.bonechi.it

Publication created and designed by Casa Editrice Bonechi
Editorial management: Serena de Leonardis
Texts: Editorial staff of Casa Editrice Bonechi
Translation: Studio Comunicare, Florence
Cover: Sonia Gottardo
Drawings: Stefano Benini

Arte e Storia - Barcellona - n° 7 - Pubblicazione Periodica Trimestrale
Autorizzazione del Tribunale di Firenze n° 3873 del 4/8/1989 - Direttore Responsabile: Giovanna Magi

Printed in Italy by Centro Stampa Editoriale Bonechi - Sesto Fiorentino

PHOTOGRAPHY ACKNOWLEDGMENTS:
The photographs are property of the Casa Editrice Bonechi Archives. They were taken by:
Marco Bonechi: pages 3; 34; 37 below; 42; 46-47; 48-49; 50-51; 52; 53; 55 below; 56-57; 58; 59; 60-61 above; 64-65; 69; 89; 90; 91; 92; 93; 94-95; 96-97; 102; 103; 106; 107; 108; 110-111; 110 below; 111 above right and below left; 112; 113; 114-115; 116 above; 118; 119 above; 124; 125 above; 130; 132.
Serena de Leonardis: pages 9; 68; 70; 71; 72 above; 73; 75 below; 76; 77; 78; 79; 80; 81; 131 above; 137.
Paolo Giambone: 25 below; 43 below; 63 left; 86 below; 98 above; 104; 105; 109 below; 117 below; 128; 131 below; 135; 136.
Sonia Gottardo: pages 100-101; 111 below right.
Andrea Pistolesi: pages 5; 11; 21; 23; 24 below right and left; 25 above; 38 above; 63 right; 67; 72 below; 74-75; 75 above; 83; 84; 85; 86 above; 87; 88; 109 above; 129; 134.
Alessandro Saragosa: pages 8; 10; 12; 13; 14; 15; 16; 17; 18; 19; 20; 22; 24 above; 26; 27; 28; 29; 30; 31; 32; 33; 38 below; 39; 40; 41; 43 above; 44; 45; 54; 55 above; 60 below; 62; 82; 98 below; 99; 116 below; 117 above; 119 below; 120; 121; 122; 123; 125 below; 126; 127; 133; 138; 139; 140; 141; 142; 143.

Other archives:
Andrea Pistolesi: pages 35; 36; 37 above and center.

The publisher apologizes for any unintentional omissions. We would be pleased to include any appropriate acknowledgments of which we are informed in subsequent editions of this publication.

ISBN 88-7009-846-X

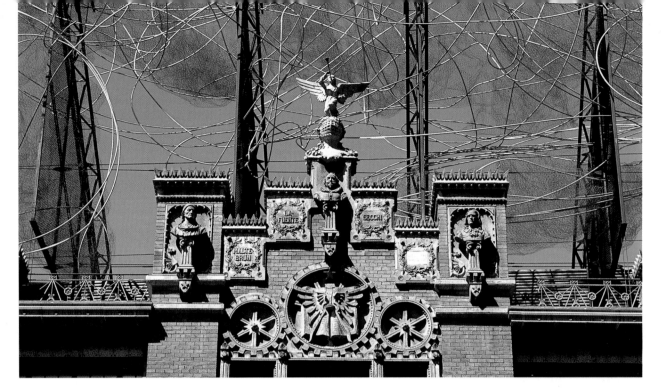

Antoni Tàpies Foundation.

INTRODUCTION

In its splendid site upstream from the mouth of the Llobregat, the capital of Catalonia lies crowned by the mountain reliefs of Montjuïc and of Tibidabo,one of the peaks of the Sierra de Collserola. The coast to the north of Barcelona, which stretches out for kilometers, includes the well-known resorts of the Costa Brava, one of the most popular tourist sites on an international level. With its over one and a half million inhabitants, it is the second largest city in Spain in population and as an important port of call and industrial pole the picture it presents is that of a large metropolitan center. The various aspects of its urban fabric, old and new at the same time, fascinating and picturesque, manifest themselves in the geometric linearity of the city blocks in the city center with the broad fast-flow traffic boulevards on either side, or in the entrancing Mediterranean jumble of the so-called Barri Gòtic, the ancient medieval heart of the city.

The Catalan capital is a green city, full of trees, parks and gardens; the squares and boulevards, magnificently shaded by decorative palms and tall trees, reflect the image of a great Mediterranean metropolis, gifted with a felicitous climate. Approaching Barcelona in terms of bull fights, flamenco and paella means limiting one's picture of the city to the most commonplace of tourist stereotypes. In reality the capital of Catalonia has a host of cultural and artistic aspects which range from an ancient linguistic tradition — the Catalan language is being used more and more, even on an official level as opposed to Castilian — to the surprising examples of Gothic, ancient and modern art, including the most stupendous, breathtaking and fabulous creations of Art Nouveau. This city, an eclectic synthesis of architectural styles — Gothic, Renaissance and neo-classical — was the experimental workshop for

Antoni Gaudí, who left indelible examples of his surrealistic abstract art, and also inspired the pictorial genius of Picasso, who sojourned there in two specific periods, which are considered among the most productive of his fertile artistic career.

Life itself in Barcelona — which in the hours of the evening and of the night means joy of living —, the magical enchantment of the Rambles, perennially crowded with towns-people and tourists, characterized by the stalls where flowers, birds and articles of all kinds are sold, the picturesque antique market and the fascinating flea market, large department stores, the marvelous Catalan food, the folklore of the Sardana — a regional folk dance —, are all elements which the tourist will long remember, after admiring the imposing monuments, the colors and lights of this extraordinary city. Having hosted the 1992 Olympic Games, today Barcelona is ideally endowed with reception and service infrastructures. Recently-built modern sports facilities, together with recently-renovated modern buildings, gave hospitality to this important international appointment which, everything considered, has become the boast and source of pride for Barcelona at the beginning of the last decade of the 20th century.

HISTORY AND TOWN PLANNING: A BRIEF SUMMARY

It was the Phoenicians and the Greeks who started Barcelona, the capital of Catalonia, off on its career as a trading center. Various legends exist to explain how the city got its name of Barcino. According to one, the city was founded by Hercules, on one of his trips from Thebes, together with the survivors of the ninth vessel of the expedition. Another version takes the origin of the city back to the

Carthaginians, who called it Barcino in honor of Hannibal's father, Amilcare Barca. Be that as it may, these and other legends all often contradict the archaeological finds in the city which indicate that indigenous populations already lived at the base of Montjuïc when the Roman expeditions decided to settle there. Around the end of the 1st century B.C. the Roman colony Iulia Augusta Faventia Paterna Barcino was founded near the slopes of Mount Taber. It was then provided with walls and laid out so that the roads would go from the sea towards the mountain, and perpendicularly, from the river Besos to the river Llobregat.

Roman domination lasted six centuries until, with the decline of the Empire, the barbarian invasions began. In order to protect the city, the walls which surrounded what was to be Barcelona were reinforced around the 4th century. It was conquered by the Visigoths and the Vandals, and although Ataulf then transformed it into the temporary capital of the Visigothic realm, it lost none of its religious importance, for councils were held there both in 540 and 589. Later Spain became a theatre for the struggle between Christianity and Islam. The Arabs seized Barcelona in 716 and occupied it until 801 when the troops of Louis the Pius, son of Charlemagne, reconquered the city, transforming it into the Hispanic March of the Frankish empire. The Garraf massifs constituted the frontier between the Arab and the Christian worlds. Wilfred the Hairy (Guifred el Pilos), Catalan national hero, fought against the Arabs together with Charles the Bald. In reward for his courage the French king granted Barcelona independence.

In the Middle Ages, under the dominion of the counts of Barcelona, the city enjoyed a period of great splendor and incomparable development, and profitable trade relations were established with Genoa and Venice. After the union with Provence, Ramón Berenguer IV (1131-1162) contracted marriage with an Aragonese princess, and a vast and solid realm in the heart of the Iberian peninsula was formed. Barcelona was on the threshold of its golden age. James the Conqueror drove the Saracens from the Balearic Islands (from Majorca in 1235 and from Ibiza in 1238). Barcelona's rule stretched all the way to Sicily, to Corsica, Sardinia and even as far as Greece. At that time Barcelona was the first port in the Mediterranean and the most important city in Spain, a role which it held until the discovery of America. The construction of the wet docks (Drassanes or Atarazanas), the shipyards of Barcelona, dates to this period (13th century).

All these military and political events together eventually, beginning with the 13th century, meant the beginning of a long period of crises and instability for the city.

Despite this, it was during this period, from the 4th to the 13th century, that Barcelona consolidated its urban nucleus founded by the Romans and began an expansion which was to definitively mark the future of the city. From the point of view of town planning, the most characteristic features of this period are the appearance of suburbs and « viles noves » (new towns) as well as improvements in the city itself.

At the end of the 13th century a new circle of walls was built, surrounding what today is the old center, aimed at protecting the most active « viles noves », or population centers scattered in the surroundings, and the new suburbs concentrated around what is now Santa Maria del Mar. Barcelona of these centuries was characterized by its great public buildings such at the cathedral, the Palace of the Government (Palau de la Generalitat), the Port, Santa Maria del Pi, the Royal Palace (Palau del Rei), the Council

of the Hundred (Consell de Cent), the Llotja. The new maritime routes inaugurated with the discovery of America meant a rapid decline in the fortunes of Barcelona and the baricenter of the peninsula shifted towards Madrid and the cities of the south. It was the beginning of a difficult period for the city, which was under the jurisdiction of the count, and which more that once rebelled against the central government and the Bourbon dynasty of Spain.

The 18th century began with the surrender of the city, on September 11, 1714, to the Bourbon troops of Philip V. It is a curious fact that September 11th is « La diada », the national holiday of Catalonia.

The price of these revolts was high: the city lost its true autonomy, the Courts (Corts) were suppressed as well as the Government (Generalitat) and the Council of Hundred (Consell de Cent). The Catalan language was outlawed.

During the 18th century some of the key infrastructures of the city were destroyed. In the northern part more than a thousand buildings were razed to the ground to make room for the construction of a military fort, and a new quarter for the fishermen's district was planned, now Barceloneta.

Not until the reign of Charles III (18th cent) did Barcelona make a comeback. The port was reopened to trade with America and new and swift phases of growth set in.

In 1775 the urbanization of what was to become the most famous and characteristic promenade of the city, La Rambla, began in line with a project by Count Ricla.

The expansion of the city towards the plain commenced in 1859 and the medieval walls which surrounded the city were razed to the ground. « El Eixample », which joined the city center to the surrounding villages, such as Gracia, Sants, les Corts, now city districts, was the brainchild of the engineer Ildefonso Cerdá. Rationality and functionality lay at the basis of the plan which took into account the industrial character of the city and its communications network. Unfortunately, as a result of speculation, it was never faithfully carried out.

The military fortress of La Ciutadella was destroyed, to the great joy of the Barcelonians, to make way for a park with a museum dedicated to science. The old fortress thus became part of the general project for expansion and reconstruction of the city which was well on its way to completion. In 1885 the mayor of the city, Rius i Taulet, made the space occupied by the hated fort available for the city's first Universal Exposition.

The Pla Macià, 20th century, was an ambitious plan for the urban renewal of the city, but was unfortunately interrupted by the Civil War.

The arrival en masse of immigrants resulted in a spectacular population rise, which led to the deterioration and suburbanization of the glorious Barcelona of the Republic of 1931.

When its democratic systems were recovered, at the end of the 1970s, Barcelona began a series of urbanistic initiatives aimed at recuperating the free spaces for public utility and recreational structures, at renovating districts and buildings and reorganizing the deteriorated communications system and thoroughfares of the city, in an attempt to achieve a new territorial equilibrium.

When Barcelona was proposed and then proclaimed seat of the 1992 Olympic Games, the city seemed to recuperate its lost face and pride. Its mistreated inner fabric has been renovated with the new metropolitan plan and the suburbs have been urbanized.

Project Barcelona '92 meant a new impulse and a new objective for the reorganization, restoration and reconstruction processes of the city's urban fabric.

4

Panorama of the city.

BARRI GÒTIC

While the Barri Gòtic, also known as « Barri de la Seu » (Cathedral quarter) or by the odd name of « rovell de l'ou » (egg yolk), may not be a district in the true sense of the word it does enclose most of what is left of medieval Barcelona and contains some of the most interesting monuments of the city. What is probably the most fascinating zone of the city includes the area between the Cathedral and the City Hall and is partially surrounded by the bastions of the Roman walls. The denomination Gothic Quarter dates to the early 20th century. While other Gothic areas existed in the city, as a whole the extant buildings in this zone were more harmonious and particular care was therefore taken in their restoration. The Barri Gòtic begins in the *Plaça Nova*, the oldest square in Barcelona, entrance to the solitary Roman « Barcino » and a 13th-century site of one of the most flourishing markets in the city where slaves were once sold. Two Roman towers that belonged to the old city walls which constituted the city's only defense until the 13th century are still to be found here. The **Palau Episcopal** (Bishop's Palace) which rises to the right of the Roman towers also

dates to the 13th century and creates an interesting contrast with the modern **Col.legi d'Arquitectes** (College of Architects), decorated on the outside by a graffito frieze designed by Picasso. Do not be deceived by the 18th-century Baroque facade facing on Plaça Nova for the building is actually much older and in part rests on Roman walls (incorporating one of the Roman towers as well) to which skillful restoration, particularly in the internal courtyard and the secondary facade, facing on *Carrer del Bisbe Irurita*, has restored its original dignity.

To the left of the Roman towers is another interesting building, the **Casa de l'Ardiaca** (at present seat of the historical Archives of the City and the Historical Institute of Barcelona), which takes its name from the fact that it was the residence of the archdeacon Lluis Desplá. The building, which is probably very old (11th century), was restructured throughout the centuries and is a harmonious fusion of Gothic and Renaissance styles. The interior courtyard, with a ground floor arcading of depressed arches and a moss-covered fountain at the center, is particularly lovely.

One of the three facades of the palace looks out on the famous **Carrer del Bisbe Irurita** (Street of the Bishop), the

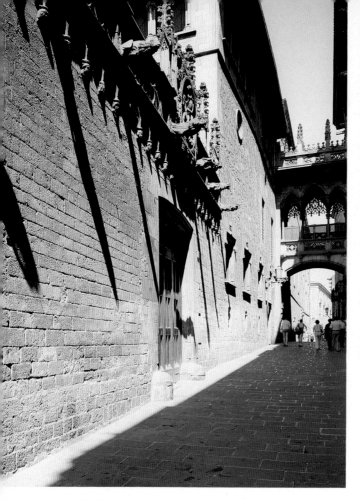

Carrer del Bisbe Irurita with its charming suspended overpass, a characteristic example of the architecture of the Barri Gòtic.

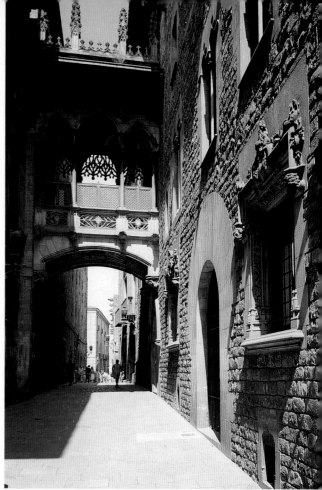

Cathedral: the facade.

heart of the Barri Gòtic, which skirts the side of the Cathedral and arrives as far as *Plaça de Sant Jaume*. About halfway down, this lovely street is passed over by a charming suspended bridge which is a trademark for the street and connects the *Palau de la Generalitat* to the secondary facade of the **Casa dels Canonges** (House for Canons). The bridge, which is a sort of miniature summing up of Gothic art, was realized in 1926 by Juan Rubió. The Casa dels Canonges is an enormous building with an irregular ground plan dating to the 14th century and recently restored, with a facade on *Carrer Paradís*. Various medieval buildings here that are open to the public house the Centro Excursionista de Cataluña and the remains of a **Roman Temple** dedicated to Augustus which dates to the 2nd century. The four imposing Corinthian

columns are topped by an architrave and stand on a podium. The temple was built here on the highest and most important point of the ancient « Barcino », on the very top of the « Mons Taber ». On the right of Carrer del Bisbe Irurita, coming from Plaça Nova, before encountering the Gothic bridge, is a narrow lane which leads to the most intimate hidden little square in the city. *Plaça de Sant Felip Neri* is one of the most peaceful spots in town (and one of the reasons why is that it is almost impossible to find and therefore rarely frequented), with a simple fountain at the center, dominated by the sober 18th-century **Church of Sant Felip Neri**. The building which shelters the *Museum of the History of Shoes* (Museu del Calçat Antic y el Gremi de Calderers) also faces onto the small square.

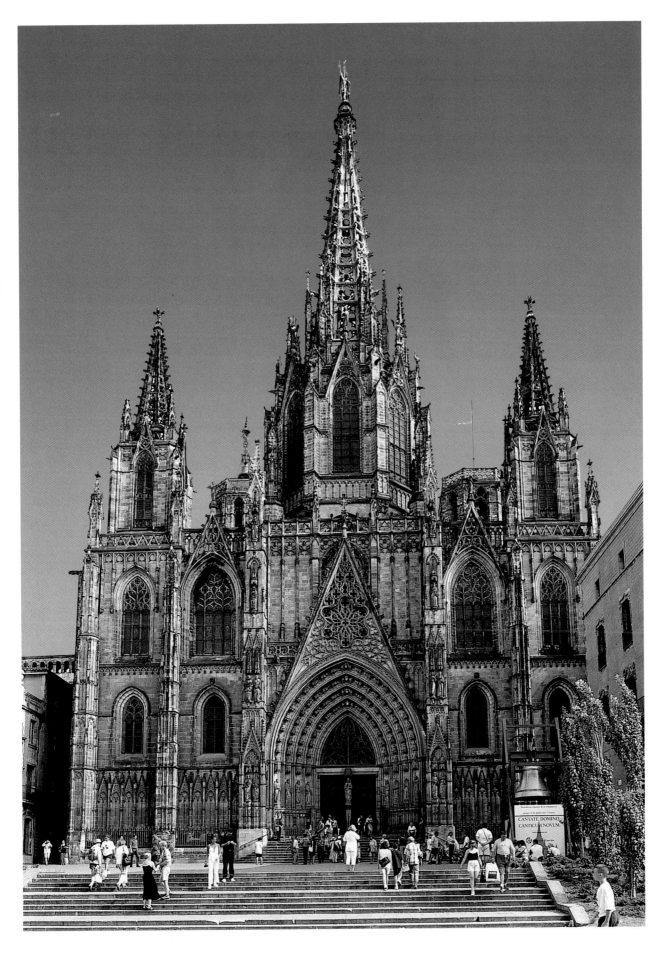

Barri Gòtic

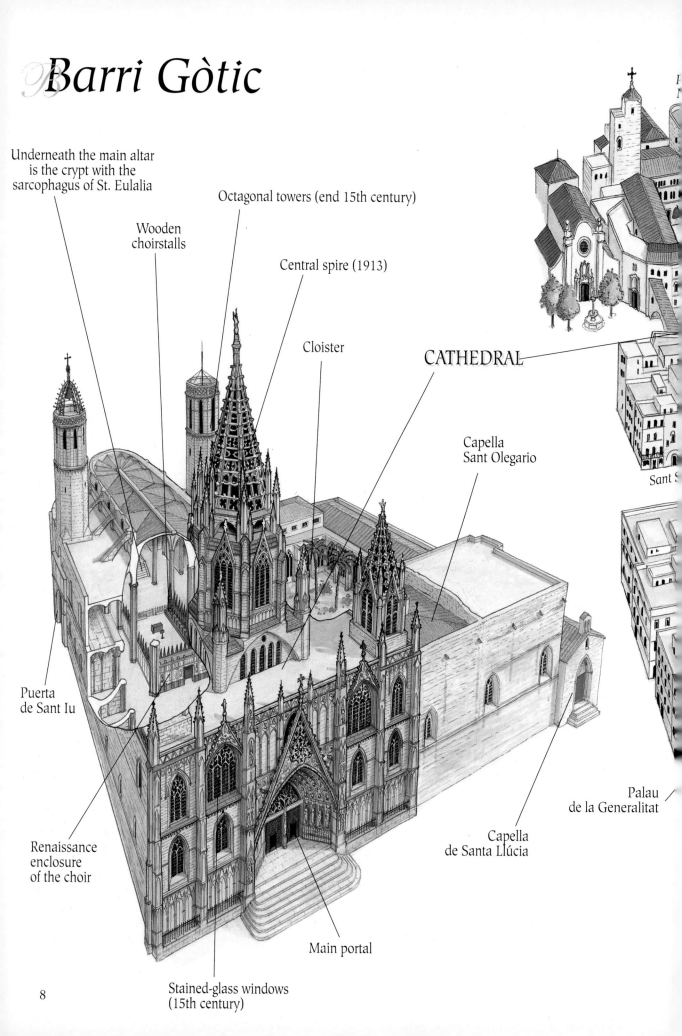

Underneath the main altar is the crypt with the sarcophagus of St. Eulalia

Wooden choirstalls

Octagonal towers (end 15th century)

Central spire (1913)

Cloister

CATHEDRAL

Capella Sant Olegario

Sant

Puerta de Sant Iu

Renaissance enclosure of the choir

Palau de la Generalitat

Capella de Santa Llúcia

Main portal

Stained-glass windows (15th century)

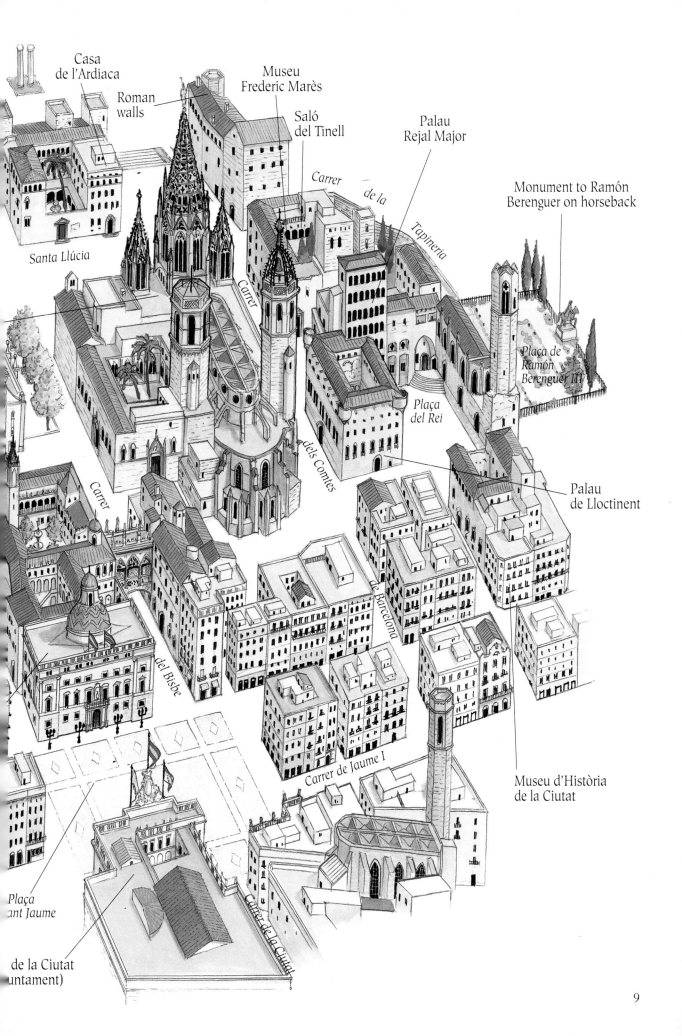

Casa
de l'Ardiaca

Roman
walls

Museu
Frederic Marès

Saló
del Tinell

Palau
Rejal Major

Monument to Ramón
Berenguer on horseback

Carrer

de la

Tapineria

Santa Llúcia

Carrer

Plaça de
Ramón
Berenguer III

dels Comtes

Plaça
del Rei

Carrer

Palau
de Lloctinent

del Bisbe

de Barcelona

Carrer de Jaume I

Museu d'Història
de la Ciutat

Plaça
ant Jaume

Carrer de la Ciutat

de la Ciutat
untament)

9

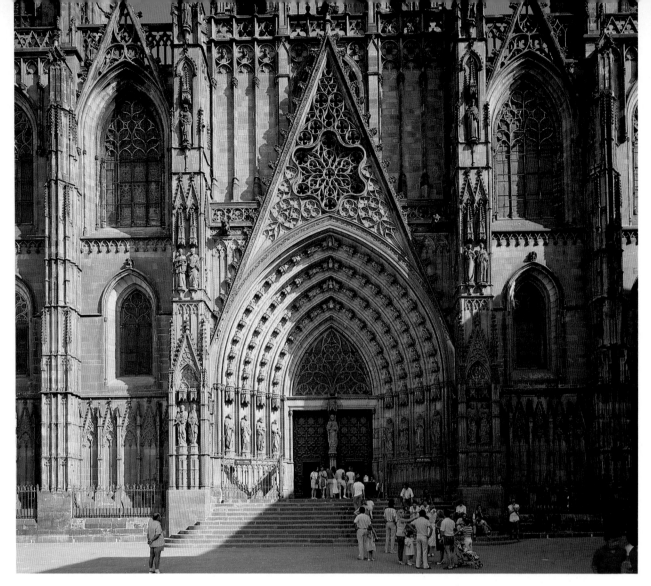

Cathedral: the main entrance portal.

CATHEDRAL OF SAINT EULALIA

In the 4th century a small church already stood on the highest point of the old Roman colony, the small « Mons Taber ». And it must have been an important church if two centuries later, as the Cathedral of Barcelona, it was the setting for the Council of 559. These were times of violence and the church was destroyed by Almanzor in 985. Shortly after the year 1000 the Catalan count Ramón Berenguer I rebuilt it in Romanesque style, but plans for the great church which today rises next to the *Avinguda de la Catedral*, in the heart of the *Barri Gòtic*, were only begun under James II, king of Aragon.

Construction began in 1298 and continued, until 1448, following the stylistic canons of the Catalan Gothic. An inscription near the *Porta de Sant Iu* in *Carrer dels Comtes* commemorates the date of the beginning of the work. The Cathedral was dedicated to Saint Eulalia, a legendary young girl who was tortured and killed for her Christian faith in the 4th century.

Throughout the years the building has undergone considerable modifications. The main facade of the church dates to the end of the 19th century and was quite controversial. The architects Mestres and Font were supposed to have followed the original designs of 1408 by a French architect. The central spire of the cathedral was not built until 1913.

The **interior** is grandiose and austere. The stained-glass windows date to the 15th century and illuminate the nave and two aisles which represent Catalan Gothic at its purest. The Cathedral is a real treasure chest: everything — the 26 chapels, the sacristy, the crypt with the sarcophagus of the Saint, the lovely cloister — is to be carefully visited. On one side of the main entrance is the **Capella (Chapel) del Baptisteri**, with the marble baptismal fonts, by Onofre Julia, dating to 1443. On the other

side is the large **Capella de Sant Oleguer** protected by a wrought iron railing. Above Bishop Oleguer's altar, a work by Ça-Anglada, is a wooden 16th-century *Crucifix* which Don Juan of Austria carried on the flagship of the Christian fleet in the battle of Lepanto. Beyond the Chapel of Sant Oleguer is the **Capella de Sant Climent**, with the Gothic sepulchre of Doña Sança Ximenis de Cabrera and an altarpiece of the 15th century.

The presbytery, the **Capella Major** (Chancel) of the Cathedral, opens off the transept. In the radiating chapels of the chevet there are numerous 14th and 15th-century *retablos*, high expressions of Catalan art. The 15th-century altarpiece of the *Visitation* is in the **Capella de Sant Miquel**, and one of Bernat Martorell's masterpieces, the altarpiece of the *Transfiguration*, is in the **Capella del Patrocini**, while the 14th-century altarpiece of the *Archangel Gabriel* is in the apse, the **Capella del Santíssim Sacrament**. The sixth chapel contains the altarpiece of

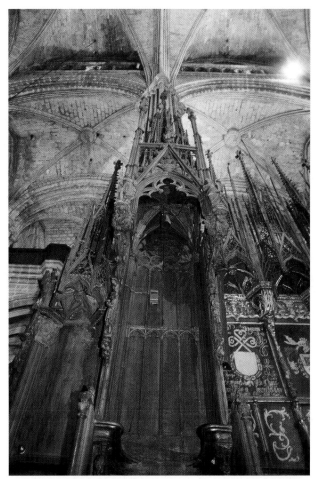

Cathedral: detail of the wooden choirstalls with their pinnacles and a view of the Renaissance enclosure of the choir.

Following pages:
view of the interior and the choirstalls with a detail of their rich polychrome and gilded decoration.

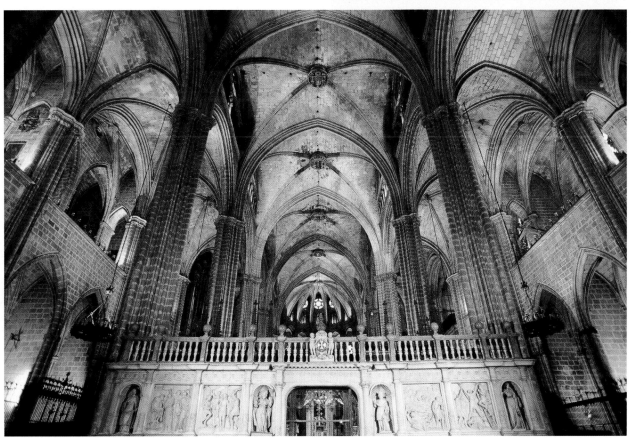

11

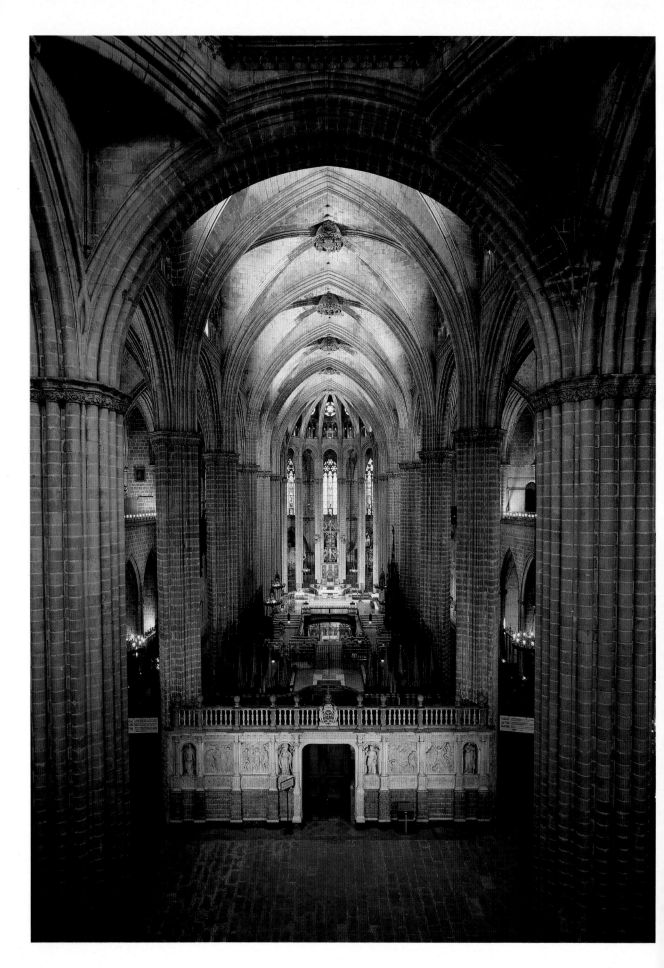

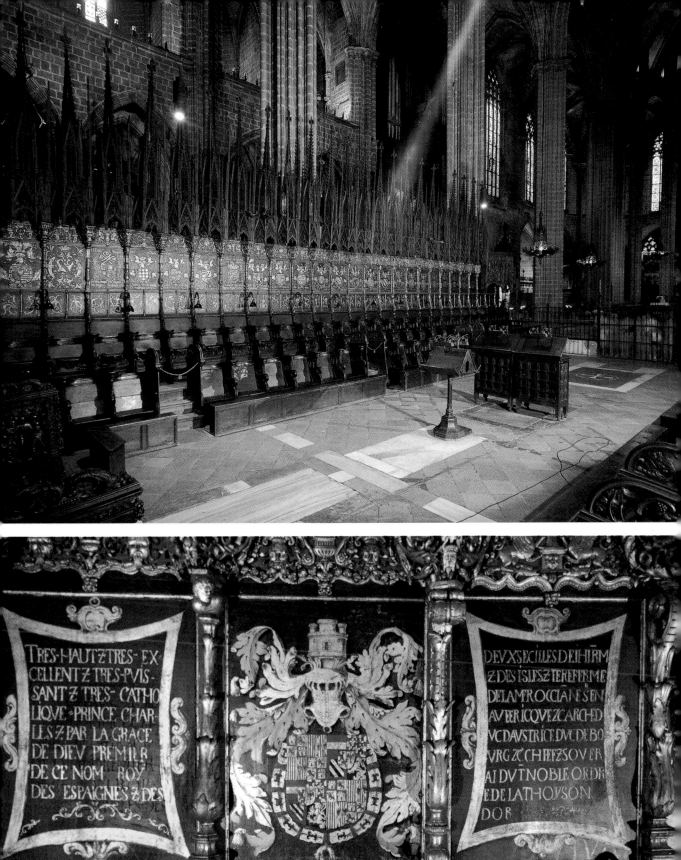

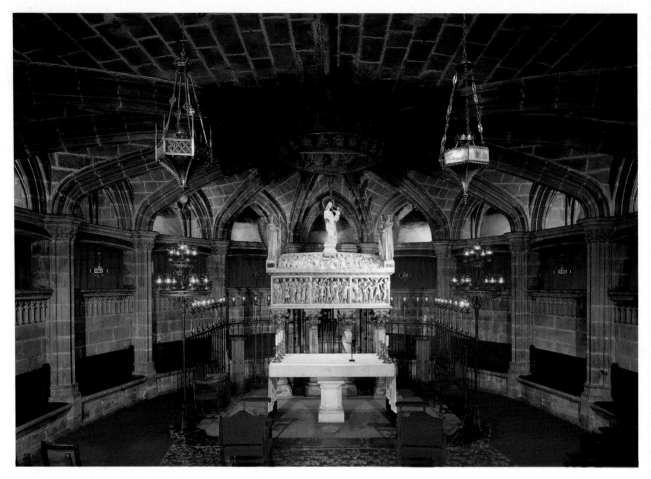

Cathedral: the crypt, with the sarcophagus of Saint Eulalia.

Saints Martin and Ambrose, the seventh the altarpiece of the middle of the 15th century representing *Saint Claire and Saint Catherine*. The Gothic sepulchre of Bishop Ramón de Escales is to be found in the **Capella dels Sants Inocents**. The two sepulchres of the founders of the Cathedral, Count Ramón Berenguer I and his wife Almodis, are to be seen to the right of the high altar. To the left of the transept, the **Porta de Sant Iu**, the oldest part of the Cathedral which is still Romanesque in appearance, leads to the *Carrer dels Comtes*.

Under the Capella Major, a short flight of stairs leads to the **Crypt** where the body of Saint Eulalia is preserved in an *alabaster sarcophagus* of 1327, the work of a pupil of the Italian sculptor Nicola Pisano. The German painter Müller painted the *Incoronation of Saint Eulalia* on the large keystone of the vault of the Crypt, which was designed by Jaime Fabré.

The Renaissance enclosure of the large **Choir** is at the center of the nave. Work on the construction began in 1390 when Ramón de Escales was bishop of Barcelona, and his coat of arms (three ladders) is sculptured on the walls of the Choir. The entire enclosure is decorated with marble bas-reliefs which narrate the life of Saint Eulalia, begun in 1517 by Bartolome Ordoñez and Pere Vilar. Inside are the famous wooden stalls, decorated with gilded polychrome coats of arms of the Knights of the Order of the Golden Fleece who were convoked in the Cathedral by Emperor Charles V and archduke Maximilian of Austria in 1519. The upper stalls and the bishop's throne are by Ça-Anglada, the lower row of stalls by M. Bonafé, and the crowning canopy of the stalls was created by the artists Lochner and Friedrich.

In a corner, to the right of the Capella Major, is the **Sacristy** which houses the *Cathedral Treasure*. This valuable collection of liturgical objects and religious art includes a 15th-century reliquary decorated with the collar

of the Order of the Golden Fleece which belonged to Charles V, the gilded chair of the Aragonese king Martin I and a gold and silver monstrance of 1390.

Access to the **Cloister** of the cathedral is through the Porta de Sant Sever, inside the church, from the Chapel of Saint Lucy, to the right of the main entrance to the cathedral, from the **Porta de Santa Eulàlia**, Gate of St. Eulalia, which opens on the *Carrer del Bisbe Irurita*, and through the **Porta de la Pietat** Gate of the Pietà, in the carrer of the same name, decorated in the lunette above the portal with a wooden *Pietà* in relief, of Nordic make (16th century).

The cloister, which is without doubt one of the loveliest Gothic cloisters in existence, is unique in more ways than one. One of these consists in the diversity of its components. The old chapels of the religious congregations, separated from the cloister portico by austere wrought iron railings, open off three of its four sides. The wing set against the side of the Cathedral is the oldest and dates to the 14th century, while the other wings are from the mid-

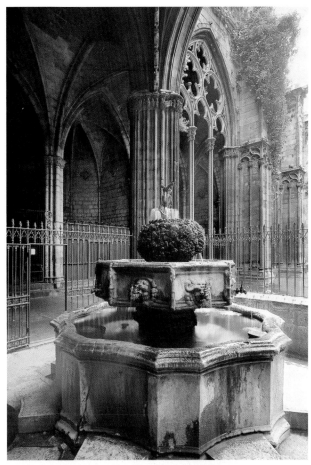

The cloister: the wash-basin and the charming Gothic loggia.

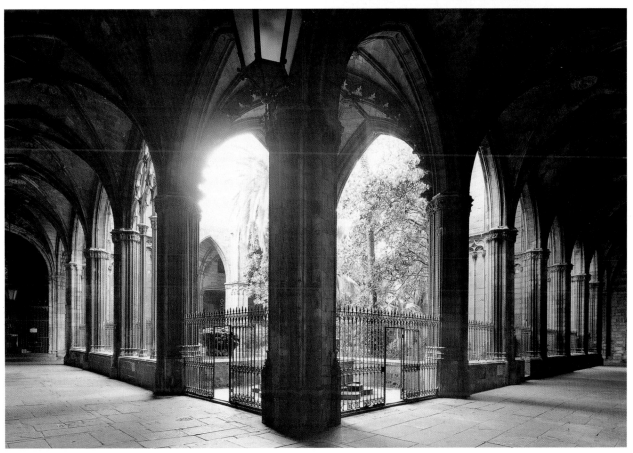

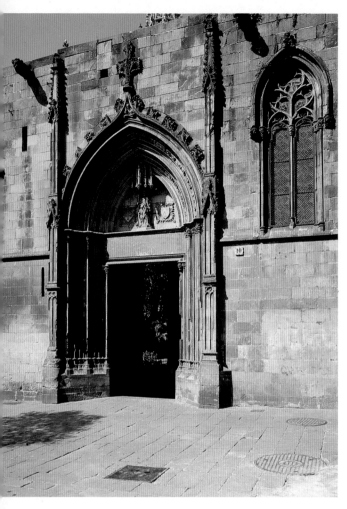

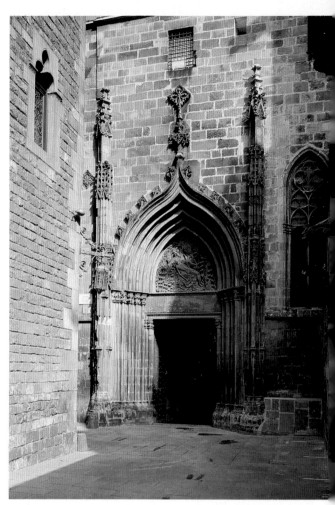

Cathedral: the Porta de Santa Eulàlia and the Porta de la Pietat.

Cathedral: a view by night.

dle of the 15th century. Where the oldest wing and the one at right angles to the side of the church meet is the Romanesque **Porta de Sant Sever**, in front of which is a charming old conventual washstand set at the center of a sort of temple, the **Pabelló de Sant Jordi**, with the vault decorated with sculpture representing *St. George* at the center and the *Fathers of the Church* on the ribs. Every year for the feast day of « Corpus Christi », the traditional « ou com balla » (dancing egg) is held: an eggshell which « dances » suspended above the basin of the washstand on its spout of water. Near the temple is a small pond and a flock of geese, which some say are symbols of Saint Eulalia's purity. In the corner diagonally opposite the Porta de Sant Severo is the Romanesque **Capella de Santa Llúcia**,

or better what is left of the Romanesque cathedral (13th century). Consecrated to the Madonna in 1268, the facade boasts a fine Romanesque portal. Inside is the tomb of the bishop Arnau de Gurb, founder of the chapel, and that of the parish priest of Santa Coloma. A picture of the saint is on the high altar.

The **Chapter Hall**, adjoining the chapel, dates to the first half of the 15th century and shelters the **Cathedral Museum**, with a collection that includes the famous *Pietà* by Bartolomé Bermejo (of the 15th century), the illuminated missal of Saint Eulalia (by Ramón Destorrent), the *altarpiece of S. Bernardino* (15th century) by Jaume Huguet, the *Madonna and Child* (15th century) by Sano di Pietro and *Saint Onofrio* (14th century) by Jaime Serra.

16

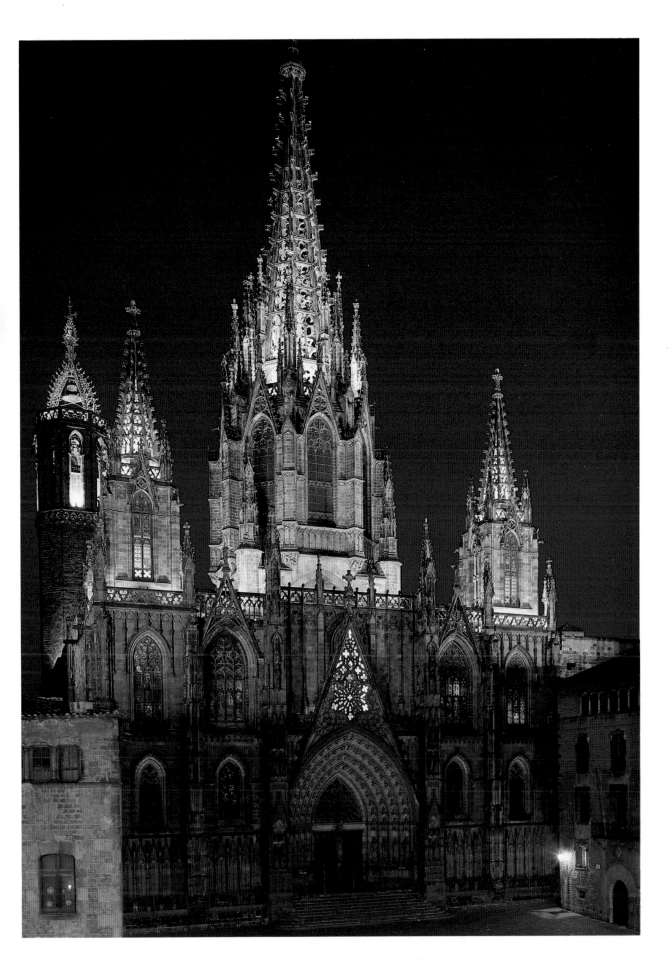

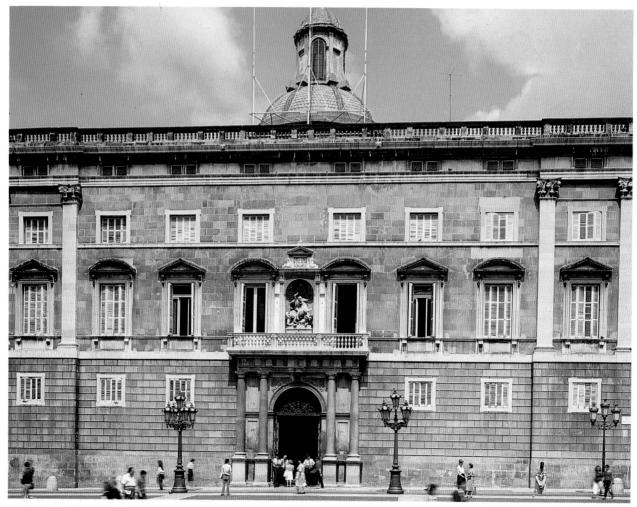

Palau de la Generalitat: the main facade.

PALAU DE LA GENERALITAT

Plaça de Sant Jaume is a sort of continuation of what was once the forum of the Roman city. The ancient tradition still holds for even today the most important government buildings of Barcelona are here: the *Palau de la Generalitat*, built in various phases, beginning with the 15th century, to house the Diputación de Catalunya (or Parliament) and the so-called *Casa de la Ciutat* or *Ajuntament* (the City Hall).

The main facade of the Palau de la Generalitat, a building in Renaissance style by Pere Blai, dates to the late 16th century. The elegant secondary facade of 1416 is in Gothic style. It faces on the lovely *Carrer del Bisbe Irurita* and is the work of the architect Marc Safont. But the finest part of the building is the ancient internal *courtyard*, access to which is through a wide depressed arch. It was also built in the Catalan Gothic style by Safont (1425) and is a perfect example of the aristocratic patio of the period. A staircase, supported by a single arch and with a finely decorated balustrade, leads to the main floor of the building where a loggia of ogee arches on slender columns

looks out on the courtyard. A bold architectural solution has been found for the corner at the top of the staircase: two round-headed arches (instead of pointed arches) are set side by side, separated only by a capital without a column which, like a stalactite, is suspended in the void. Once past this fascinating « entrance » we come face to face with the admirable ***Capella de Sant Jordi*** (Chapel of St. George), also by Safont (1432).

The loggia of the main floor leads to the ***Saló de Sant Jordi***, realized at the end of the 16th century by Pere Blai, which occupies the central part of the palace. It is a vast room with three aisles and vaults, supported by square pilasters, and with a dome at the center decorated with frescoes of historical subjects executed in the 1920s by Josep Mongrell.

The courtyard loggia also leads to the famous ***Pati dels Tarongers*** (Orange Tree Courtyard) executed between 1526 and 1600 and a good example of the transition from Gothic to Renaissance architecture. It in turn leads to the *Saló del Consistori Major* or *Saló Daurat* (Gilded Hall), so-called because of the gilded ceiling. The wooden coffers of the ceiling also contain the carved and painted portraits of the Catalan kings.

AJUNTAMENT

The neoclassic facade of the palace is the result of a 19th-century restructuration of the original Gothic building. On one side, in the *Carrer de la Ciutat*, the old Gothic facade, realized at the end of the 14th century by Arnau Bargués, can still be seen. The entrance portal is marked by a fine arch in relief which, on the right, « trespasses » into a wing of the palace that is at right angles to the facade, creating an original aesthetic solution. Above the arch are the coats of arms of Barcelona and Catalonia and the statue of the *archangel Raphael*.

The **Saló de Cent** is on the main floor of the building. It was created by Pere Llobet for the City Council of the Hundred in the 14th century and was inaugurated in the session of August 17, 1373 and enlarged in the middle of the 19th century. From here access to the 19th-century *Saló de Sessions*, known as *Saló de la Reina Regent* (the Hall of the Queen Regent) — so-called because of the portrait of the *Queen Maria Cristina with her son*, the small Alfonso XIII, which hangs there — where the City Council normally meets. The main floor also contains the evocative *Saló de les Cròniques* of the first half of the century, almost completely frescoed by Josep Sert with historical scenes.

Ajuntament: detail of the secondary facade with its unique Gothic portal and the Saló de Cent.

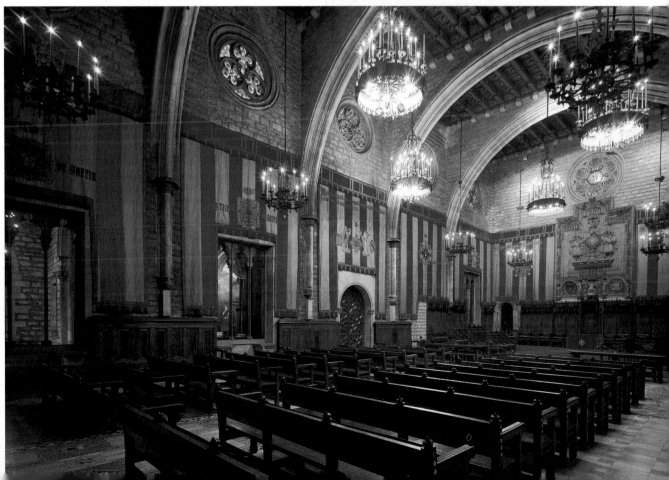

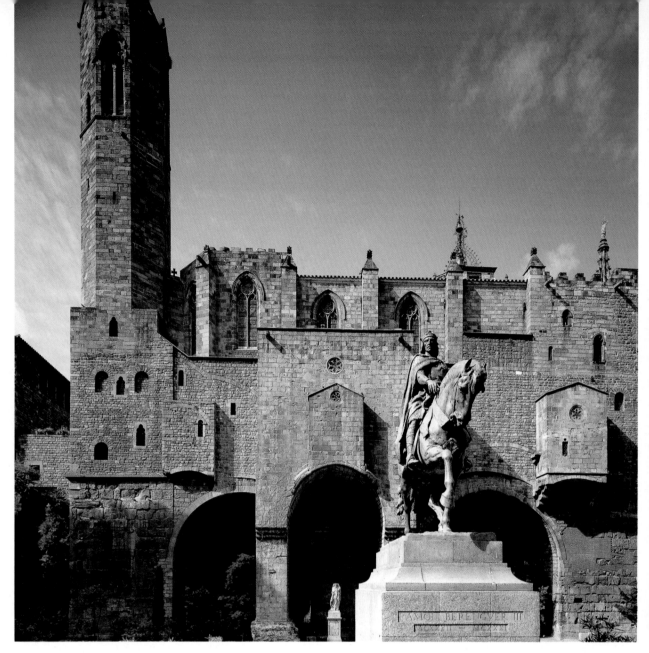

The monument to Ramón Berenguer III in the square of the same name.

PLAÇA DE RAMÓN BERENGUER EL GRAN

Plaça de Ramón Berenguer el Gran, which is at the eastern edge of the enclosing walls that are incorporated into the royal palace, creates a sort of narrow garden at the foot of the walls. Here, in *Via Laietana*, stands the *equestrian Monument to the count-king Ramón Berenguer III* (1082-1131), a member of the family of the Ramón who reconstructed the Cathedral of the city in 1058. The monument is set against the backdrop of the Roman walls and the side of the **Capella de Santa Agata**.
This palatine chapel of the Palau Reial Major stands on the site of an old oratory of Santa María and was built on the old Roman walls. The single tall nave, scanned by ogee arches at intervals, has a fine polychrome wooden coffered ceiling. The coats of arms of James II and his wife Blanche of Anjou can still be seen in the apse and one of the masterpieces of old Catalan painting is set above the high altar, the retablo representing the *Adoration of the Magi* (at the center, below) and the *Crucifixion* (at the center, above), surrounded by six stories. The altarpiece was painted by Jaume Huguet in 1464 and is known as « *Retablo del Condestable* » because it was commissioned by the Constable Don Pedro of Portugal, one of the pretenders to the crown of Catalonia-Aragon. *Via Laietana* is one of the most important urban arteries of the city and crossing the oldest quarter of Barcelona it joins the « old city » to the harbor. Evenings the panorama from here is spectacular: the majestic complex of the walls and of the Chapel of Saint Agatha, with the Mirador and the bell tower of the Cathedral rising up over them, are brightly illuminated and form a fantastic backdrop.

MUSEU D'HISTÒRIA DE LA CIUTAT

The museum is housed in the Casa Clariana-Padellàs, a 15th-century Gothic palace, which was transported stone by stone to its present site when Via Laietana was opened. In 1931 when excavations were made for new foundations, important remains of the old Roman city came to light. The discovery furnished the pretext for using the building as the Historical Museum of the City.

In the vaults the remains of the ancient Roman colony can be seen, with the old Roman forum (2nd cent.), a bathing establishment, a reproduction of the Visigothic necropolis, drainage canals. The remains of a 4th-century Christian basilica are also to be found in the vaults of Calle de los Comtes.

The rooms of the museum, at present in the process of re-organization, contain plans and up-to-date panoramas of the city, archaeological remains, photographs of the Gothic district, various paintings and prints, portraits, antique books, sarcophaguses, the development of Barcelona in paintings and prints. Once ready, they will furnish an idea of the city's history and its evolution as a town.

Museu d'Història de la Ciutat: fragment of a bas-relief and two amphoras which contained oil.

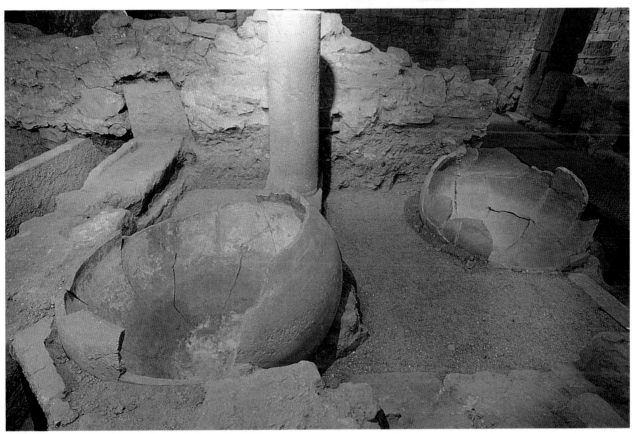

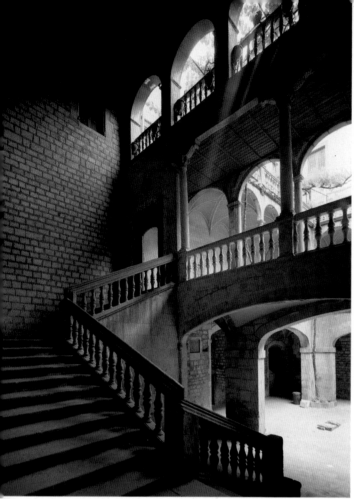

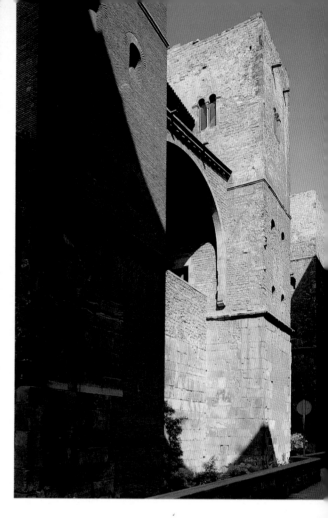

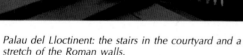
Palau del Lloctinent: the stairs in the courtyard and a stretch of the Roman walls.

PALAU DEL LLOCTINENT

The majestic *Plaça del Rei*, once the central part of the *Palau Reial Major*, residence first of the counts of Barcelona and then of the kings of Aragon, is at the very center of the city's Gothic district.

Facing on the square are the *Palau del Lloctinent*, the tower known as **Mirador del Rei Martí** (a fascinating building of the middle of the 16th century with five superimposed galleries), the **Saló del Tinell** (the great hall of the palace of the counts, 14th century), the **Chapel de Santa Agata** (the 14th-century Palatine chapel) and the 16th-century **Casa Clariana-Padellàs** in which the *Historical Museum of the City* is installed.

The Palace of the Lieutenant or Viceroy, whose secondary facade overlooks the square, is a sober building erected by Antoni Carbonell in 1549. It contains the *Archives of the Crown of Aragon*, over 4 million documents, dating back as far as the 9th century.

Worthy of note is the characteristic patio with several orders of superposed loggias and the airy main staircase, with its splendid coffered ceiling.

THE ROMAN WALLS

The Barri Gòtic, contrary to expectations, does not consist only of buildings that date to the 13th and 14th centuries, for considerable Roman remains that date back to the 4th century A.D. are to be found in their midst.

The remains in question are what is left of the city walls built by the Romans after having reconquered the old « Barcino » which had been occupied and destroyed by the Barbarians in the second half of the 3rd century A.D. These walls, which were 1270 meters long, were about 9 meters high, about 3.50 meters thick and had strong polygonal towers and entrance gates set at intervals. The remains of a basilical building of the same period as the walls have been brought to light under the Cathedral and part of the initial structure of a Roman acqueduct as well as a stretch of walls were found in the Cathedral square. Remains of the encircling walls can still be seen in Carrer Carreu Vell, Baixada Caçador, Carrer Sots-jinent Navarro, Plaça del Angel, Baixada Llibreteria, Carrer Tapineria, Plaça Ramón Berenguer el Gran, Carrer dels Comtes, which skirts the side of the Cathedral.

MUSEU MARÈS

This museum is in an annex of the *Palau Reial Major* which consists of various buildings completed in different periods. Formerly the residence of the counts of Barcelona, it became the seat of the Holy Office in the second half of the 15th century. Subsequently it became the residence of the kings of Aragon and Castille, and Christopher Columbus was received there upon his return from the New World. During the 17th century the shorter wing was turned into a convent: and this is where the *Museu Marès* was installed. The initial core of the collections was created by the sculptor Frederic Marès Deulovol, who donated it to the city of Barcelona in 1940. The exhibitions deal particularly with medieval sculpture, not only Catalan, but also from other regions of Spain. The collections on the ground floor of the museum range from a panorama of ancient Iberian, Greek and Punic sculpture to 15th-century Castilian statuary and Aragonese sculpture. Of particular interest is a rich collection of *Crucifixes* of the 14th-15th centuries and one of enameled or painted *Crosses* in wood or metal from the Gothic period to the 17th century.

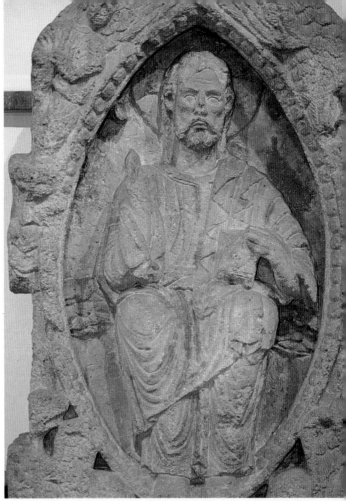

Museu Marès: an antique bas-relief and two of the crucifixes in the rich collection housed on the ground floor.

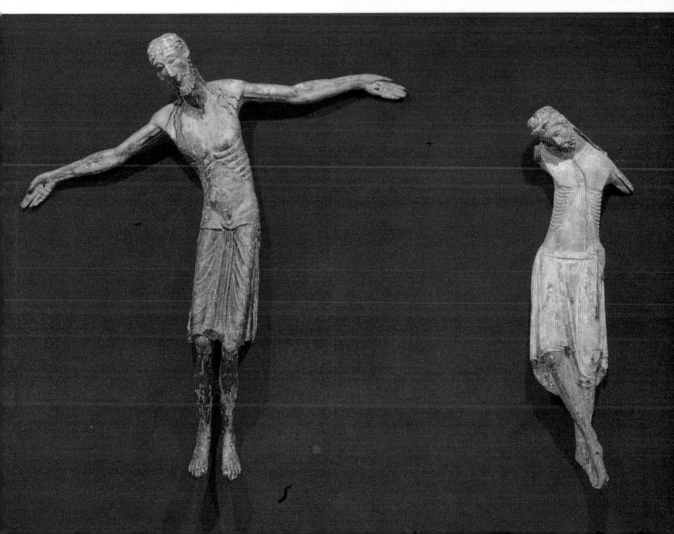

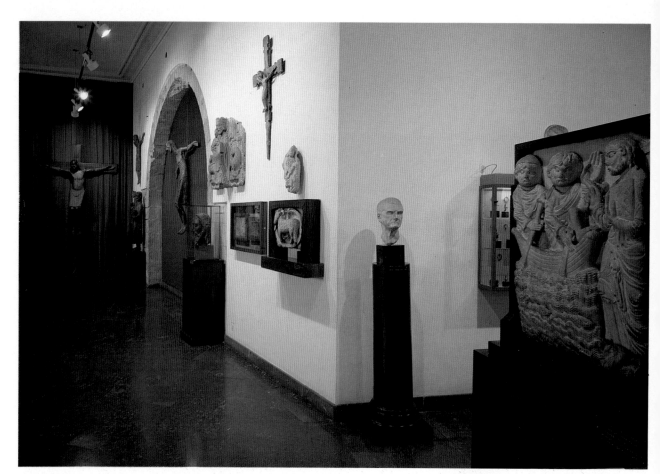

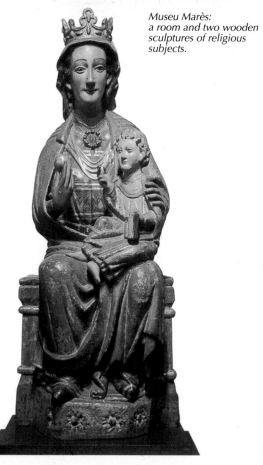

Museu Marès:
a room and two wooden
sculptures of religious
subjects.

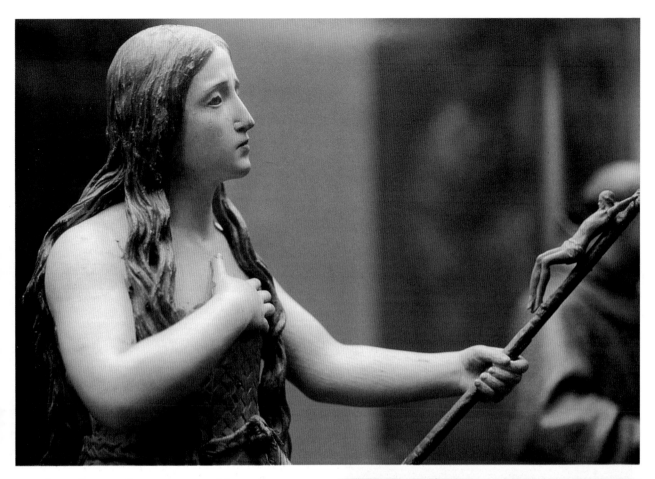

Two other sculptures in the museum: a Magdalen and a haunting Christ taken from the Cross.

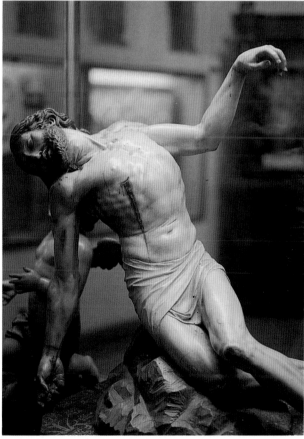

The sculpture and painting exhibited on the first floor range from the early Middle Ages to the 19th century. The *Madonna and Child* was a common theme in 15th- century sculpture while the *Holy Family* appears often in 13th-to 16th-century work. The examples of Spanish Renaissance sculpture clearly document the Italian and Flemish influences. Particularly interesting from this point of view is a group of sculptures in alabaster (reliefs representing the *Annunciation*, the *Visitation*, the *Adoration of the Shepherds* and the *Presentation in the Temple*, by Francisco Giralte) and a *Virgin and Child* attributed to Alonso Berruguete.

SANTA MARÍA DEL PI

Known also as *Nuestra Señora de los Reyes* and rising on the site of a religious building of the 10th century, the construction of the church began in 1322 (utilizing in part precedent structures, such as the 13th-century side portal) and it was consecrated in 1453, although the crypt is 16th century. A large rose window stands out against the simple rigor of the Gothic facade. Of fine polychrome stained glass, it is of modern make and is what characterizes the building. ***Inside***, a single wide nave flanked by chapels preserves a tomb dated 1394.

The church stands on one side of the square of the same name, a small intimate corner which every so often is given over to an amusing little market. The entire area around the church — the well known quarter of the Pine — is full of cafés, places in which to pass the time of day and pastry shops, which occupy rooms that are often very old, antique shops or boutiques which deal in specialized products such as masks, maps, etc. A walk along *Carrer*

Petritxol which leads to the church square gives you an idea of the charm of a typical Barcelona calle and in addition provides an opportunity for tasting the best known local titbits.

SANTS JUST I PASTOR

Another interesting building in the Barri Gòtic, this very old church is mentioned in sources as far back as the year 801 and is situated on Plaça Sant Just together with various other Gothic buildings. The church as it is now dates back to the 14th-15th century. The simple facade is flanked by only one of the two bell towers originally planned. ***Inside***, a single nave has side chapels decorated with reliefs. The *retablo* of San Felix is in the Chapel of San Felix. An estimable work by the Portuguese Pedro Núñez, it dates to the first half of the 16th century. The two holy water stoups were originally Gothic capitals. According to the directives of the city statutes of 1282, the

Santa María del Pi: the austere Gothic facade.

Sants Just i Pastor: the old facade.

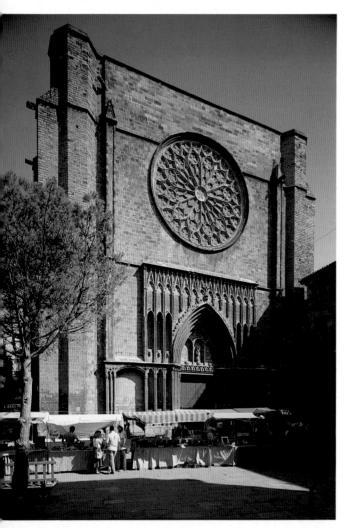

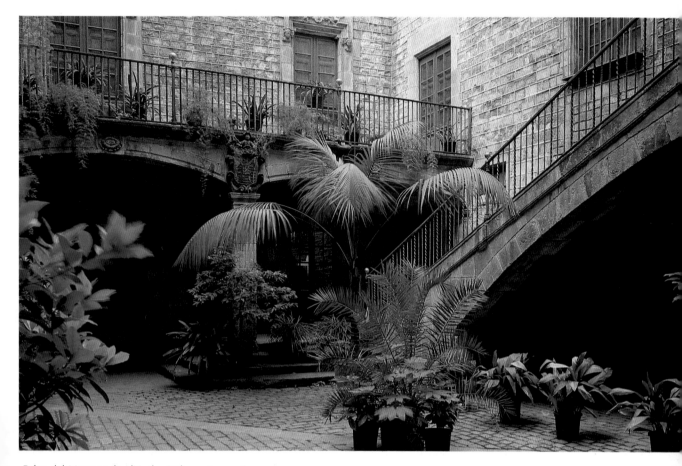

Palau del Marques de Lló: the 16th- century patio.

Church of Sants Just i Pastor has the power of conceding the privilege « de los Testamentos Sacramentales » (The Right of Sacramental Wills), which is still valid and according to which the last will of a dying person, verbally pronounced, becomes legally valid, even in the absence of written documents, if it is repeated, under oath and within six months, before the altar in the chapel of San Felix, by the witnesses present when it was formulated. The palace in Gothic style in the immediate vicinity is the 15th-century *Palau Requesens*. Inside is the **Gallery of Illustrious Catalans**, with portraits of the famous figures of the region, from the 10th century on.

CARRER DE MONTCADA

Carrer Princesa, a street off the large Via Laietana, leads to *Carrer de Montcada*, originally little more than a path along the banks of a brook, but honored with the name of « Calle Nueva » when the first buildings began to rise just outside the old city walls. The present name derives from Guillem Ramon de Montcada who built his palace there in 1153.

From the 13th to the 18th century this street was at the height of its splendor and was one of the most aristocratic in the city thanks to the rich mansions which were built on either side. This all ended in the 19th-century when the high society of the time preferred other areas of Barcelona.

One of the old houses that still stands in this street at n. 12, is the **Palau del Marques de Lló**, a fine 16th- century building, now owned by the city which has installed the *Museu Tèxtil i d'Indumentaría* (Costume Museum) there, realized thanks to the generous bequest of Manuel Rocamora. The three floors of the palace contain exhibitions of liturgical vestment, dolls, shoes, costume accessories (fans and purses), matador costumes, tapestries, uniforms, examples of fine embroidery.

The oldest objects date to the 16th century, the most recent are 20th-century.

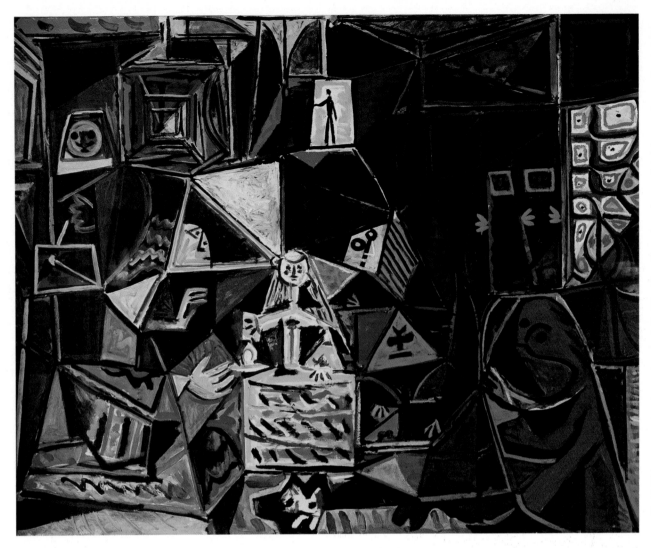

Museu Picasso: "Las Meninas".

MUSEU PICASSO

Palau Berenguer d'Aguilar, a 14th-century building with a fine Gothic patio, is at n. 15 *Carrer de Montcada*. It was the residence of the Llinás family and then of the counts of Santa Coloma who modified the original Gothic structure of the building in Renaissance and Baroque style. It is now the home of the *Museu Picasso,* and the three floors are given over to the donation of Jaume Sabartés, a friend of the painter's, and the donation Picasso himself made, consisting of several hundred oil paintings, sketches, drawings and etchings. The space was insufficient for all these works and the collection overflowed into the *Palau Baró de Castellet,* a 17th-century building adjoining the Palau Berenguer d'Aguilar. The quantity and variety of the material on exhibit (arranged chronologically) make this museum a unique and indispensable instru-

ment in understanding the work of the great artist — from one of his first attempts (a drawing done when he was nine years old) to the works painted towards the end of the century, in La Coruña, the production of his two sojourns in Barcelona (from 1895 to 1897 and from 1901 to 1904), the famous « blue period » (after his stay in Paris), his cubist experiments, up to the paintings done in Cannes in 1957. To mention only a few of the masterworks here, there is the large oil painting, *Science and Charity,* done by the master when he was barely fifteen, *El Paseo Colón* and *Barcelona* (dedicated to the city he loved so much), *El Niño Enfermo* (blue period) and *Harlequin* (1917, cubist period). A whole section of the museum is dedicated to the 58 paintings which Picasso donated to the museum in 1968, 44 of which are variations on the theme of *Las Meninas,* the famous painting by Velázquez in the Prado.

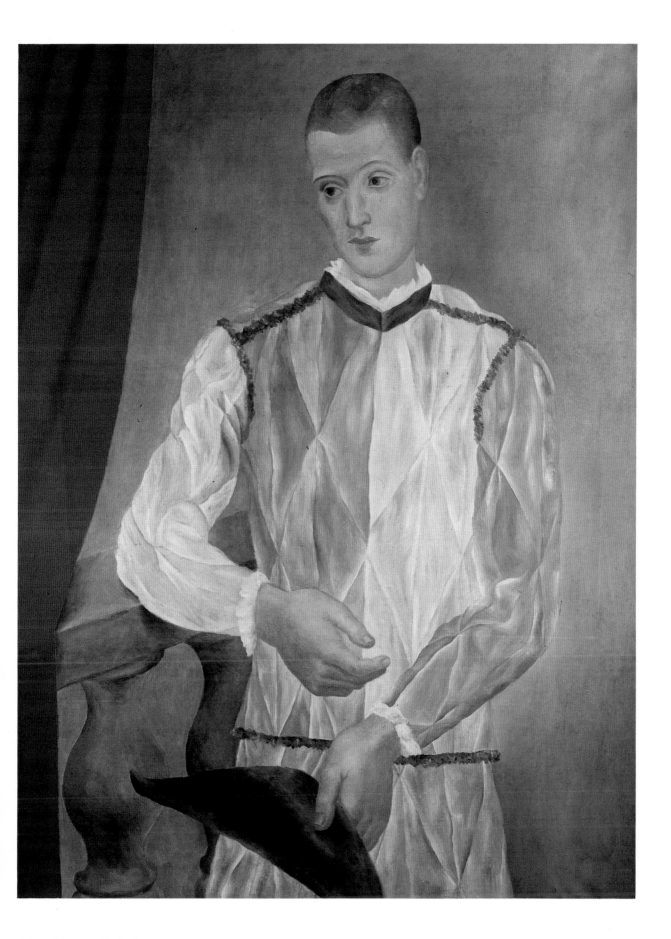

Museu Picasso: « Harlequin ».

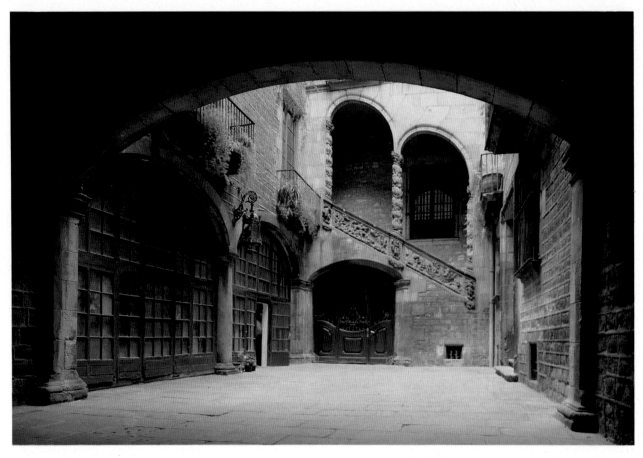

Palau Dalmases: the patio in typically Baroque style.

Santa María del Mar: an inspiring night-time view of the upper part of the facade with the rose window and the slender octagonal towers.

PALAU DALMASES

Continuing along *Carrer de Montcada*, the Palau Dalmases at n. 20 is one of those aristocratic residences which help to make this street so charming. Even if it is not perfectly preserved, the 17th-century palace with its fine Baroque patio and family chapel with a vault decorated in relief on the piano nobile stands out among the others in all its splendor. Built as the residence of Pau Ignasi de Dalmases, it was later also the seat of the « Academia dels Desconfiats » (Academy of the Diffident).

SANTA MARÍA DEL MAR

The apse of the church of Santa María del Mar lies at the end of *Carrer de Montcada*. The street and the Church have been declared national monuments, for it is one of the most important examples of medieval Catalan architecture. In the first half of the 14th century, after having occupied Sardinia, Alfonso IV had the building of the church begun, in fulfillment of a vow previously made by James I, the Conqueror.

The architect Berenguer de Montagut built it on the site of a precedent parish church of the 10th century, and it was terminated under Peter III, in 1383. The exterior of the church is majestic with its wide flat surfaces, fine splayed portal, harmonious tall pointed-arch windows and two slender octagonal bell towers crowned by three orders of windows. The lovely flamboyant Gothic rose window which decorates the upper part of the facade is the result of a revision carried out in the second half of the 15th century after the original window had been destroyed in 1428.

Stylistically the nave and two narrow aisles of the ***interior*** are unusually unified and are supported by octagonal

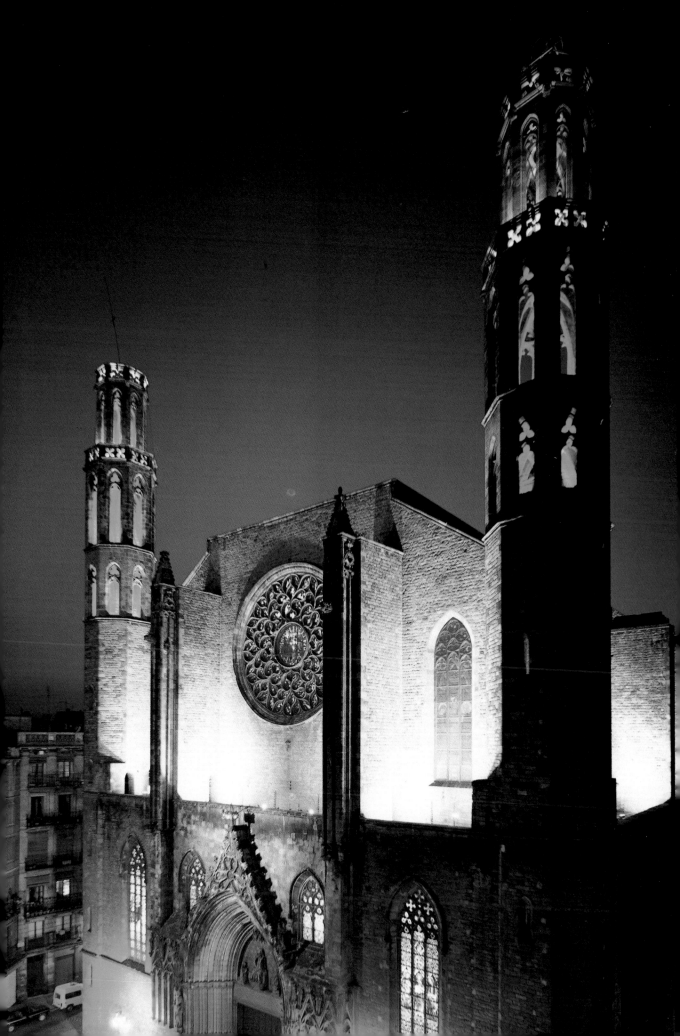

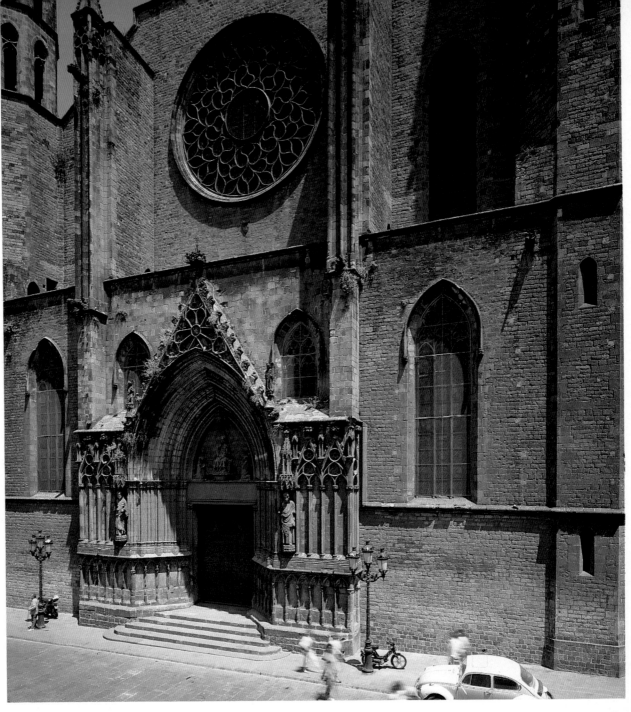

Santa María del Mar: the main portal, one of the finest examples of Catalan Gothic.

Santa María del Mar: a view of the interior seen in all its austere simplicity.

piers. There are so few of these that they are 13 meters apart, a surprisingly great interval for Gothic cathedrals and one of the particular characteristics of the building. Some of the elegant stained-glass windows, of the 15th century, are also noteworthy (the *Last Judgement* in the left aisle, the *Ascension of the Virgin* in one of the side chapels, and above all the *Coronation of the Virgin* at the center of the rose window on the facade).

Unfortunately the fire of 1936 almost completely destroyed the decoration of the interior and the high altar, an estimable Baroque work of the second half of the 18th century.

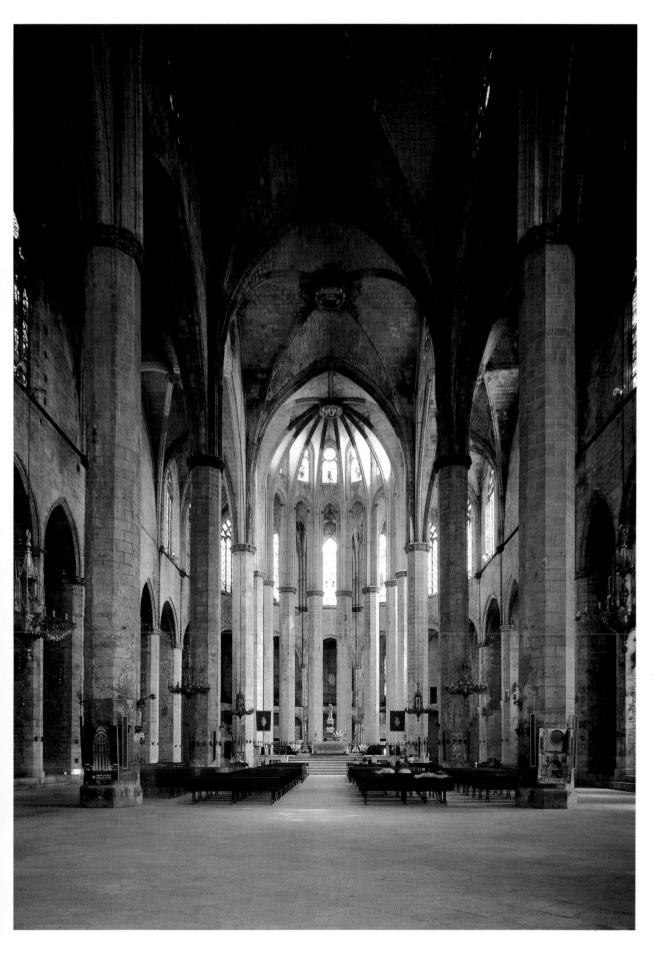

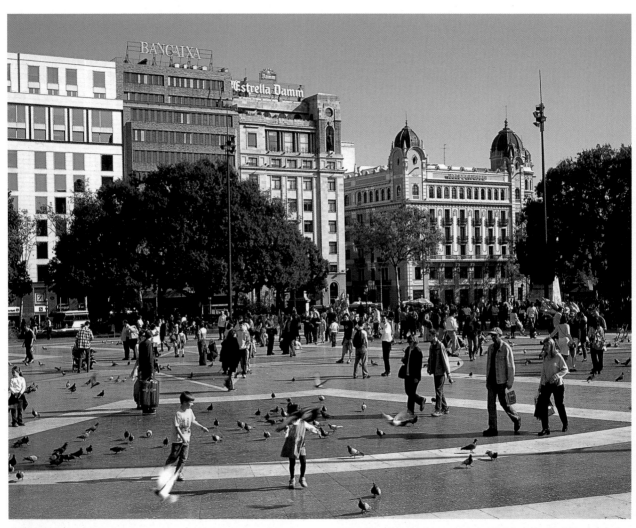

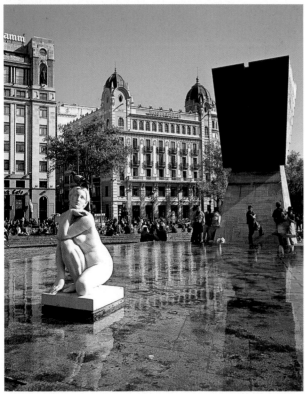

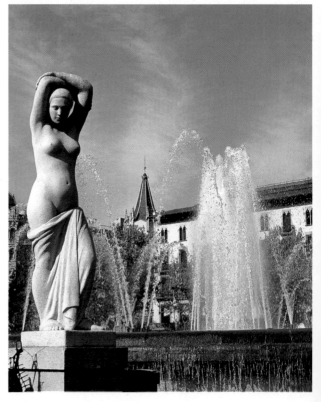

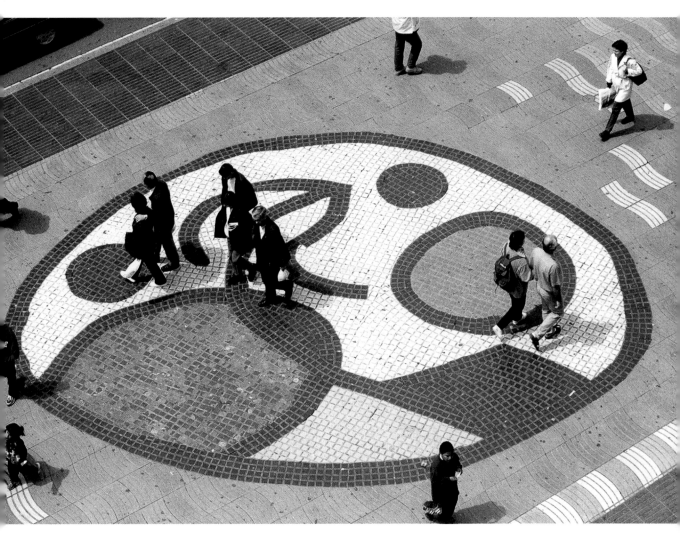

Plaça de Catalunya.

Les Rambles: the mosaic of Joan Miró.

LES RAMBLES

« It's the most beautiful street in the world ». This is how the English writer Somerset Maugham defined Barcelona's Rambles, the most famous avenue in the Catalan capital, the most famous in all of Spain. The long shady street lined with plane trees is a promenade in the heart of the old city, a straight line, that joins two of Barcelona's vital points: *Plaça de Catalunya* and *Plaça Portal de la Pau* with the column bearing the monument to Christopher Columbus. In the Rambles traffic runs along either side of a wide stone ribbon where one can freely walk, rest, play, talk.

Plaça de Catalunya is the most famous and best loved square in the city, a strategic nerve center of Barcelona. Nine of the city's principal streets encounter each other here and underground the tracks of the subway cross. Plaça de Catalunya is the downtown business and banking district of the city. It is the square which divides ancient Barcelona and the medieval quarter from the modern part of the city. Two large fountains with ornamental waterworks embellish Plaça de Catalunya, which is always crowded until late at night. Across from the avenue of the Rambles stands a celebrated statue — *The Goddess* by Josep Clarà. One of the outstanding buildings in the vicin-

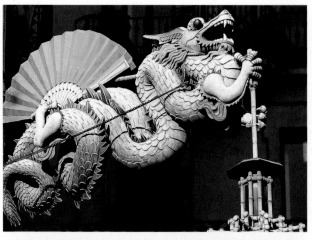

ity of the avenue of the Rambles is the Romanesque Gothic church of **Santa Anna**, built in 1146 and restored after it was destroyed by fire in 1936. Inside is an elegant galleried *cloister* with pointed arches in its lower arcade, dating to the 14th-15th century.

The avenues of the Rambles, over a kilometer long (1180 meters) begin at Plaça de Catalunya. The trees were planted during the Napoleonic occupation by General Duchesne who had them brough from Gerona.

Actually the Rambles lies on the bed of a river which the Arabs called « Ram-la » and which marked the boundary of the medieval stronghold. A second circle of walls was built around old Barcelona along the course of the stream. As years went by, the buildings erected on the banks of the « Ram-la » were mostly religious in nature and what was later to become the Rambles was at the time known as the *Calle de los Conventos*.

It was not until 1704 that what was left of the stream began to be covered up and urbanized and that the Rambles began to look like it does now.

« Ramblejar » is one of the favorite pastimes of the Bar-

celonians. It is a neologism which means « walk along the ramblas ». To walk untiringly up and down this long boulevard, back and forth between Plaça de Catalunya and the Port, stopping to discuss football (around the Font de Canaletes) or corrida (at the Arch of the Theatre) is how the inhabitants of Barcelona love best to pass the time of day. The Rambles is the beating heart, the market of the city: newsstands that look more like bookshops, cafés, venders of flowers and birds, mimes and ambulant players, sailors off duty populate this part of Barcelona at all hours of the day and night.

Actually the Rambles is a succession of avenues, five stretches of streets with different names and aspects. The *Rambla de Canaletes* is the first part, right off Plaça de Catalunya. The lovely fountain almost at its beginning is magic. Legend says that whoever drinks its waters will never more leave Barcelona.

The name of the old university which Philip V transferred to Cervera still exists in the second part of the Rambles, the *Rambla dels Estudis*, now occupied by the cages of the bird venders. The Baroque church of **Mare de Dèu de Betlem**

(Church of Bethlehem, of the 18th century) and the **Palau Moya** (late 18th century) close the Rambla dels Estudis. The liveliest and loveliest part of the Rambles begins here: the *Rambla de Sant Josep* now rebaptized *Rambla de les Flors* because of the dozens of flower venders to be found there. On either side is the popular **Mercat de la Boquería** (colonnades with an iron roof) and the **Palau de la Virreina** which houses the *Museu — Gabinet Postal* and hosts temporary exibitions. The *Pla de la Boquería*, a confusing and noisy intersection of the Rambles, interrupts the Rambla de les Flors and is followed by the *Rambla dels Caputxins* where Barcelona's most important theatre stands — the **Gran Teatre del Liceu**, next to the church of *Sant Pau del Camp*. *Carrer Nou de la Rambla*, to the right of the Rambles, leads to **Palau Güell**, by Antoni Gaudí, which now houses the *Museu de les Arts de l'Espectacle*. This small street is one of the streets bordering the *Barri Xino* (the Chinese quarter). The *Rambla de Santa Mónica* is the last part of the avenue and leads directly to the column of the monument to Columbus, a few steps from the entrance to the port of Barcelona.

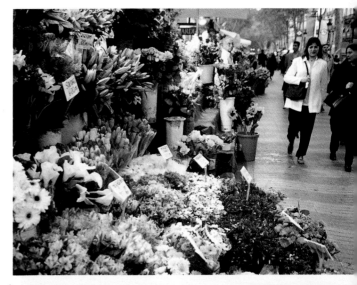

The colours of the Ramblas.

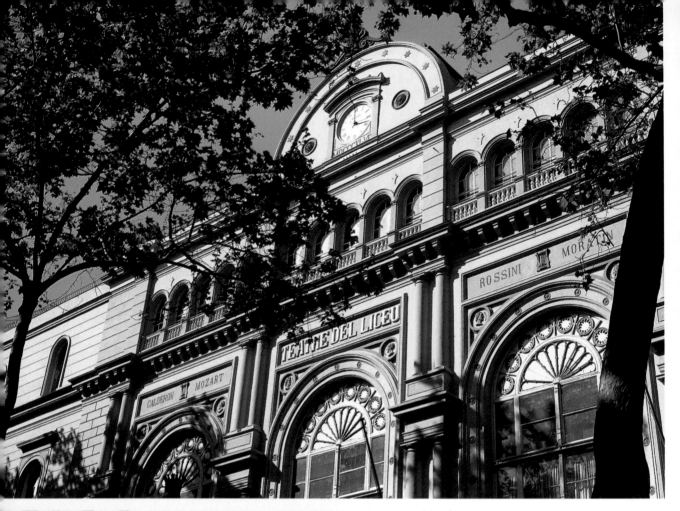

Gran Teatre del Liceu.

Palau de la Virreina: the exterior.

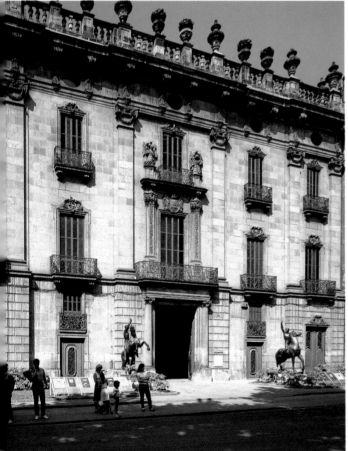

GRAN TEATRE DEL LICEU

One of the most famous theatres in the world, it is one of the best in Europe as far as acoustics is concerned and second only to La Scala of Milan in its seating capacity. Originally begun in 1844 on the Rambla dels Caputxins on the site of the Monastery of La Bona Nova which was initially built in 1638, it was based on the plans of the architect Garriga i Roca and took four years to build.

PALAU DE LA VIRREINA

Facing on the Rambla de les Flors, the palace was commissioned in 1772 from the architect Carles Grau by the Viceroy of Peru, who died before it was completed.. His wife, María Francisa de Fivaller, went to live there and the palace took its name from her, vice-queen of Peru. The building houses interesting museum institutions such as the *Gabinet Postal* and the *Gabinet Numismàtic* (interesting collections of stamps and ancient and modern coins).

HOSPITAL DE LA SANTA CREU

The Hospital of the Holy Cross, *Hospital de la Santa Creu*, is an extraordinary ensemble of buildings in the heart of the old hospital district, not far from the Rambles. The first four stones were laid in 1401 by religious and royal authorities on a site that had already been occupied by a hospital. The original core of the Hospital consisting of four wings around a central courtyard was finished in 1415, enlarged in 1509 and rebuilt in 1638. Eventually the hospital was transferred to more suitable quarters and the Santa Creu ensemble was used for the *Biblioteca de Catalunya*.

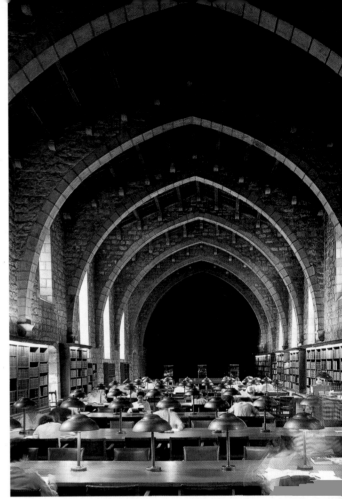

Hospital de la Santa Creu: the reading room in the Biblioteca de Catalunya and the exterior.

39

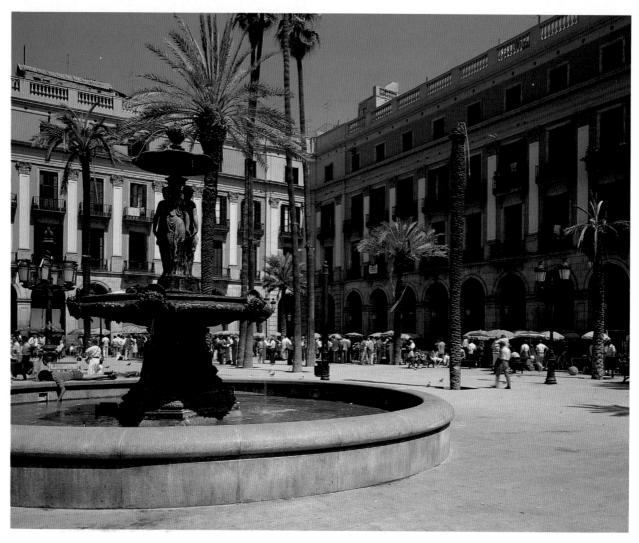

Plaça Reial: the fountain with the Three Graces.

Sant Pau del Camp: the exterior and a view of the charming Romanesque cloister.

PLAÇA REIAL

If Plaça de Catalunya is one of the nerve centers of Barcelona, Plaça Reial is the romantic and popular heart of the city. Classical arches, one after the other, in the center of Barcelona's old quarters, a row of austere palaces with clear references to architecture in the French cities of the Napoleonic period, palms which rise up from the stone pavement, a fountain flanked by the *Three Graces*, Plaça Reial is the place to seek refuge from the rush and hubbub of the Rambles, to interrupt the interminable « ramblejar » and sit down in one of the innumerable cafés or beer halls and try the Catalan « bocadillos ».

Plaça Reial was planned and built by Daniel Molina who also designed the houses with fine porticoes which surround the *Mercat de la Boquería*, on the other side of the Rambles. The great Antoni Gaudí also had a part to play in the outfitting of Plaça Reial. It was one of his first works: he designed the curious lamp posts in the square. Every Sunday Plaça Reial is a particularly lively spot when it becomes the philatelic and numismatic center of Barcelona.

SANT PAU DEL CAMP

The exact date of the construction of the stupendous Church of Sant Pau del Camp is unknown. Various hypotheses have been put forward: according to some sources a community of Benedictine monks had been set up here in the fields which divided the heart of the old city from the hill of Montjuïc. Their monastery was probably destroyed during the years of Arab domination.

At the beginning of the 12th century the Romanesque church of Sant Pau del Camp was built on those ruins — one of the loveliest churches in Barcelona. While the main building dates back to 1117, the chapter hall and the abbot's house were built a century later. The bell tower dates to the 18th century. The architrave of the entrance *portal* is supported by columns with Visigothic capitals. Inside are lovely bas-reliefs.

The gem of the church is its delightful *Cloister*, scanned by small polylobed arches. Its loggia and garden are another refuge well known to the native Barcelonians when they want to flee from the confusion of the Barri Xino which is adjacent to the church.

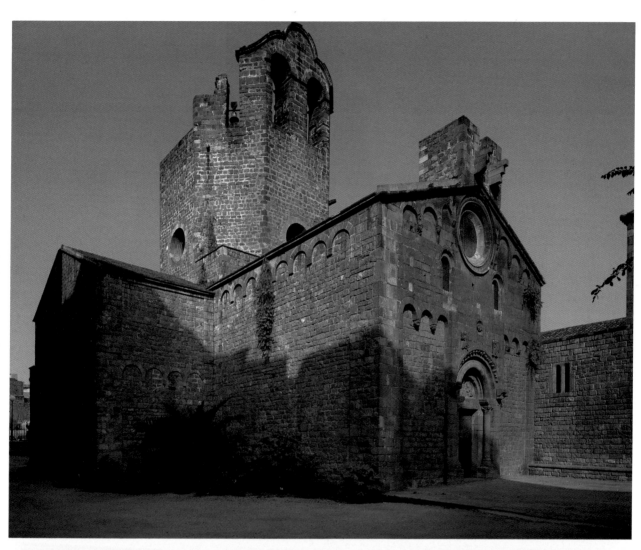

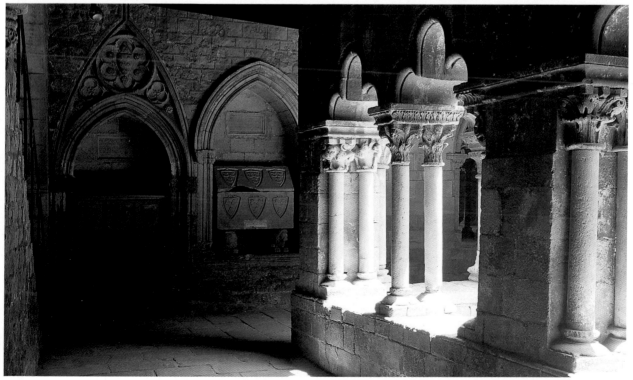

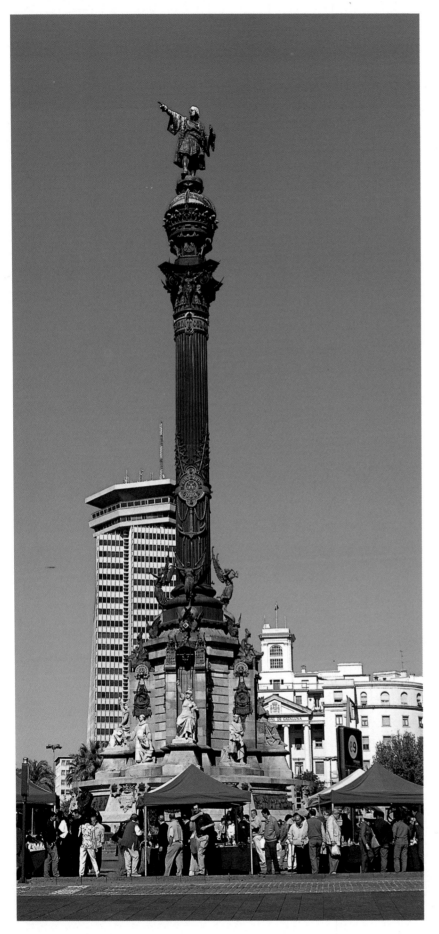

PORTAL DE LA PAU

The Gateway of Peace is the natural outlet for the long avenues of the Rambles, a large square which is one of the many nerve centers of Barcelona. This square marks the boundary between the medieval city and the port and is at the crossing between *Passeig de Colom* and the *Avinguda del Paral-lel* on the street that rises to the castle of Montjuïc.

The famous *Monument to Christopher Columbus*, one of the best-known symbols of the Catalan capital, rises at the center of Portal de la Pau. The monument commemorates the return of the Italian navigator from the shores of the New World and his meeting, after his trip, with the Spanish sovereigns in Tinell Hall in the Royal Palace of Barcelona. But fate can be ironical — the discovery of America, favored by a Catalan king, marked the beginning of the decline of the port of Barcelona.

The monument was built at the end of the 19th century after designs by Gaieta Buigas. It was inaugurated late in the spring of 1888 and consists of an iron column about 51 meters high. The statue of Columbus is in bronze and not over 8 meters high. An elevator rises to the top of the column and permits a fine close-up panorama of the port of Barcelona. Some of the most important buildings in the city are situated around Portal de la Pau: behind the monument to Columbus is the *Royal Arsenal*, in which the *Maritime Museum* is housed while the *Customs* offices are located on the opposite side of the square in a palace designed by the architect Enric Sagnier at the end of the last century.

The *Palace of the Military Governor* and the Port offices are also on the Portal de la Pau. At the entrance to the Paral-lel, which joins Portal de la Pau to *Plaça de Espanya*, is part of the 15th-century walls, with the only extant gate of that stretch of the encircling walls: the *Porta de Santa Madrona*. In the immediate vicinity of the Portal de la Pau there is an interesting **Wax Museum** (Museu de Cera). The curious survey of famous personalities and others that are lesser known but still distinctive consists of over 300 figures which can be admired in an expressly prepared setting.

Plaça Portal de la Pau.

ROYAL SHIPBUILDING YARDS

The *Drassanes*, the huge Royal Shipyards of the great medieval Catalan navy, lie opposite the monument to Columbus, on one side of the Portal de la Pau. The original core of the building was constructed on order of James I on the occasion of the war against the Saracens for the control of the Balearic Islands. The original building was enlarged by Peter II and completed by Peter III. This was the period in which Barcelona dominated the Mediterranean Sea, the golden period of Catalonia as a sea power. The royal shipyards worked full time for centuries: they were capable of building 30 sailing ships at a time. But with the discovery of America, the Catalan capital was excluded from the route to the New World and relegated to a subaltern role.

As time went by the naval shipyards changed owner and scope until 1941 when the city decided to install the Maritime Museum there.

The immense rooms have permitted the reconstruction and exhibition of the flagship of the Christian fleet in the battle of Lepanto (1571) against the Turks. The royal galley of Admiral Don Juan of Austria was built right in the shipyards of the Catalan capital. The replica was built in 1971, the year in which Barcelona celebrated the quatercentenary of its victory.

The **Maritime Museum** collections also include archaeological finds, navigation charts, models of fishing boats and merchant ships, ceramics, original figureheads, and among other riches, an atlas of 1493 which belonged to Amerigo Vespucci.

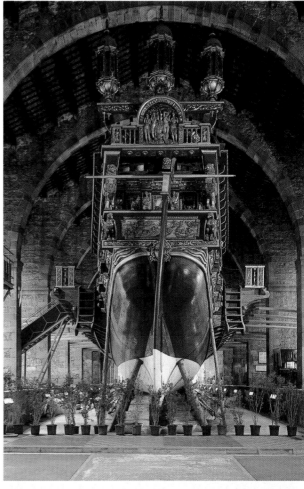

Maritime Museum: reconstruction of the galley of Don Juan of Austria and a detail of the rich decoration to be found on the sides.

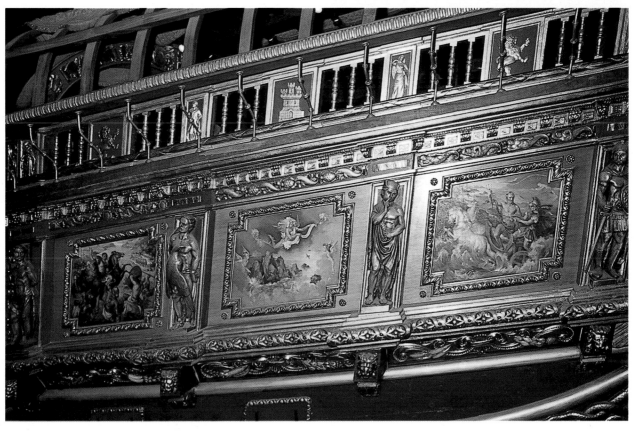

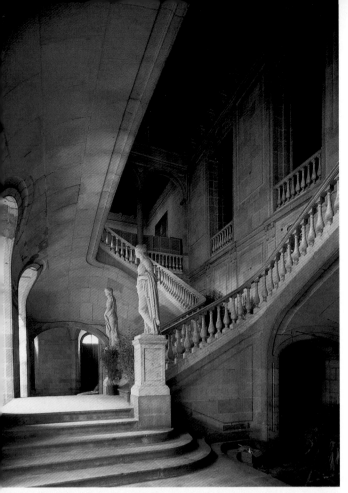

THE LLOTJA

Situated between *Plaça d'Antoni López* and the lovely *Plaça Palau*, at the end of the long *Passeig de Colom*, the *Llotja* houses the Stock Exchange of Barcelona and the Chamber of Commerce and Navigation.

Plaça Palau, in the center of which is a monumental fountain decorated with allegoric statues of Italian school, is the entrance to the maritime district of the city, Barceloneta.

The facade of the Llotja, neoclassic like all the changes the building underwent, is by the architect Joan Soler i Faneca, who redesigned the palace in the second half of the 18th century.

But the real history of the palace of the Llotja begins in the 14th century with the original core, built between 1380 and 1390 as a covered market, the first building of its kind in all of Spain. In the 15th century it became the headquarters for the customs offices and the naval consulate. The large *Transactions Hall* is all that is left of the original structure. It is a fine example of Gothic style, with three aisles and six arches which support the polychrome coffered wooden ceiling.

Noteworthy inside the palace are the garden with marble statues and the famous *staircase* of the foyer, which leads to the offices of the Chamber of Commerce and Navigation.

The Llotja: the entrance staircase and the Transactions Hall, in Gothic style.

BASÍLICA DE LA MERCÈ

Very close to *Passeig de Colom* is a small church in Baroque style built in the second half of the 18th century, between 1765 and 1775. This is the *Basílica de la Mercè*. Josep Mas, who designed it, utilized the old Gothic remains of the Church of San Miguel and preserved a Renaissance side doorway dating to 1516. The basilica was actually the sanctuary of the Convent of the Brothers of Mercy and is now occupied by the *Capitanía General*. The Basílica de la Mercè is important for Barcelona because it preserves the sacred venerated image of the *Virgin of Mercy*, a small but elegant wooden statue, richly dressed in gold raiments, made in the 14th century by the wood sculptor Pere Moragues. The Virgin of Mercy, together with the « Moreneta » of Montserrat, is a protectress of Barcelona.

At the end of September, in the first days of autumn, the entire city celebrates its protectress in grandiose style. It is the finest holiday of the year, a joyous rite that is both secular and religious, which crosses over the borders of the church and explodes into the streets and squares. *Plaça de Sant Jaume*, secular heart of Barcelona, is invaded by the « Castellers », who outdo each other in daring human pyramids, and the tall manikins (the « caperudos ») in papier-maché of the royal personages of Catalonia.

PASSEIG DE COLOM

Passeig de Colom is Barcelona's water-front: it skirts the entire area of the port and runs from *Plaça Antoni López*, at the far corner of the district of Barceloneta, to the slopes of the hill of Montjuïc.

It is a large thoroughfare more than forty meters wide and despite the traffic it is possible to walk in all tranquility. It is one of Barcelona's historical sites: one of the many legends narrates that Miguel de Cervantes, the author of « Don Quixote », lived at n. 33 of Passeig de Colom and finished his masterpiece in the Catalan city. His hero too visited Barcelona and was amazed at the sombre, macabre atmosphere of those years.

From *Plaça Portal de la Pau*, Passeig de Colom crosses *Plaça Duc de Medinaceli*. Sober 19th-century palaces surround this tree-shaded square with its *Monument to Admiral Galceran Marquet* by Daniel Molina.

The *Palace of the Capitanía General*, set between the old walls of the convent of the Brothers of Mercy, also lies along Passeig de Colom. The long avenue ends in Plaça Antoni López, adjacent to the lovely *Plaça del Palau*. The *Statue to López* at the center of the square is by Venancio Vallmitjana. On one side of the square is the large *Post Office Building*.

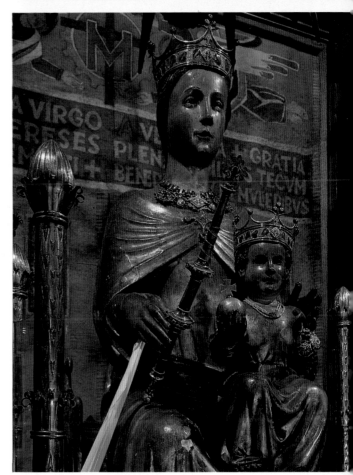

Basílica de la Mercè: the facade in Baroque style and the highly venerated wooden statue of the Virgen de la Mercè (14th century), protectress of the city.

45

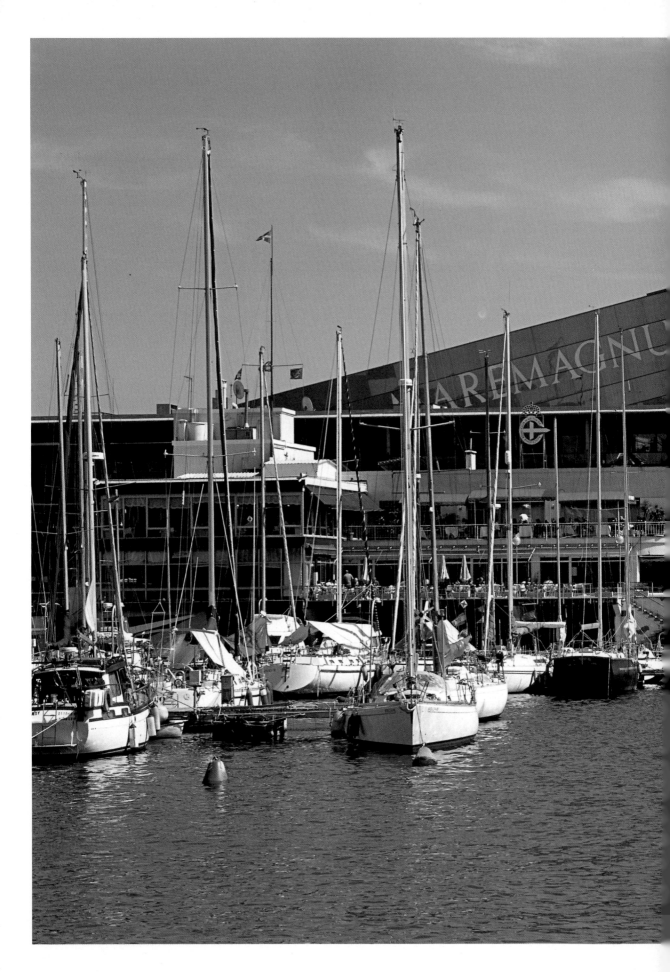

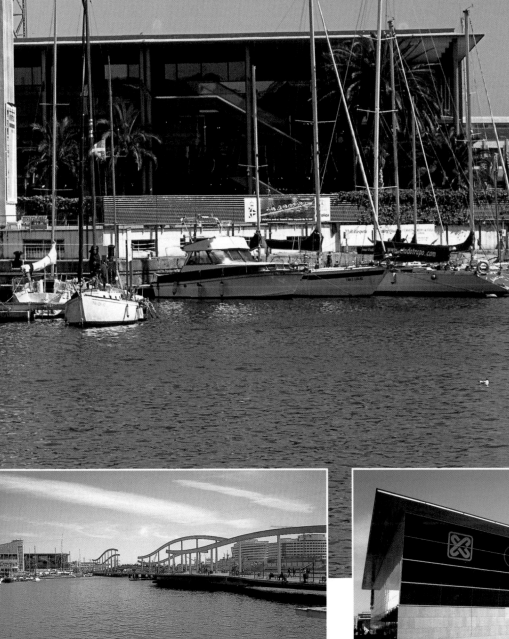

Port Vell:
Maremagnum
and the jetty.

PORT VELL

Port Vell:
the Aquarium.

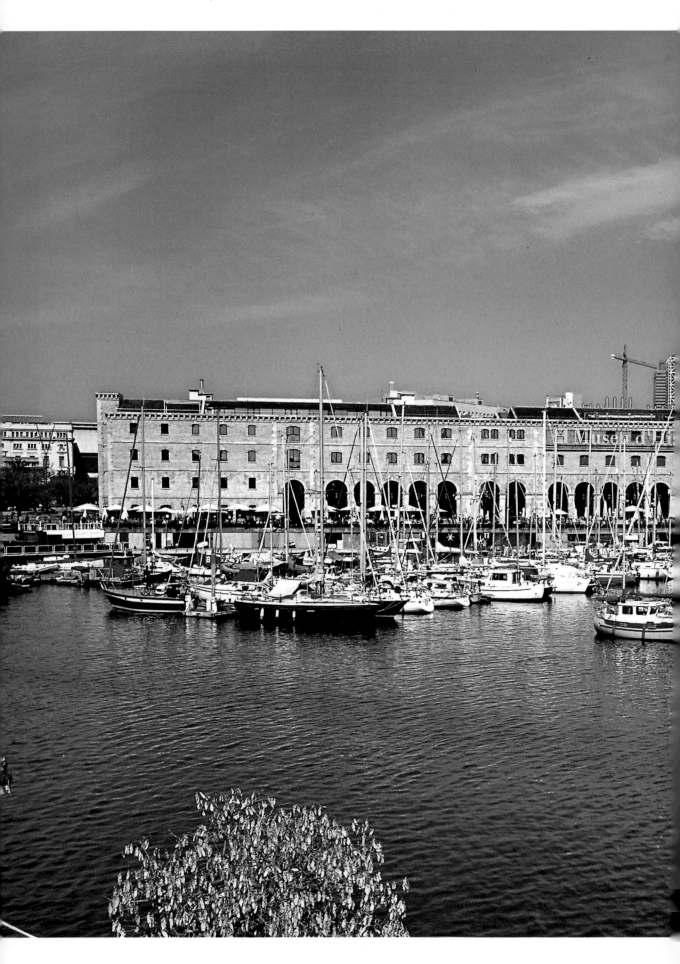

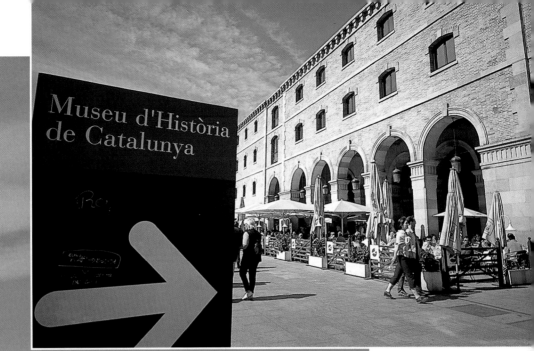

Port Vell:
Museu d'Història
de Catalunya.

Platja Barceloneta.

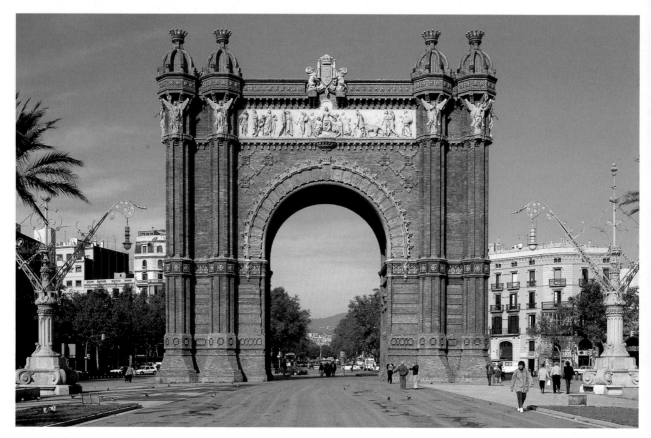

The Arch of Triumph.

The Cascada Monumental.

LA CIUTADELLA

The large park of the city of Barcelona, the Ciutadella, lies at the end of the *Avinguda del Marquès de l'Argentera*, between the district of Barceloneta and the *Passeig de Sant Joan*. The Ciutadella is a splendid green area covering more than 700 acres: tree-shaded avenues, palms, fields, terraces, statues, flower gardens, pools and lakes, waterfalls and palaces form a mosaic created according to the classical criteria of landscape architecture of the late 19th century.

It was called Ciutadella because Philip V had a military fortress built here between 1715 and 1718. The Bourbon king, who had won the War of Succession to the throne of Spain, decided to punish Barcelona for having sided with his adversaries. After the conquest of the city, which took place in 1714, the new sovereign dissolved the Catalan parliament, officially prohibited the Catalan language and razed one of the residential districts, the Ribera, to the ground. More than 10,000 inhabitants had lived here and this was where he built the fortified bastions of the Ciutadella.

The Ciutadella existed not much more than a century. In 1808 the French took over the fortification, and it was not until 1869 that the land on which nothing but ruins remained was restored to the city of Barcelona. The idea for a city park took form in those years. The project was by the architect Josep Fontserè with the collaboration of Josep Vilaseca, but it was not until 1888, when the World Fair was held in the gardens of the Ciutadella, that the park acquired its present luxurious aspect.

The **Arch of Triumph** was built then as the entrance to the Exposition. It stands at the end of the Passeig de Sant Joan and is a showy structure of Mudéjar inspiration (the Arab-Christian art which developed after the 12th century), designed and built by Josep Vilaseca. At the top of the arch (30 meters high) is an impressive frieze by Josep Llimona. The arch leads to *Passeig de Lluis Companys*. On the left rises the **Courts of Justice**, a example of modern architecture (1911) by Sagnier and Domènech Estapà. Inside, in the *Hall of the « Pasos Perdidos »*, murals by Josep Sert can be seen.

The large tree-shaded avenue leads to the heart of the park of the Ciutadella. One of the main buildings was originally the old city Arsenal, which, as time went by, was transformed into the Royal Palace and the seat of the **Catalan Parliament**. Today this neoclassic building houses the **Museu d'Art Modern** (Museum of Modern Art).

The museum collections are concerned with Catalan sculpture and painting of the 19th and 20th centuries. Many pictures by the Tarragonian painter Marià Fortuny are exhibited here side by side with Isidro Nonell's delicately colored works and paintings by Josep Sert. Joan Miró, Salvador Dalí (a *Portrait of his Father*) and the surrealism of Antoni Tapies are also represented in the Museu de Art Modern. In front of the building the white statue of a nude by Josep Llimona, « Desolation » (« *Desconsol* »), stands in the midst of a small pool with waterlilies.

One of the most spectacular attractions of the Ciutadella is the fountain known as *Cascada Monumental*, a grandi-

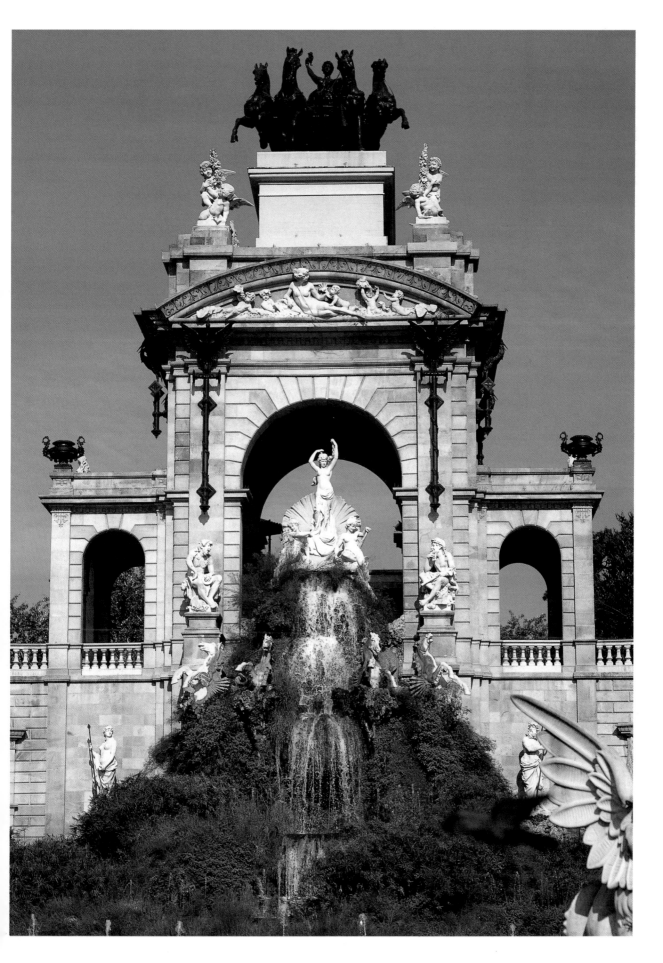

Ciutadella: a view of the park and the famous 19th-century fountain of the Senyoreta del Paraigua.

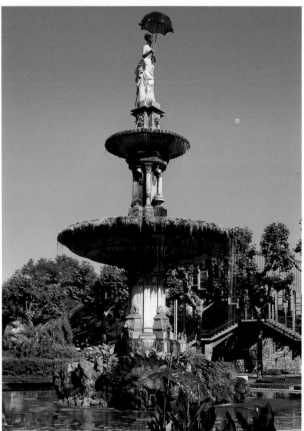

ose redundant example of Catalan neoclassic taste. It was designed and executed by the architect of the Ciutadella, Josep Fontserè, but a young university student at his beginnings and still unaware of his great future, by the name of Antoni Gaudí, also contributed to the work. The fountain of the Cascada Monumental is decorated with statues by Venanci Vallmitjana, while the ensemble of *Aurora's Quadriga* on top is by Rosend Nobas.

Numerous other buildings rise around the central core of the Ciutadella. A sort of medieval **castle** (actually an austere palace in red brick decorated with crenellation and coats of arms in stone) houses the collections of the **Zoological Museum**. The building, situated at the end of Avinguda dels Tillers, was designed by the architect Domènech i Montaner. The museum is dedicated above all to the naturalistic patrimony of Catalonia.

Not far from the Zoological Museum, between the greenhouses of the *Umbráculo* and the *Invernáculo*, is the Geological Museum, the fine **Museu Martorell** with its valuable collections of minerals and palaeontology.

Barcelona's **Zoological Garden**, with a never-ending flow of visitors, is also to be found in the park of the Ciutadella.

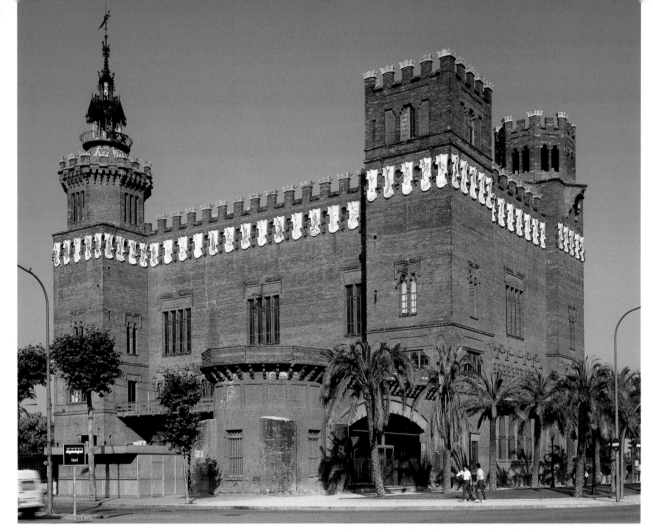

Ciutadella: the Zoological Museum and the Museum of Modern Art.

A small statue at the entrance to the zoo, representing *Saint Francis of Assisi*, is by Pere Jou.

Statues are to be found throughout the park. In the long walks through the Ciutadella one is likely to come face to face with the obelisk dedicated to Rius y Taulet (at the entrance to the *Passeig de Lluis Companys*), mayor of Barcelona in the period of the 1888 World Fair and its sagacious promotor, as well as a bronze group of *gazelles* by Nuria Tortras, dedicated to Walt Disney. Another famous statue in the Ciutadella is the *equestrian monument to General Prim*, a copy by Puigjaner of the original by Frederic Marès which stood in the exact same place. Note should also be taken of the statue that commemorates the *Catalan Volunteers* of World War I.

But the most famous statue in the Ciutadella is an elegant and charming lady shading herself from the sun with a parasol. The *Senyoreta del paraigua* is in the Zoological Garden, surely one of the most romantic of the many symbols of Barcelona and deserving of the thousand ornamental waterworks and tree-lined avenues in the Ciutadella. The lady was sculptured by Roig i Solé in 1888 and is set above a simple fountain with two basins.

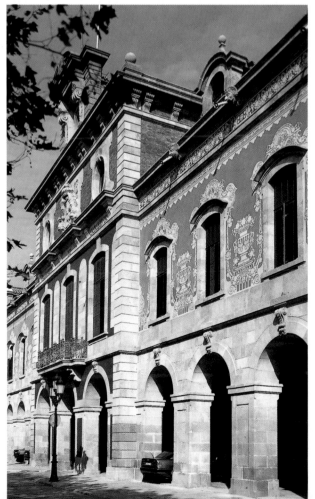

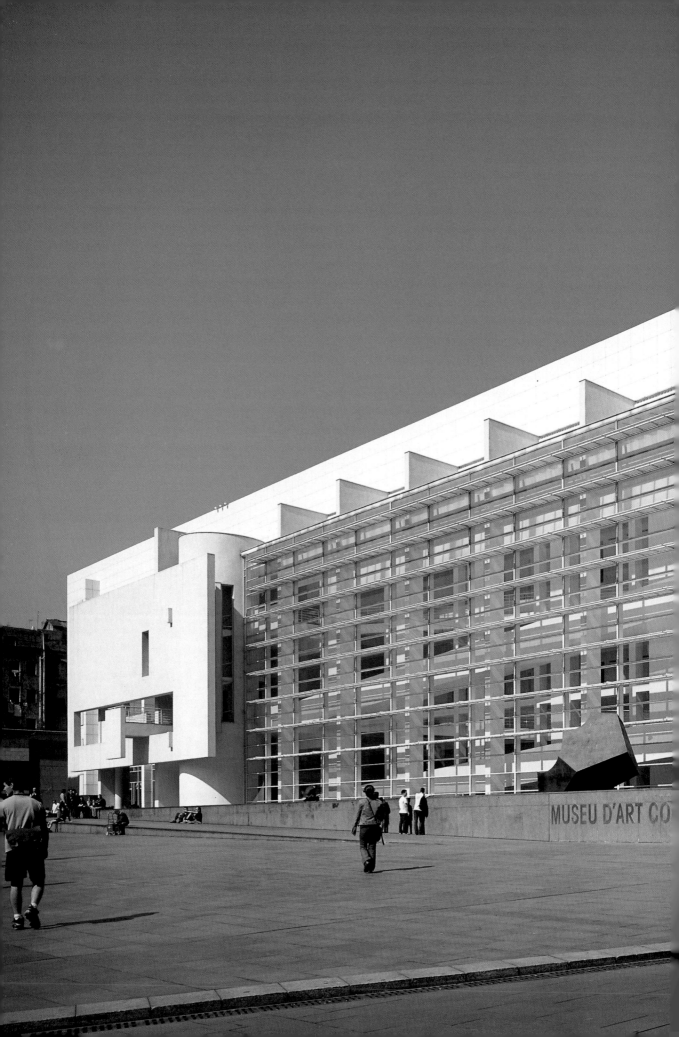

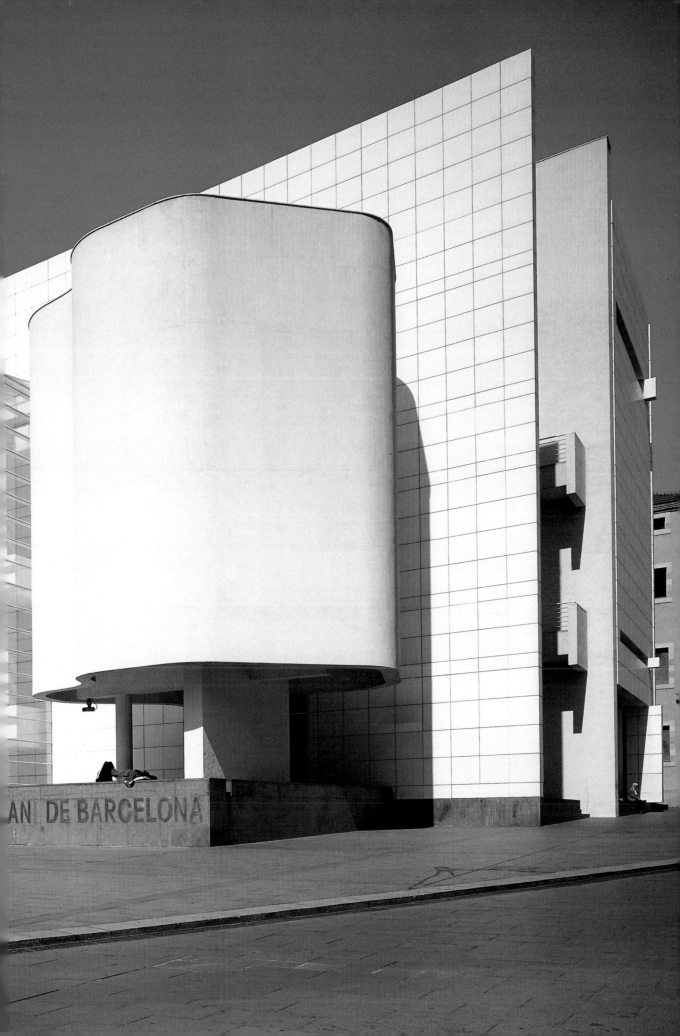

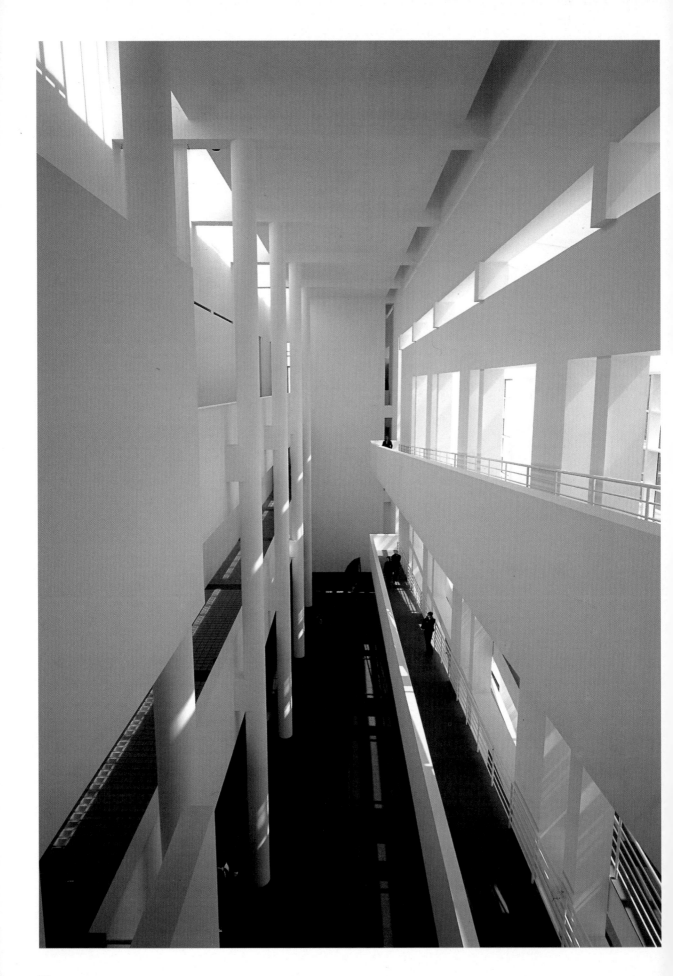

MACBA: a few
interiors.

Pages 56-57:
the MACBA,
the Museum
of Contemporary
Art in Barcelona.

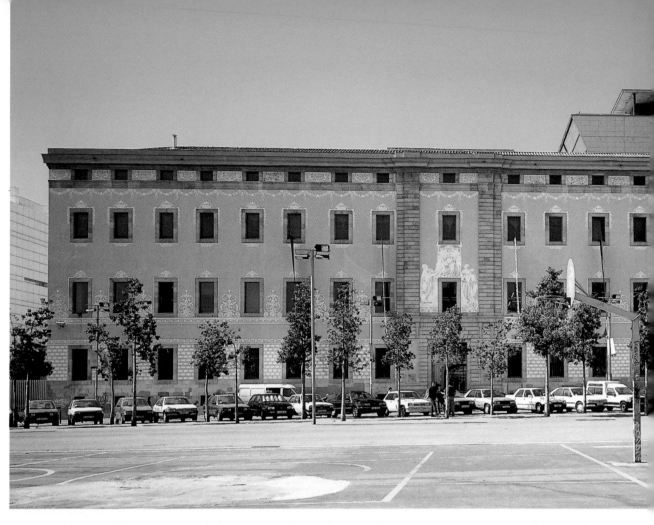

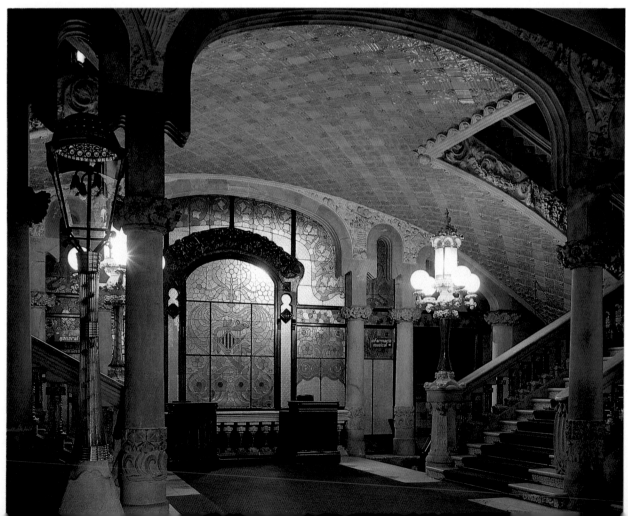

The Casa de la Caritat, at present CCCB, Center of Contemporary Culture in Barcelona.

Palau de la Musica Catalana: the foyer and the staircase in pure Art Nouveau style.

PALAU DE LA MÚSICA CATALANA

For a long time this building was a bone of contention but today it is justly held to be one of the outstanding examples of the art that developed in Barcelona at the end of the 19th century.

A group of enthusiastic young artists, including Vilaseca, Berenguer, Puig i Cadafalch, Martorell and, especially, Lluis Domènech i Montaner, the architect who designed this building, animated by an ardent desire to promote an aesthetic and stylistic renewal in the ambit of the Catalan « renaixença », organized numerous artistic events which led to varied brilliant exhibitions. Built in 1908, today this palace is the largest concert hall in Barcelona, seat of the famous « Orfeó Català », a magnificent setting for the most important musical performances of the city.

The decoration is purest Art Nouveau with a generous use of colored glass, glazed polychrome tiles, mosaics, sinuous wrought iron. Altogether the effect is fantastic and theatrical and the atmosphere is one of enchantment. A robust piece of sculpture by Miguel Blay, at one corner, is an allegory of popular song.

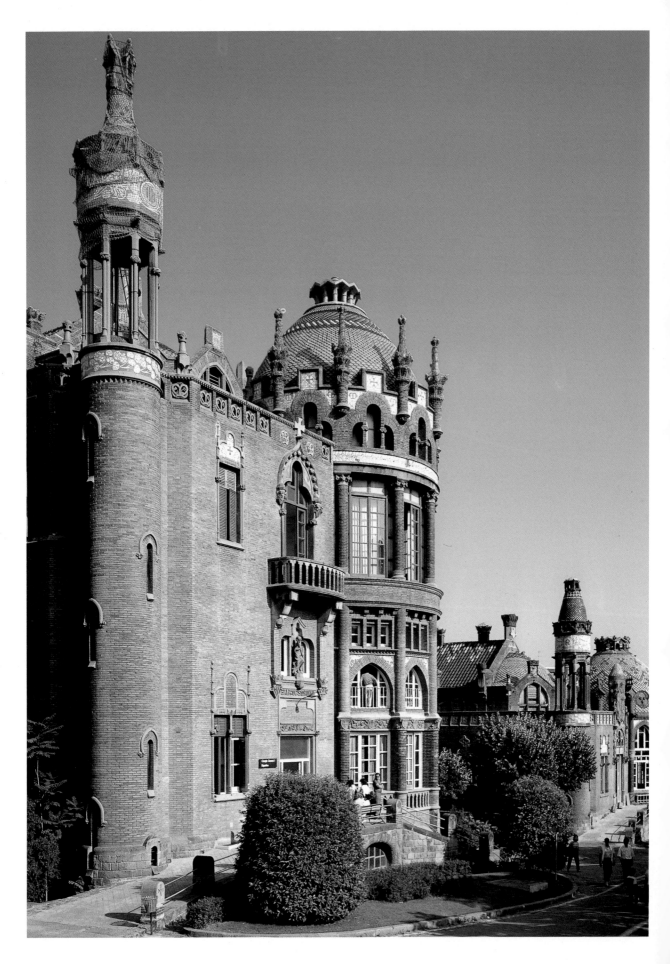

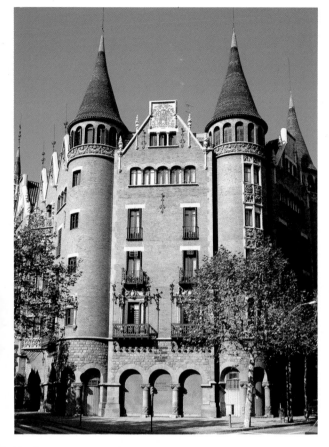

The Casa "Les Punxes" by Puig i Cadafalch and, right, detail of the facade.

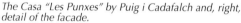

The Hospital de la Santa Creu i de Sant Pau, by Domènech i Montaner.

MODERNIST ART

The style known as Art Nouveau in England, Liberty in Italy and Jugendstil in Germany, was called Modernist Art in Catalonia. Here, as in other countries, this movement resulted from the opposition to the reigning bourgeois taste in art, and the desire for renewal.

There can be no question as to the fact that the presence of the millionaire Eusebi Güell i Bacigalupi in Barcelona was what permitted Antoni Gaudí's genius to express itself as fully as it did. But there were also others who revolved around the undisputed personality of Gaudí, so solitary, so very Catholic and so isolated from the rest of the art world, and helped transform the aspect of Barcelona. In the ambit of the catalan « renaixença » architects such as Lluís Domènech i Montaner, Francesc Berenguer, Martorell, Joan Rubió i Bellver, Josep Puig i Cadafalch,

Granell etc., made a name for themselves with works such as the Casa Amatller, or Casa Roviralta, or the Palace of Catalan Music.

At the close of the 19th century Barcelona began to change and assume a new identity. Not only were the buildings themselves suddenly animated with surprising zoomorphic aspects (an outstanding example is the incredibile « butterfly house » of Calle Llansa), but the various accessories of street furniture also participated in this transformation: the ramblas and the avenidas were decorated with lamps in wrought iron, the gateways of the fincas enriched with volutes and curlicues, the lightning rods on the roofs twisted into fantastic shapes, the balconies and railings seemed to swell, crumple, bend under an invisible hand. It is also these anoymous craftsmen who gave Barcelona that refined and elegant aspect which distinguishes it in the panorama of Spanish art.

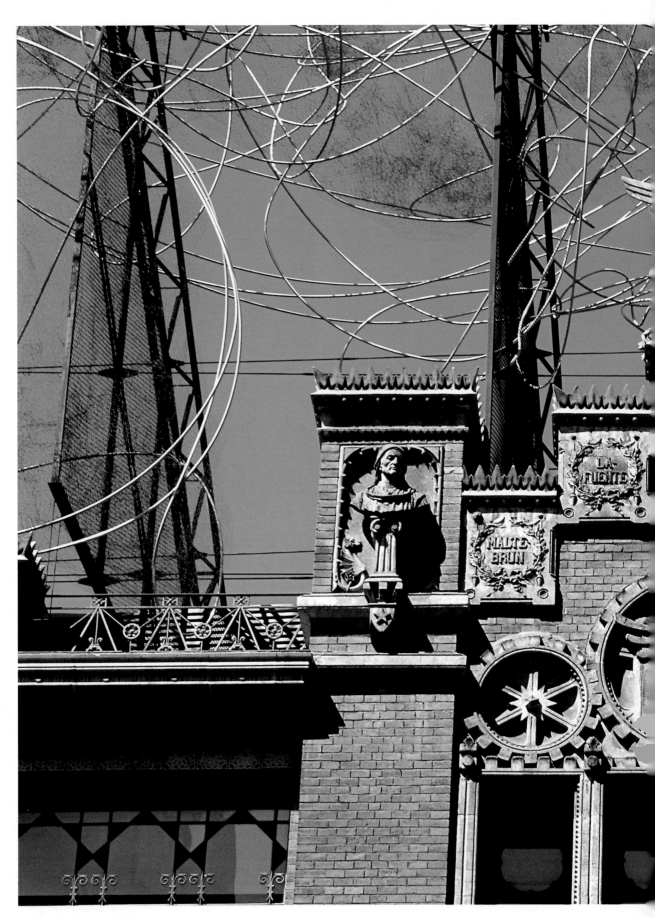

The Antoni Tàpies Foundation and a sculpture by the artist.

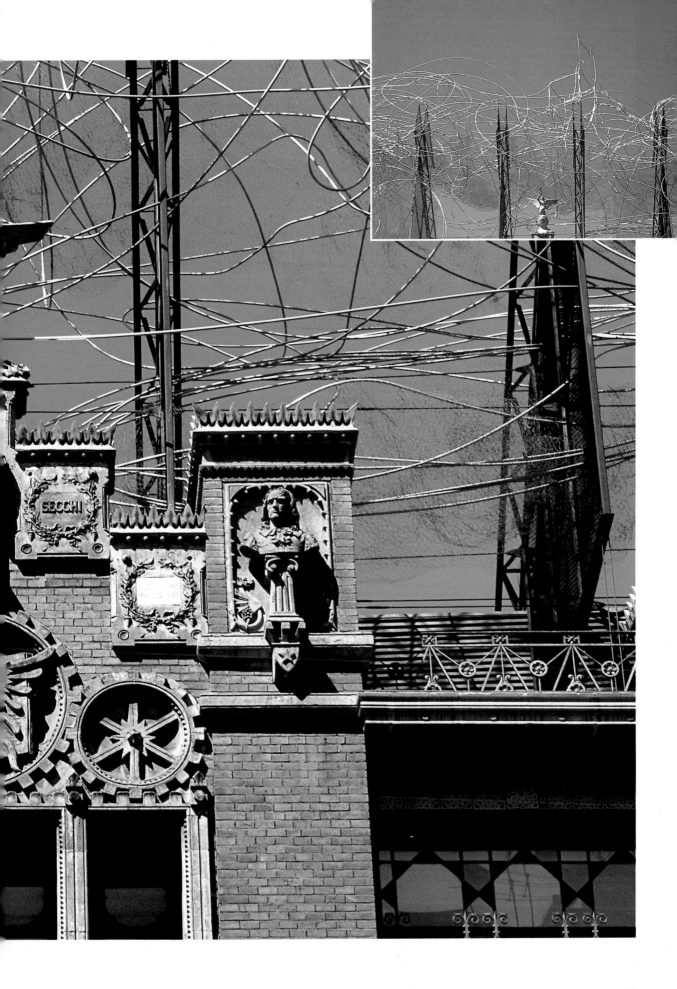

ANTONI GAUDÍ

Antoni Gaudí was born in Reus, near Barcelona, on June 25, 1852. The son of an ironsmith, he first studied in his native town, at the school of Francesc Berrenguer. In 1876 he continued his cultural studies in Barcelona where he attended the school of architecture, and graduated in 1878.

These years for Gaudí were also a sort of apprenticeship and the architectural restoration the famous French architect Viollet-Le Duc was carrying out on the walls of Carcassonne left its mark. In addition the philosophical ideas of Lorens y Barba and the theories of romantic aesthetics of Paul Milà y Fonaneis were also fundamental. In these preparatory years, in which he probably created the four winged dragons in the Park of the Ciutadella, Gaudí developed his original architectural aesthetic.

His point of departure was an inspiration which included both the Gothic art of Spain and elements peculiar to the Catalan culture, which he then gradually integrated with the stylistic features of Art Nouveau, the new artistic-cultural movement which permeated much of European artistic expression at the end of the 19th century. By around 1880 he was already able to share a dominant role in Catalan Modernism with Domenech y Montaner.

Between the 1880s and 90s, he created a series of works which left an indelible mark on the urban structure of Barcelona. Casa Vicens, one of his works dating to between 1878 and 1880, Casa Güell built in 1885-89 and named after the man who commissioned it, the Maecenas of art Eusebio Güell, a wealthy industrialist who admired Ruskin and Wagner, the Convent de les Teresianes of 1889-94, all testify to an eclectic interweaving of experimental forms of a modern type with elements of local tradition.

In the 1890s there was an accentuation in the tendencies to the inventive use of color and imaginative sculptural decoration, with references to Catalan culture still constantly present. One example is the repeated use in Parc Güell of dragons, figures which played an important part in the legends of Catalonia. In the wealth of daring ornaments, at times at the limits of artistic delirium, forms inspired by the vitalism of nature are to be encountered in the works of the 20th century, such as Casa Milà, known as "La Pedrera", whose undulating architecture echoes the multiform aspects of the sea, and, naturally, his unfinished masterpiece, the "Sagrada Familia".

Gaudí had taken over the project for this new building in 1884. During almost forty years of work he had conceived an architectural plan which wedded all the elements of his art. Of the three facades planned, the Catalan architect saw only the first completed, that of the Nativity, for he died in Barcelona in 1926. His remains are in the crypt of the "Sagrada Familia", whose high bell towers, at present almost finished in line with Gaudí's project, leave the imprint of his style on the heart of Barcelona. In 1957 Le Corbusier defined him as "the builder of the 1900s" and modern critics have acknowledged his gifts as builder, sculptor, painter and architect, both of supporting structures and of interiors, of large as well as small, all coexisting in a single person.

ANTONI GAUDÍ AND BARCELONA

The extraordinary relationship between Gaudí and Barcelona was however to be brusquely interrupted. On June 7th, 1926, Gaudí was hit by a tram as he was leaving the workyard of the Sagrada Familia. None of the passersby recognized him and he was taken to the hospital of the poor where he died three days later. His mortal remains now rest in the crypt of the cathedral.

Mention has already been made of the fact that Gaudí immediately left his mark on the city of Barcelona. His first truly important work was *Casa Vicens*, commissioned in 1878 but begun in 1883. Since the site, the tranquil and simple *Carrer Les Carolines*, is extremely narrow, Gaudí decided to stress the height of the building by running the chimneys down the facade. While he was working on Casa Vicens, Gaudí began on another commission. In 1884, the rich cotton industrialist Eusebi Güell commissioned two pavilions for his summer residence in Pedralbes, in the outskirts of Barcelona. The two *Güell Pavilions*, on the corner of what is now *Avinguda de Pedralbes*, one octagonal and the other rectangular, are united by a splendid wrough-iron gate in the form of a dragon. Between 1885 and 1890 Gaudí built the *palace* facing the *Carrer Nou de la Rambla*, again for Eusebi Güell who « discovered » him in the Paris World Fair in 1878. For the first time Gaudí turned his attention to the play of space on the roof, covering the chimneys and the aeration system with pieces of tile, and arranging them around the central cone which corresponds to the internal dome and through the openings of which the light penetrates and spreads throughout the building. The interior is a magnificent synthesis of ivory and marble, carved wood, frosted glass, and gilt metal.

A completely different spirit — formal simplicity and aesthetic rigor — pervades the *Convent and School of Saint Teresa*, begun in 1889. The year before, Gaudí had begun work on the *Casa Calvet*, commissioned by the textile manufacturer Pedro Martin Calvet, and for which he had even won a prize from the municipal authorities. Gaudí's imagination went wild inside in the realization of the elevator which has been transformed into a complicated reliquary in carved wood and wrought iron, surrounded by an elaborate baldachin supported on twisted granite columns which continue along the entire height of the building. The *villa of « Bellesguard »*, on the Tibidabo, also dates to more or less the same period. It is characterized above all by the shape of the roof, a truncated pyramid pierced by projecting dormers at the corners.

Details of the pinnacles of the Sagrada Familia.

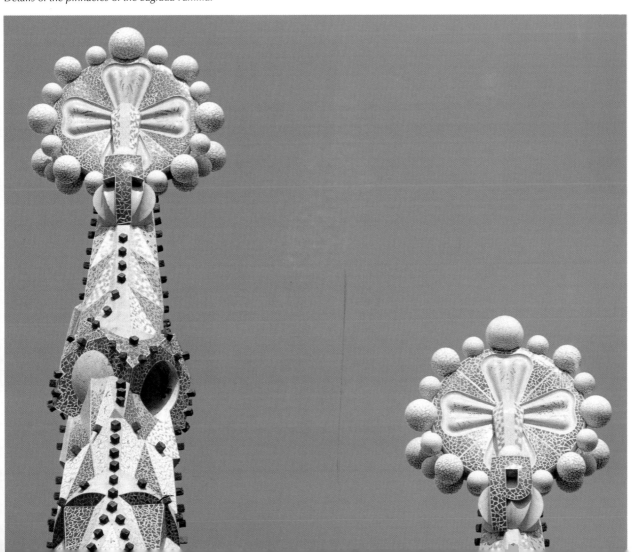

SAGRADA FAMILIA

Gaudí's intense series of works culminates in what is considered his masterpiece, even though it was left incomplete when he suddenly died — the *Sagrada Familia*.

In 1866, the book dealer Bocabella founded a spiritual association dedicated to St. Joseph. In 1881 two hectares of land in the Barrio del Poblet, a modest district in the outskirts of the city, were acquired with the contributions of a public subscription. Initially the construction of a church dedicated to the Holy Family was entrusted to the architects Martorell and Francesc de Paula Villar. After having begun the construction of the crypt, the latter resigned and Martorell called in Gaudí who was then 31. On the death of the bookseller Bocabella, the Bishop of Barcelona officially took over what had been a private firm and formally put Gaudí in charge of the works. At the time, Gaudí had already finished the vault of the crypt and radically changed Villar's original plan. Gaudí saw the Sagrada Familia as a great symbolic building, a colossal allegory which was to evolve on the three monumental facades. The west facade was to be dedicated to the *Birth of Christ*, the one on the east to *His Life* and the *Passion* and the facade to the south to the *Ascension*. Of these three facades, Gaudí succeeded in realizing only the one to the west, which is so perfect and complete that it can be considered as a building in its own right. The three portals, which symbolize *Faith*, *Hope*, and *Charity*, are completely covered with sculpture in Art Nouveau style, and the architecture disappears under a forest of vibrant figures which stretch, twist, and expand. The portal of Hope, dedicated to the *Virgin*, shows the mystical *Marriage of Mary and Joseph*, the *Flight to Egypt* and the *Massacre of the Innocents*. The palm-shaped column is supported by a Nile tortoise, symbol of perseverance. The central portal of Charity is divided by the *tree of descendants from Abraham to Joseph* and is dominated by the *grotto of Bethlehem*. The cypress is crowned by a *tau cross* and features a pelican, symbol of sacrifice, at its base. The last portal, on the right, is dedicated to St. Joseph and illustrates *stories of Jesus in the Temple* and in the carpenter's workshop.

A glimpse of Gaudí's working methods throws some light on the composition of the allegoric representations. The master used to choose his models off the street, then photograph them against a set of mirrors so as to have a complete view from all angles. After that he made a plaster cast which he then used for the figure, modifying the proportions as he saw fit. It is truly a pity that this extraordinary neo-Gothic building was never finished. The models preserved in the crypt show Barcelona's « unfinished cathedral » as a traditional Latin cross plan, with five aisles crossing a transept that is three aisles wide. The nave is illuminated by wide windows and was to have been a real forest of columns, each dedicated to a saint, an apostle, or a bishop. At the crossing, a colossal central

View of the church from the facade of the Nativity and, below, a detail of the elaborate sculptural decoration.

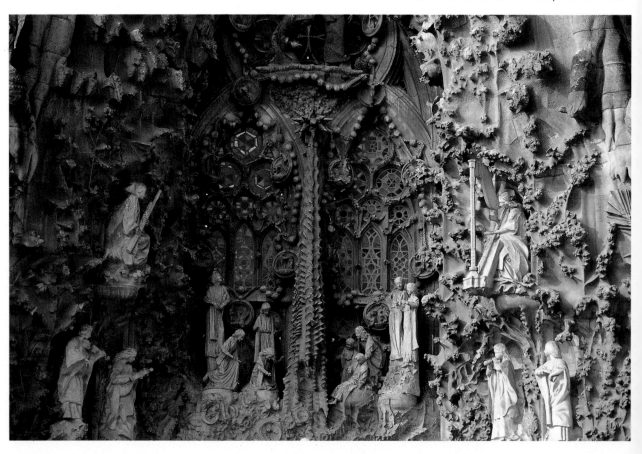

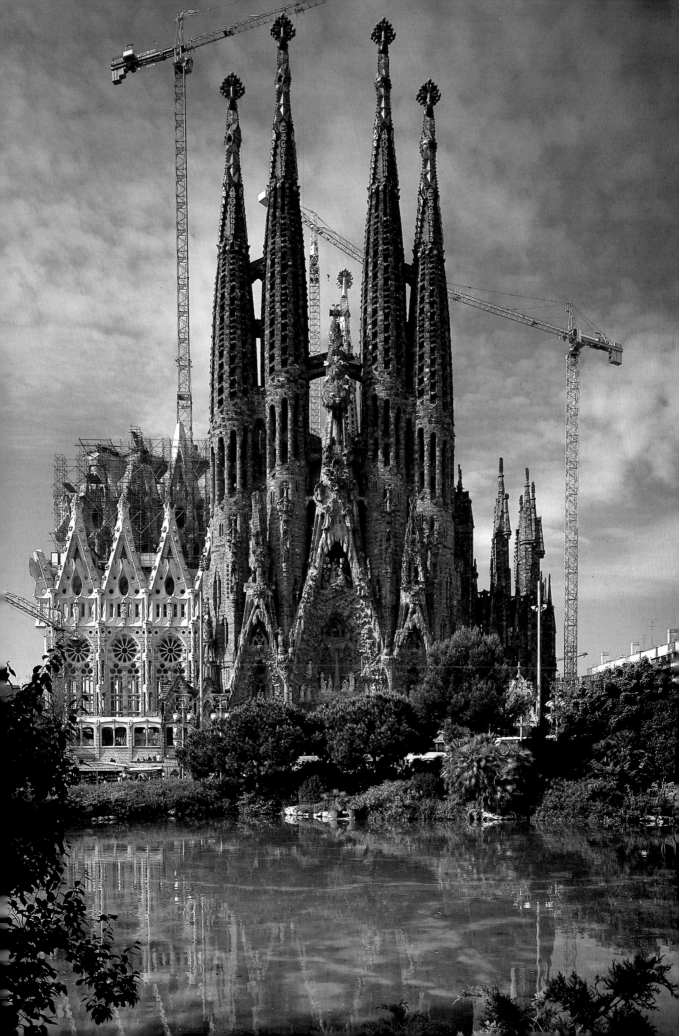

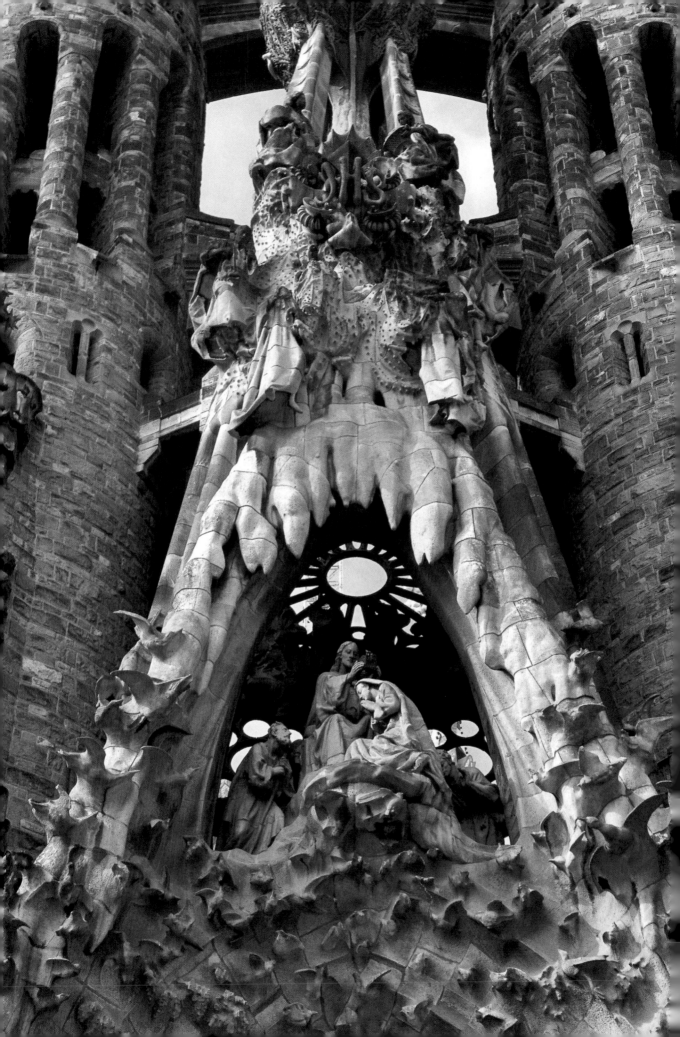

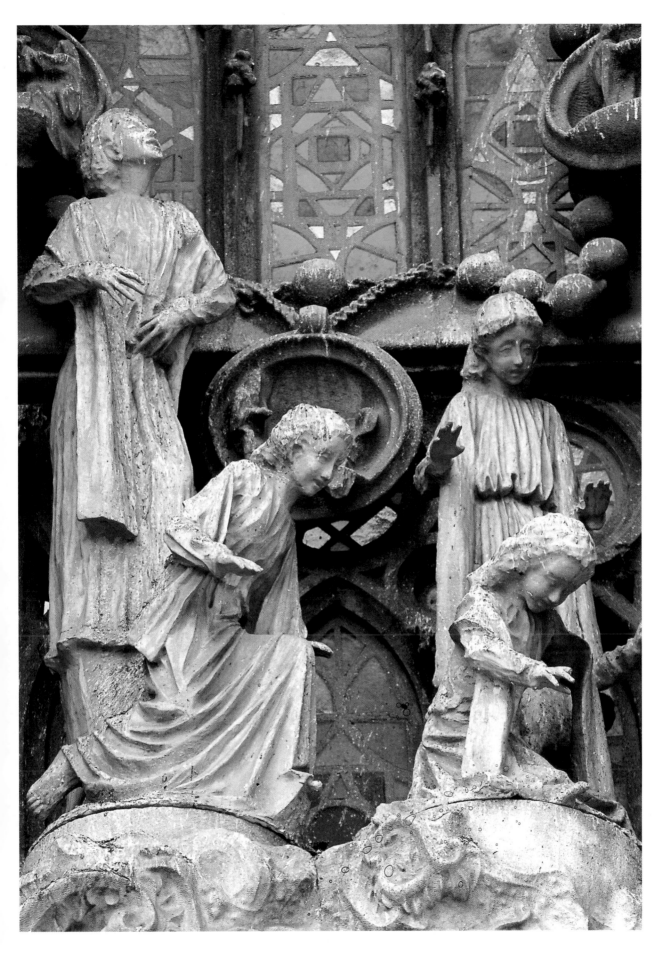

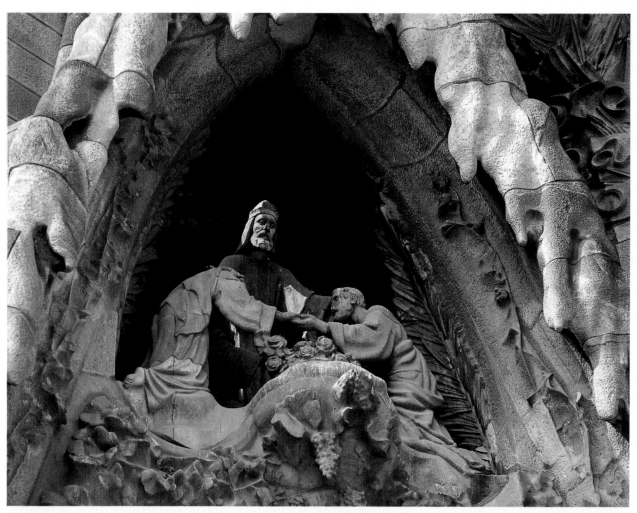

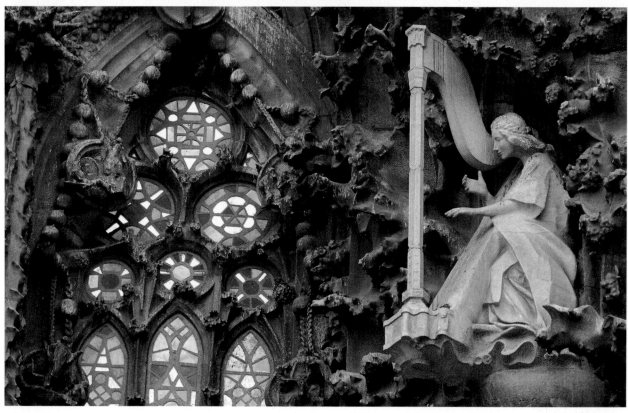

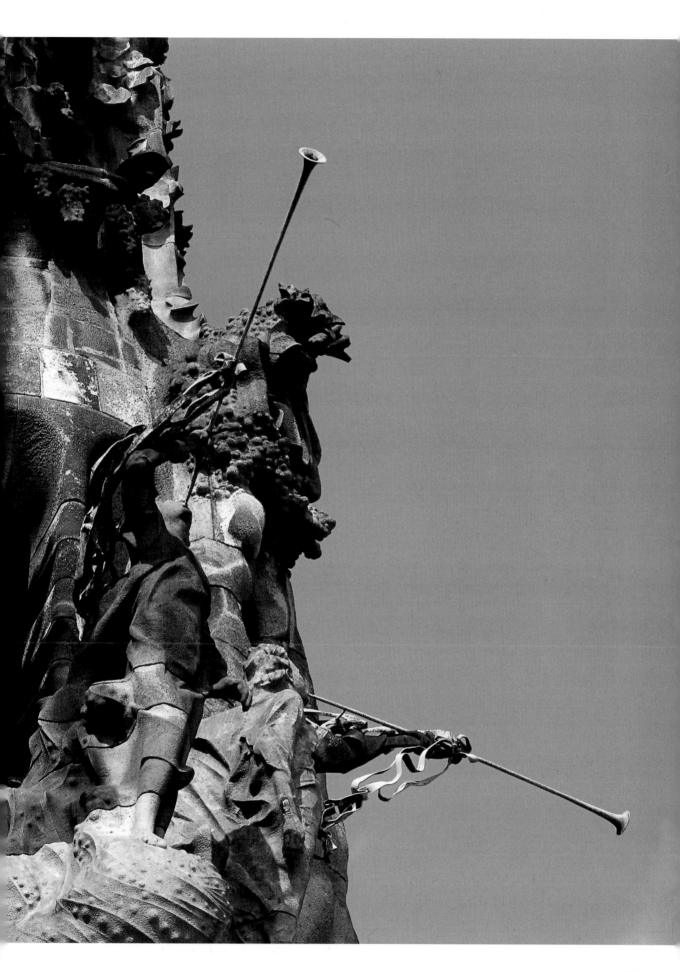

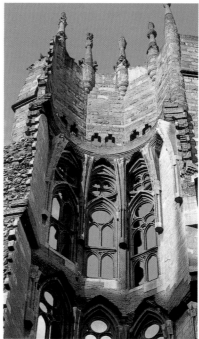

Sagrada Familia: elegant rose-windows, elaborate windows and an incredible flourish of sculptures of intense expressiveness (these and preceding pages).

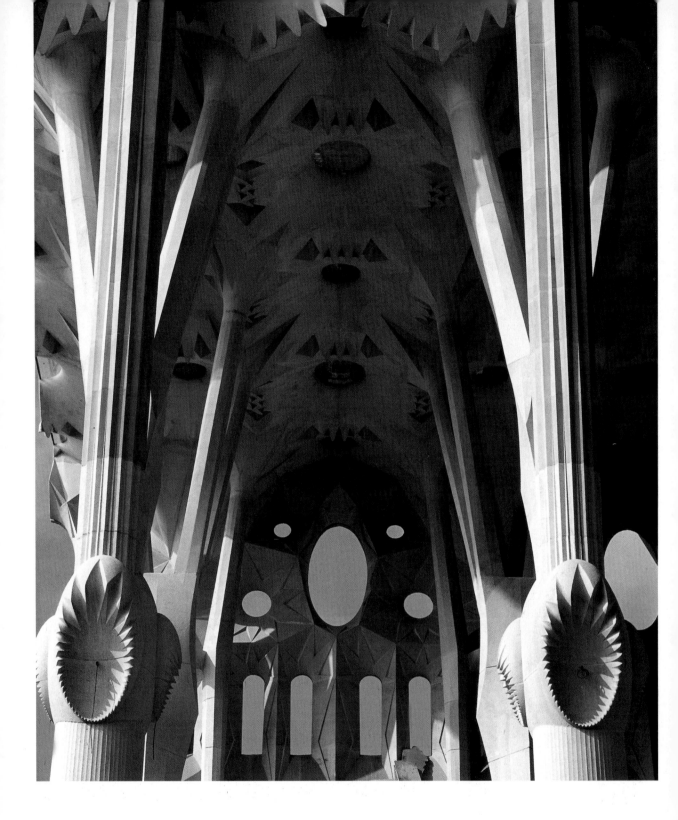

tower, the *symbol of Christ*, was to rise up surrounded by four smaller towers (*symbols of the Four Evangelists*). Each of the three facades was to have four bell towers, making a total of twelve, to symbolize the *Apostles*.

This enormous complex vision, with its emphasis on the vertical so as to symbolize the union of sky and earth, was to be further completed by brilliant colours, as is evident from the model which Gaudí presented to the 1910 Paris Exposition. On the Nativity facade, the portal of Hope was to have been green, symbolizing the *valley of the Nile*. The portal of Charity was to be the blue of a *night in Bethlehem* and the portal of Faith was to have been burnt Sienna to symbolize the *sands of Palestine*. The interior of the church was also to have been colored: white and gold in the right aisle to symbolize *joy*, violet and black in the left side aisle to symbolize *grief*.

Gaudí threw himself heart and soul into this colossal work. In 1914 when he was already 62 he even decided

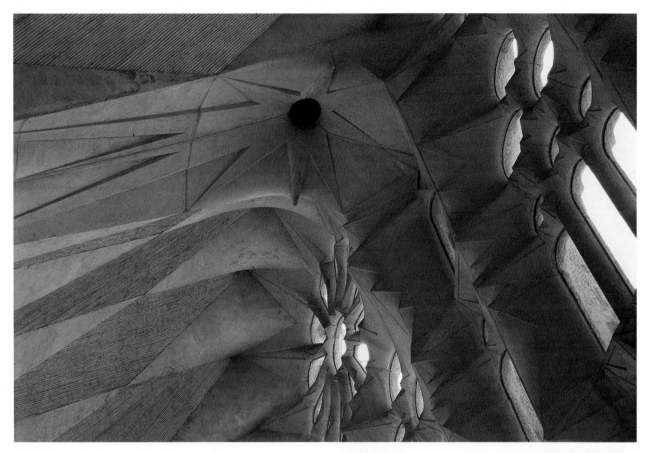

Other impressive images of Gaudi's masterpiece.

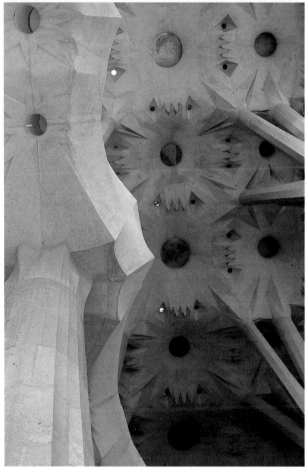

to live in a room in the building yard of the church. When he died, the work was carried on, according to his plans by a group of his closest collaborators including Sugranes, Quintana and Matamela. Work was interrupted in 1935 when the Spanish Civil War broke out, during which time a fire destroyed part of the building and many plans and models in Gaudí's studio.

Even today, financed by the offerings of the faithful, construction continues, albeit extremely slowly. When it is finished the church should be 110 meters long and 45 meters high — one of the largest and finest churches in the Christian world. The so-called **Museum of the Sagrada Familia** is part of the complex: wall panels, showcases and photographs have been arranged in some of the rooms. An interesting documentary survey in chronological order makes it possible to follow the various building phases of what has so far been terminated of this ambitious project drawn up by Gaudí.

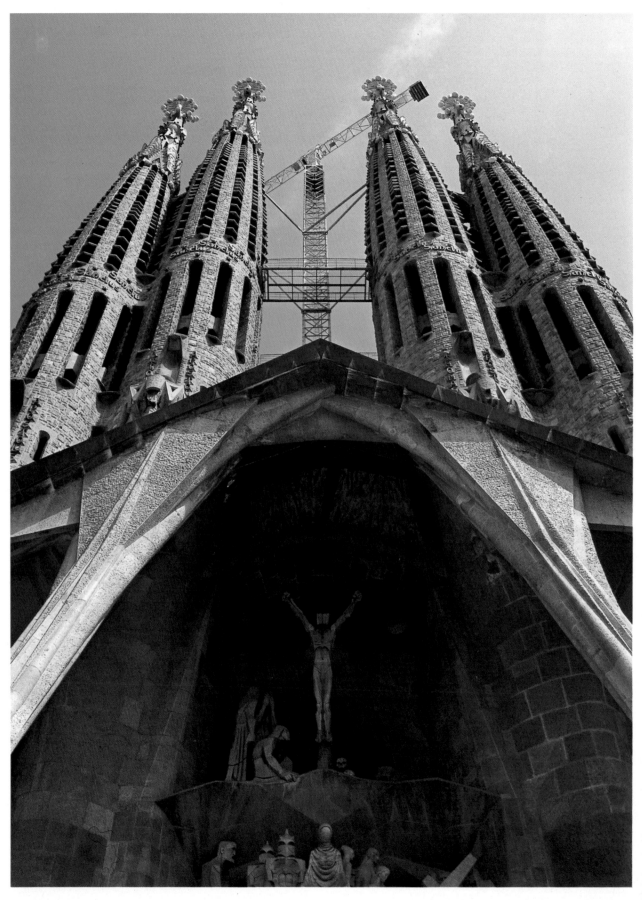

Sagrada Familia: a view of the apse of the church and details of the sculptures.

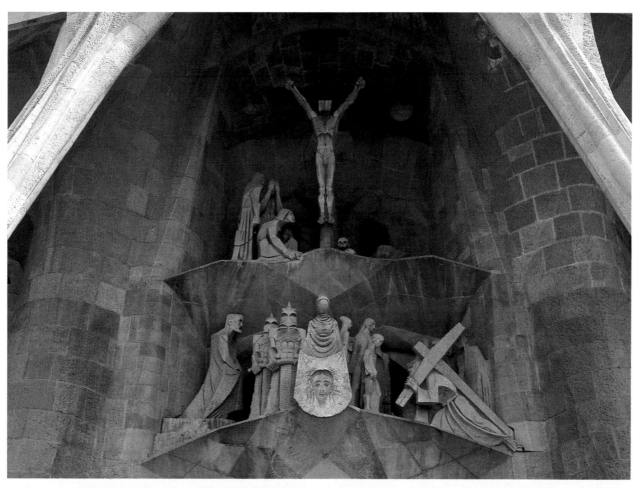

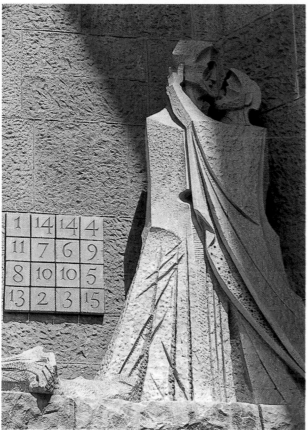

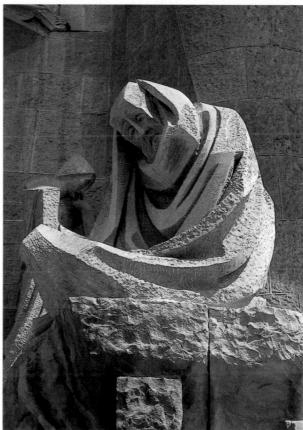

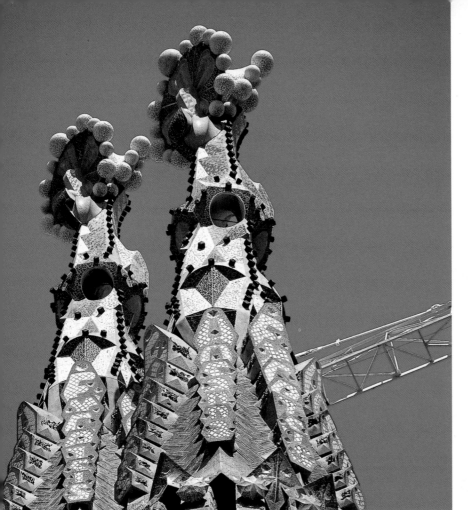

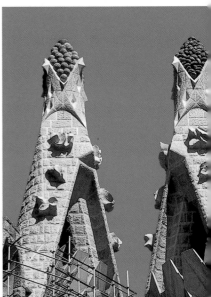

Sagrada Familia: impressive views of the building sites, still very active.

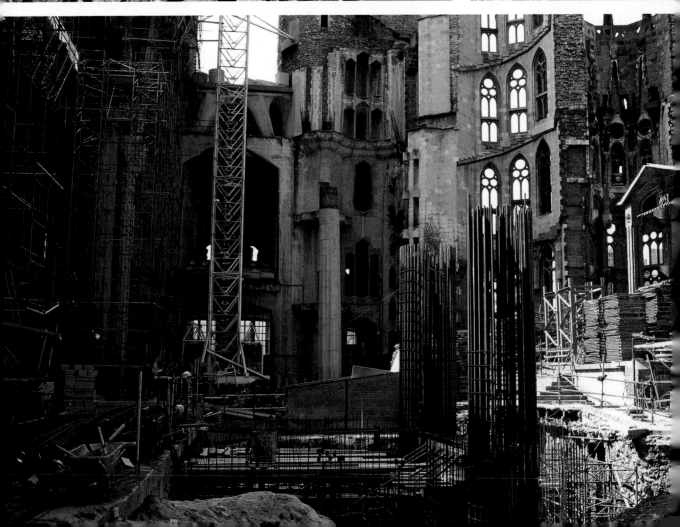

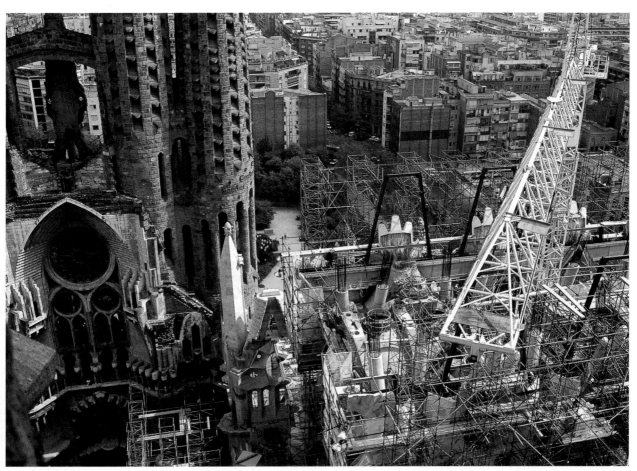

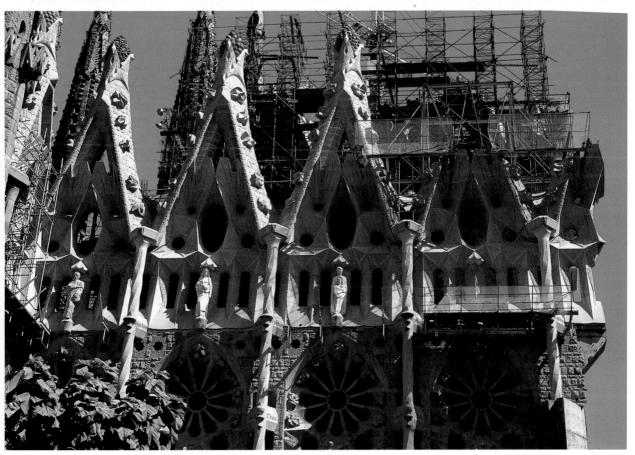

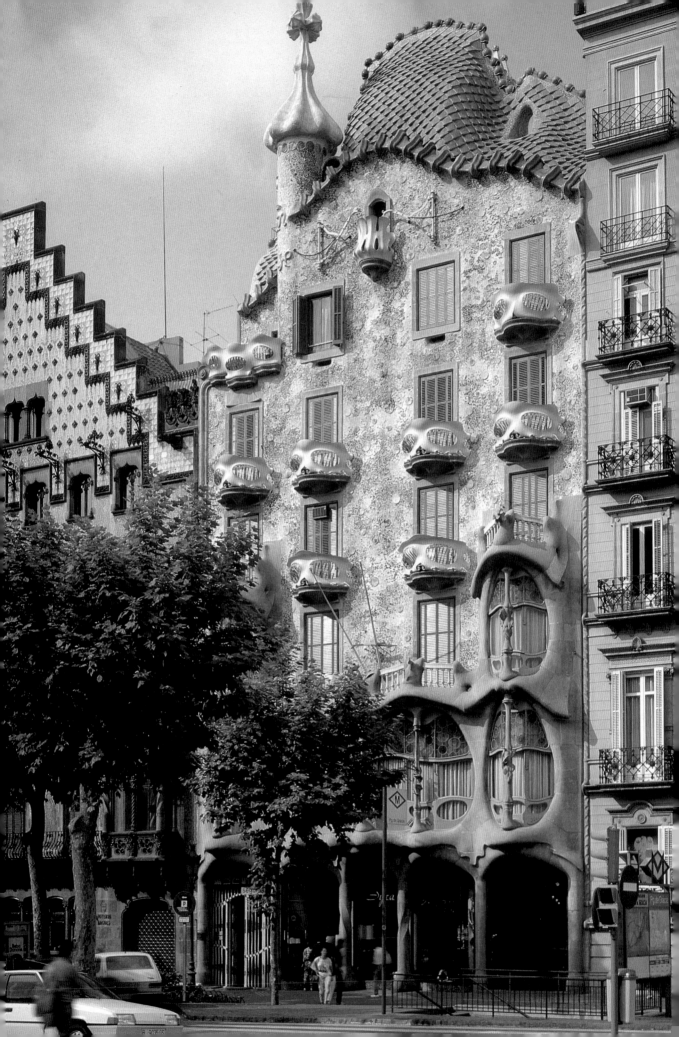

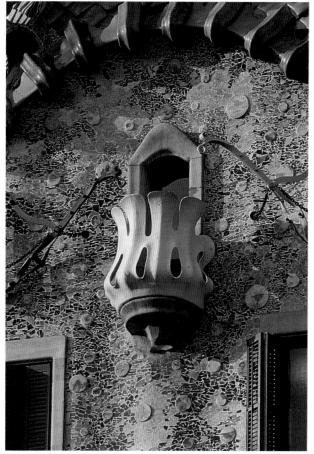

Casa Batlló: the facade of the house and a few details of its architectural structures.

On the following pages: Casa Batlló at night.

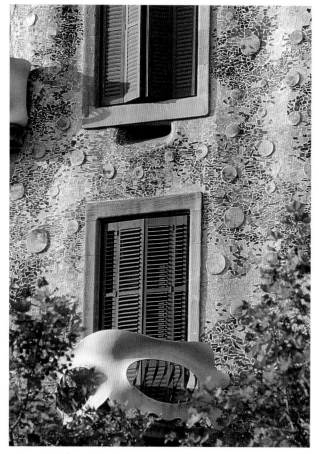

CASA BATLLÓ

Casa Batlló, at no. 43 *Passeig de Gracia*, rose between 1904 and 1906 in the city block known as the « manzana de la discordia » or the « Apple of Discord », with its diverse examples of Catalan modernist (Art Nouveau) architecture standing side by side. Since manzana means both apple and city block, this is also a play on words. Casa Batlló was restored by Gaudí for the family of José Batlló y Casanovas. Gaudí applied his own extremely personal style to the whole building, restructuring the facade, restoring the interior and redesigning the furniture. An « immense, senseless multicolor mosaic shimmering with scintillating light from which forms of water emerge » is what Salvador Dalì had to say of Casa Batlló. The cult of the curved line and the expansion of the form as a pure vital symbol, reach their apex here: everything, from the columns to the balconies, is seen as something that must be made to vibrate and live.

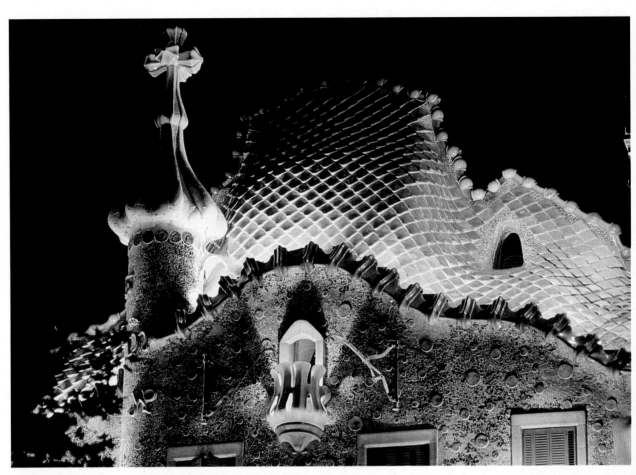

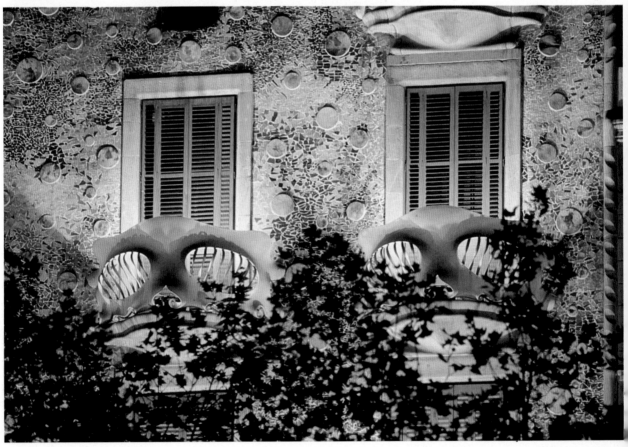

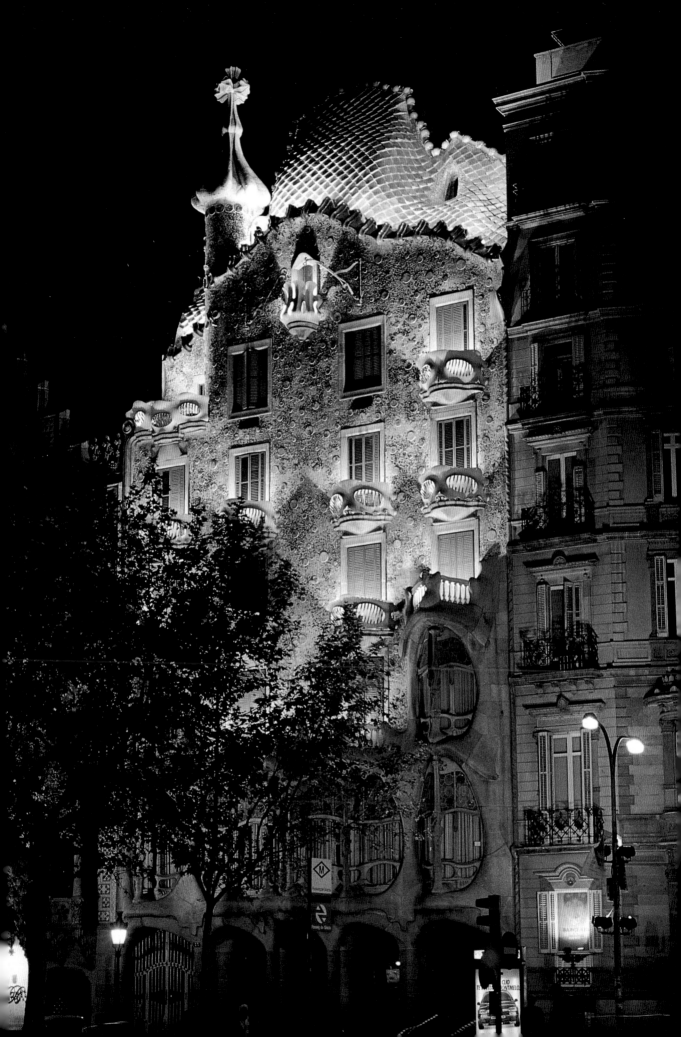

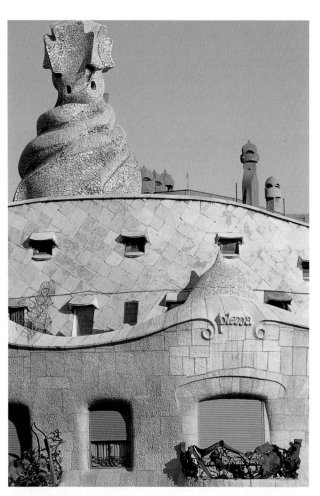

CASA MILÀ

Casa Milà, begun in 1905 and finished five years later, also faces *Passeig de Gracia*. A glance at the facade suffices to explain why this five-story building is better known as « *La Pedrera* » or the quarry. The Pedrera may very well be the best and most complete example of Gaudí's concept of Nature: a sort of stone mountain created by man, with a group of « caverns » which open onto the facade which emanates an enormous vital force.

Gaudí, this solitary introvert and fervent Catholic, succeeded here in transforming the most profound moment of Art Nouveau into an expression of pure vitality: something that is no longer a static geometric space, but a space which expands with its birth and development. The facade thus materializes in a series of waves which follow the movement of the entire building. On the other hand,

Casa Milà: a few pictures of this unique building and some of the architectural details.

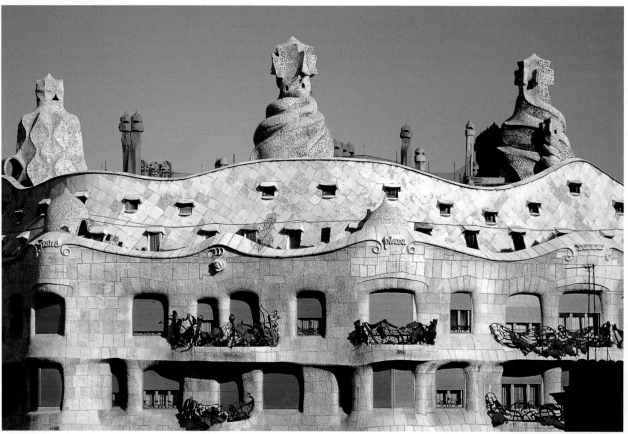

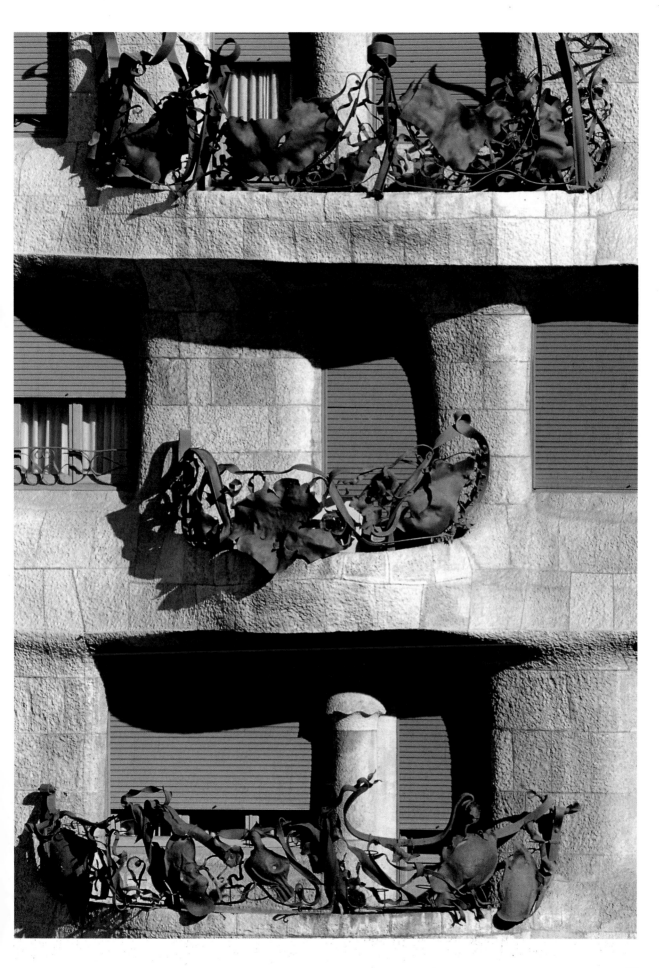

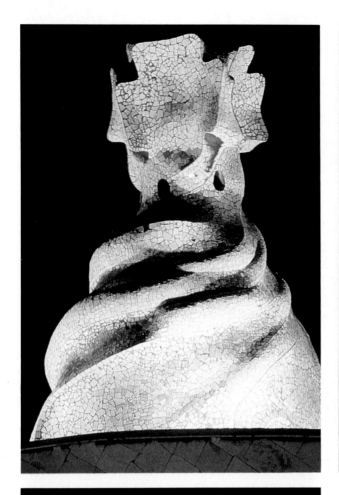

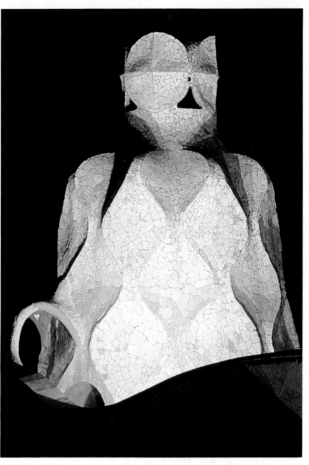

On these and following pages: a few images of the chimneys which look like pieces of sculptures.

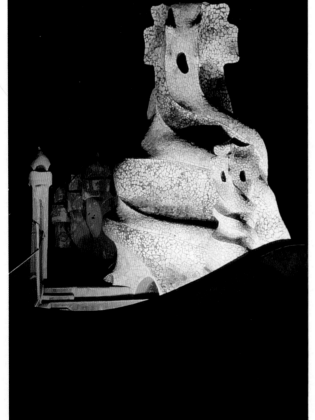

Gaudí himself once said: «. . .corners will disappear and the material will abundantly manifest itself in its astral rotundities: the sun will penetrate on all four sides and it will be the image of paradise. . . and my palace will be more luminous than light. »

But let us climb for a moment to the roof of the house, and receive the impact of the unrestrained fantasy of the artist. No railings, but gardens overlooking deep courtyards and hooded monsters of an enigmatic and disquieting aspect. In this abstract stage-set (the bizarre shapes of the chimneys alone suffice) Gaudí anticipates by a good forty years the aspects of the best of surrealism.

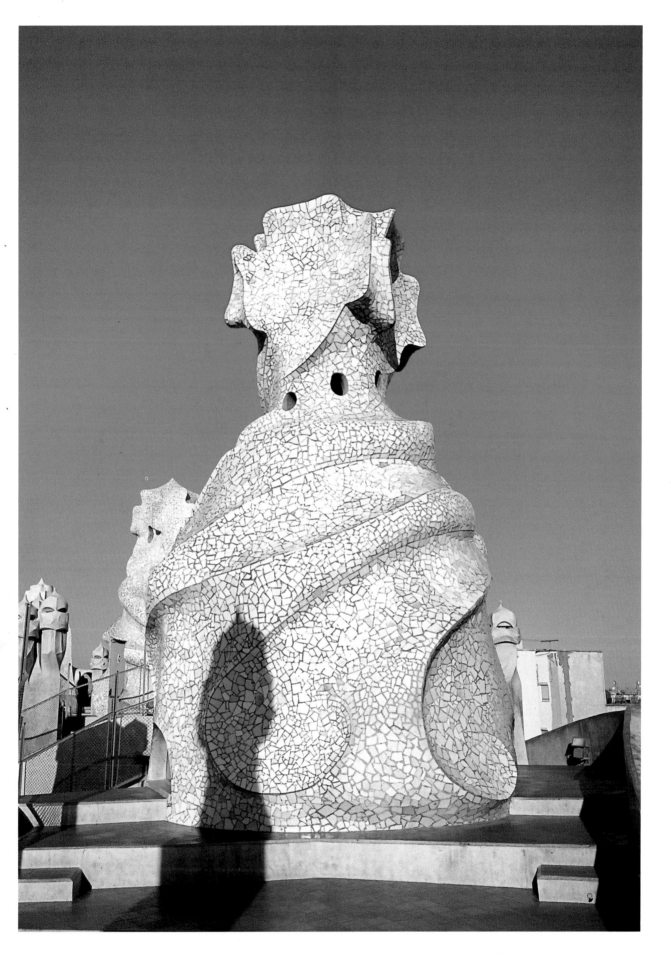

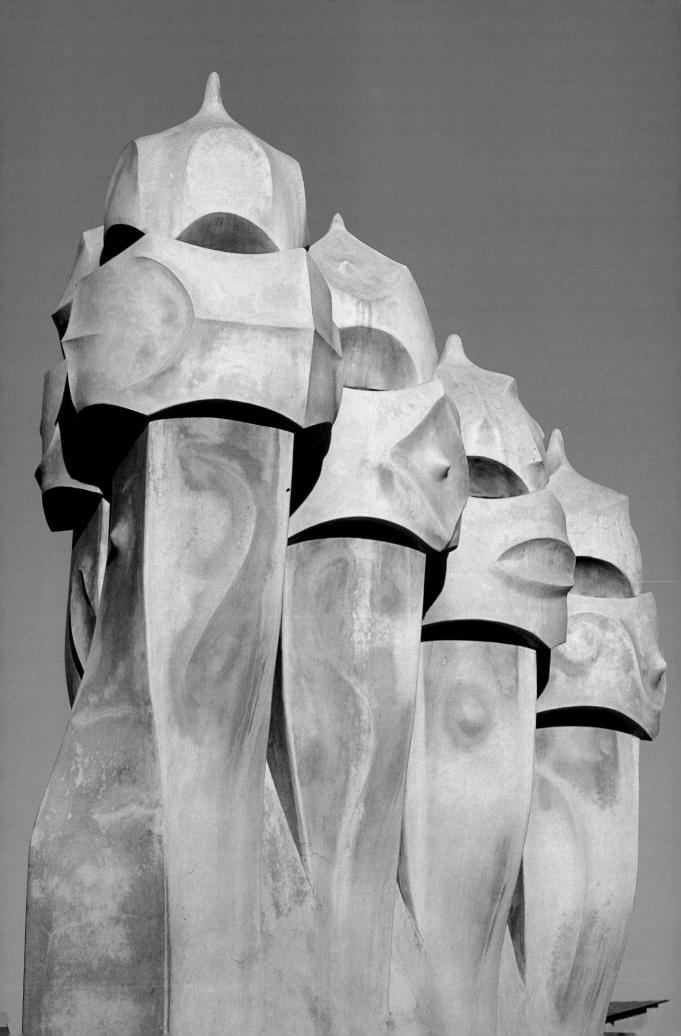

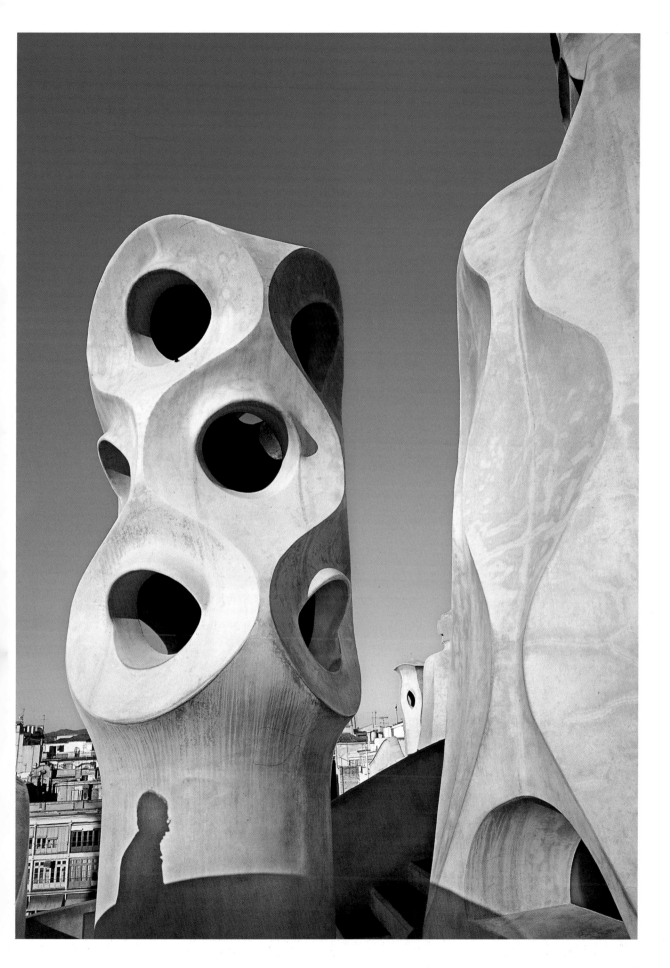

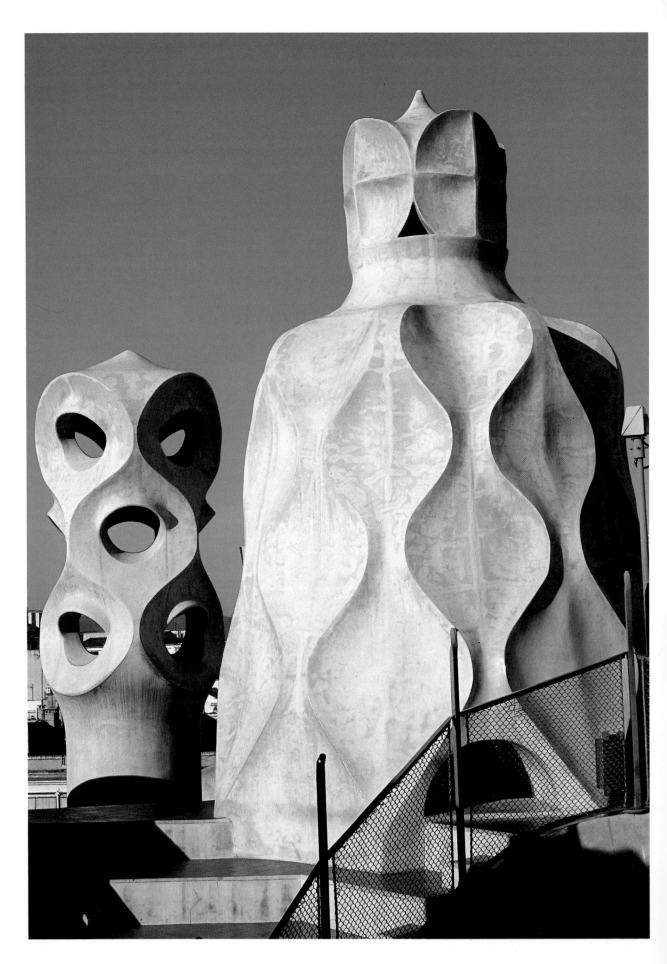

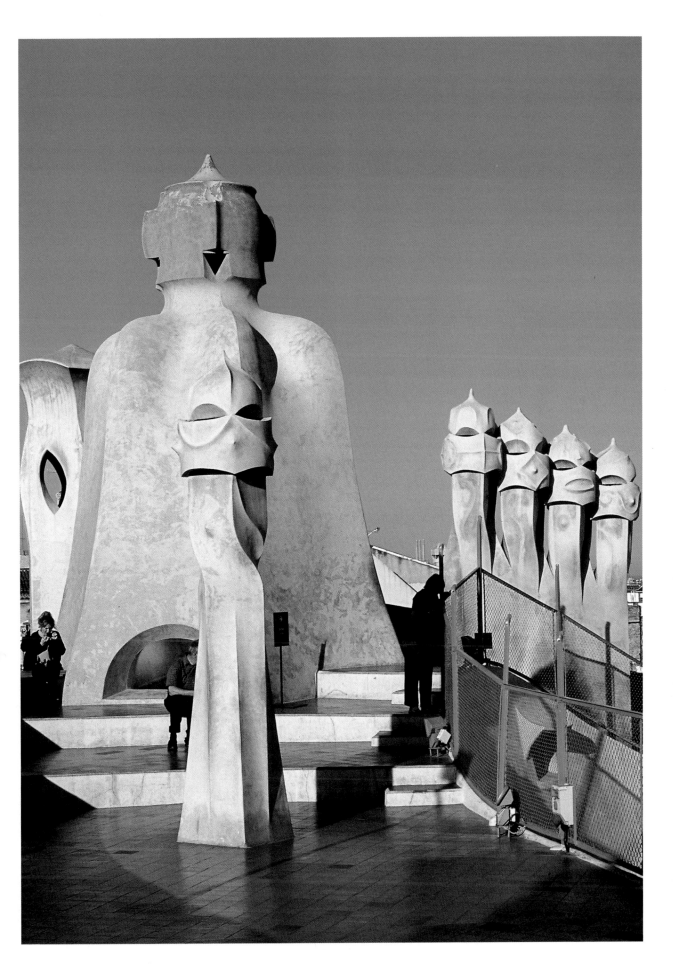

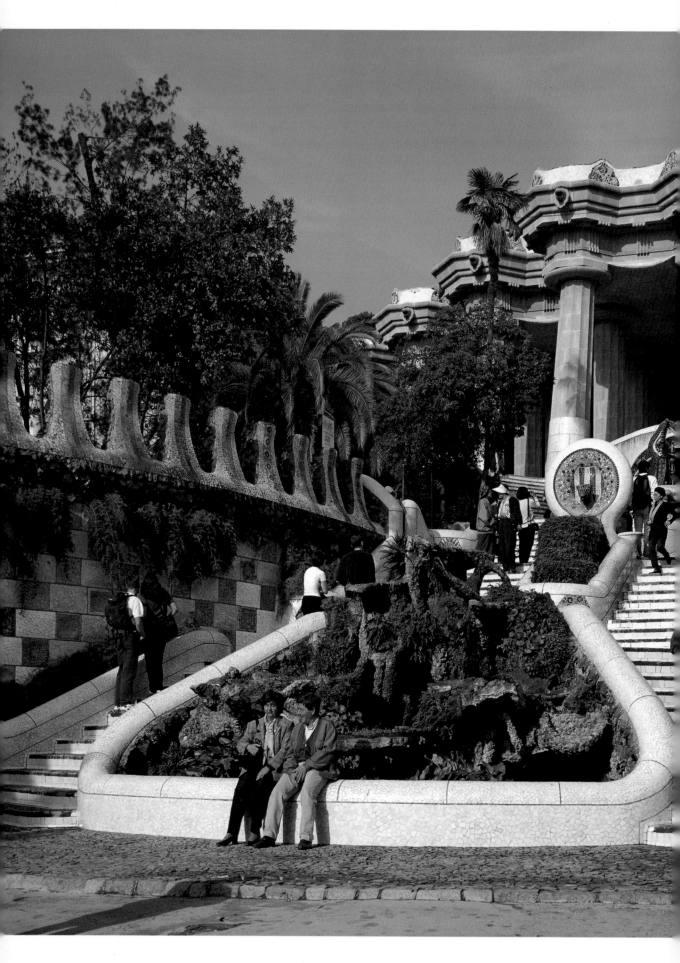

PARC GÜELL

From 1900 onwards, with Eusebi Güell as his patron once more, Gaudí created one of his loveliest works, *Parc Güell*. The genius and art of the Spanish architect could never have been expressed as it was without the presence of his patron, Eusebi Güell i Bacigalupi, in Barcelona. The wealthy count of Güell, who greatly admired the English garden-cities so fashionable at the time, wanted to create a residential district of about 60 homes on 15 hectares of land he owned in a zone called « Montaña Pelada ». The inhabitants were promised a new revolutionary way of life. Gaudí was commissioned to prepare an ideal town plan, with complete freedom of expression as far as buildings and ornaments were concerned. Despite the most optimistic previsions, the experiment of the new garden-city failed. Only two of the 60 plots were sold, one to Gaudí himself and the other to a friend, Dr. Alfonso Trias. That is why in 1922 the city of Barcelona acquired the entire area and transformed it into a public park.

A high encircling wall encloses the park. The main entrance is at the intersection with **Carrer d'Olot**. The two curious pavilions in polychrome tile which flank the splendid wrought-iron gate were originally meant to serve as a porter's lodge (the one on the right) and as administration headquarters (on the left). A double staircase departs from

Parco Güell: the entrance stairway to the Room of the Hundred Columns.

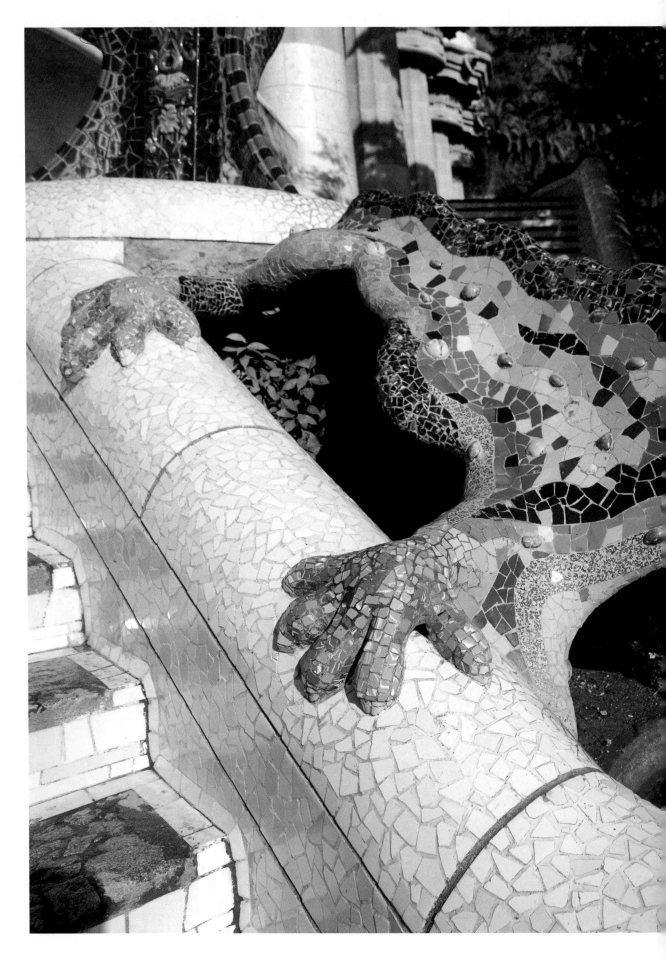

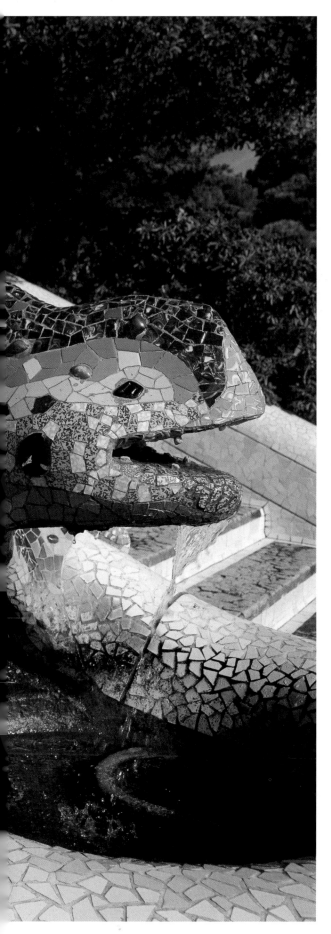

the entrance and the flights of stairs, united by ornamental waterworks and zoomorphic sculptures covered with mosaics (including *dragons* which are always present in Gaudí's art), meet at the top in what is commonly called the « room of the hundred columns », even if there are really only 86. In this capricious « hypostyle hall » the columns in Doric style bend to support a vault which also seems to be moving because it is wavy, and, in unexpected anticipation of Pop Art, encrusted with pieces of bottles, plates, glass and ceramics. In 1912 Gaudí put the crowning touch on this room in what is considered the symbol and synthesis of his « total art », that is the great curved bench which marks the boundaries of the upper terrace overlooking the city. It is said that in his attempt to give the bench seat an anatomical form, Gaudí had one of his workers sit nude on the wet plaster and thus obtained the profile which he then used in designing the seat. Here too, Gaudí is once more a skilled forerunner of the form and color of an art which was yet to come: in fact the entire bench is composed of a mosaic of ceramic shards of various colors and sizes which he arranged in a gigantic abstract collage. At the center of the park is Gaudí's unusual House-Museum, where he lived from 1906 to 1926 and which still preserves the furniture, paintings, and objects which belonged to the great Catalan artist.

Mosaics by Gaudí in the Parco Güell.

Following pages:
Gaudí's House-Museum and some shots of the beautiful mosaics bench which borders the terrace of the park.

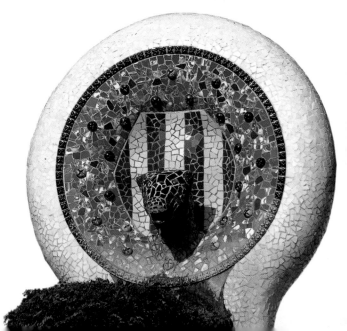

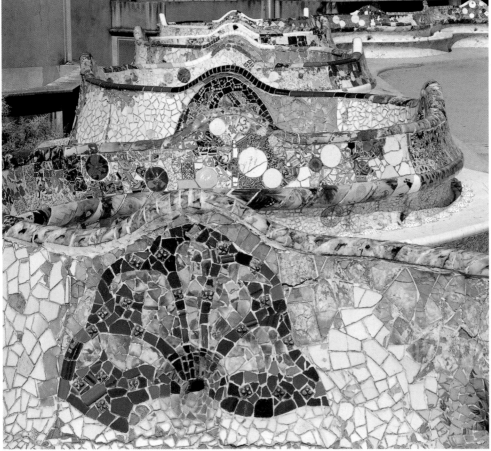

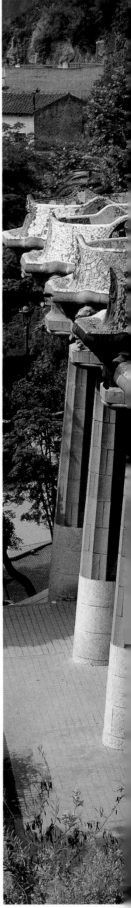

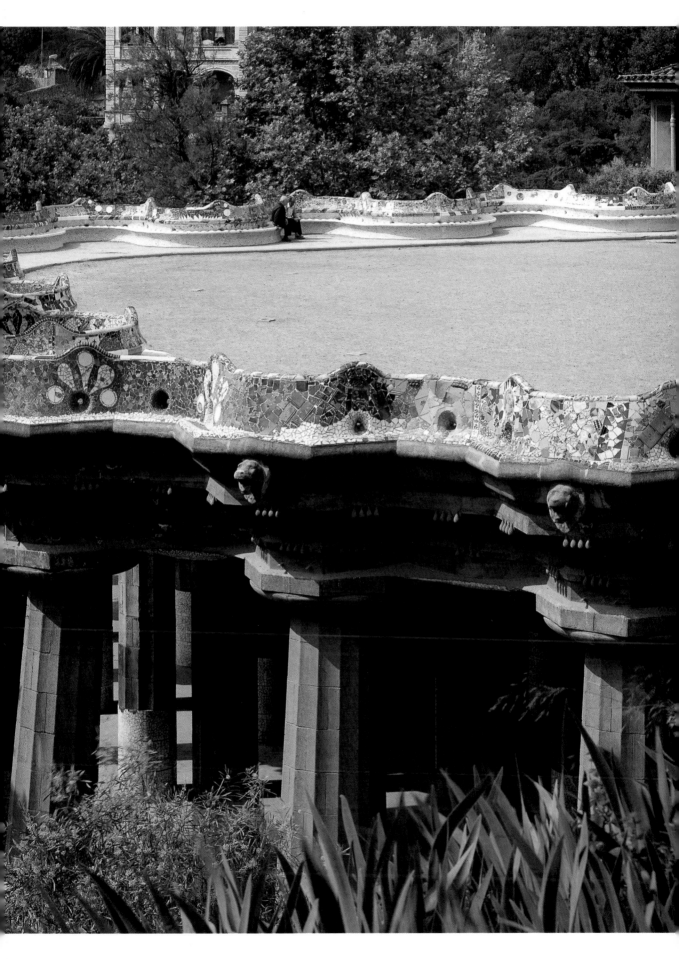

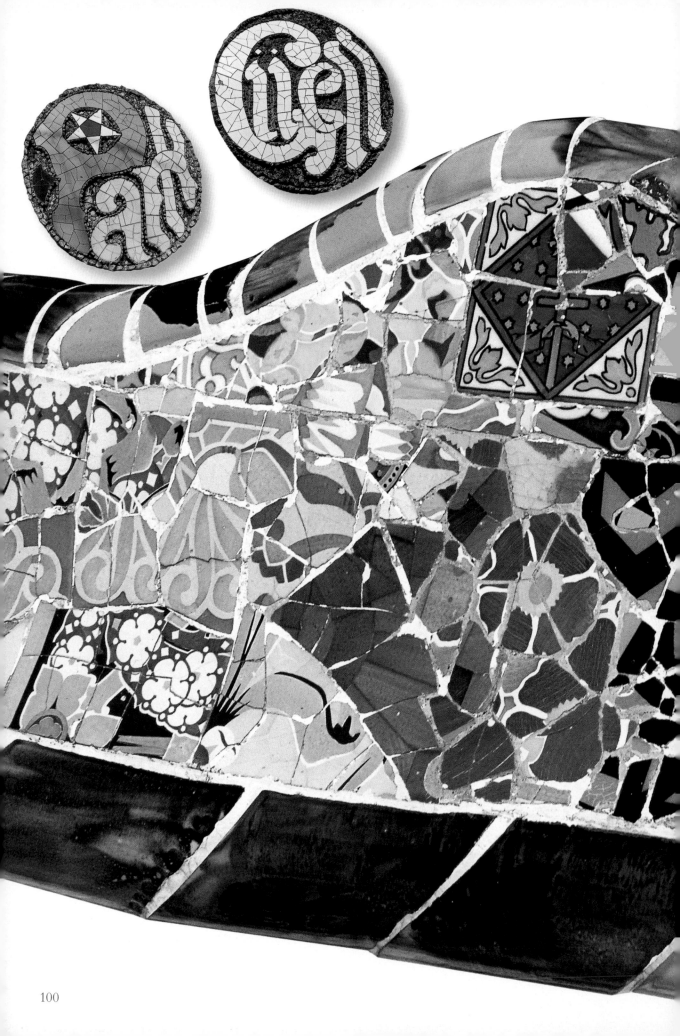

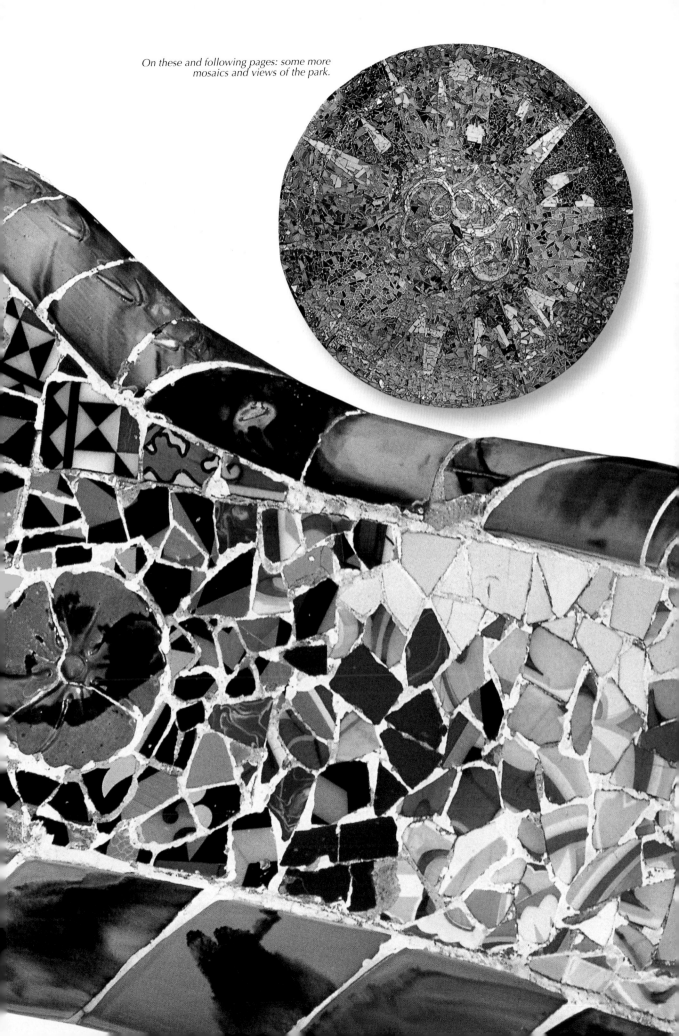

On these and following pages: some more mosaics and views of the park.

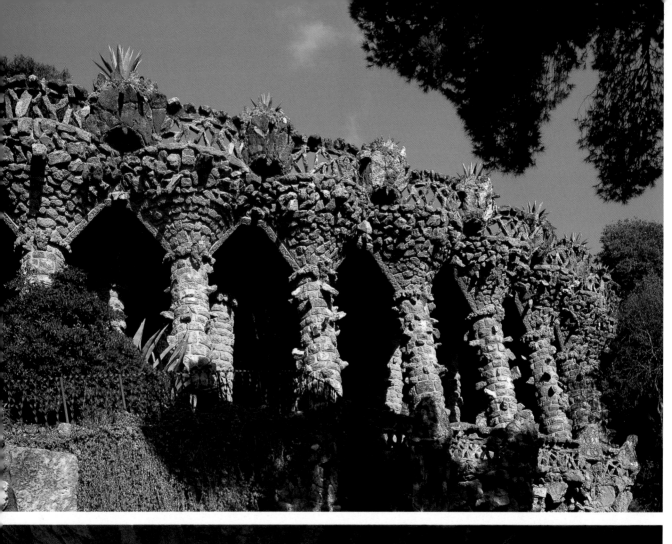
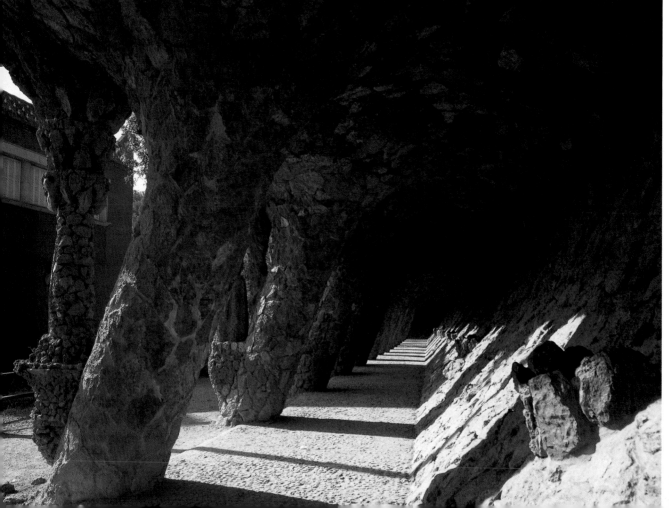

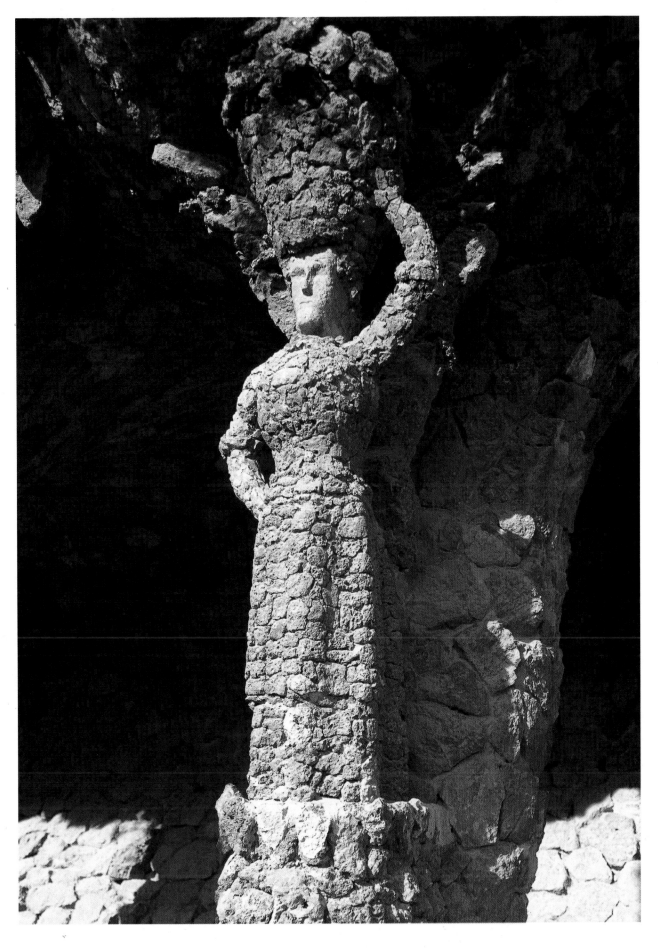

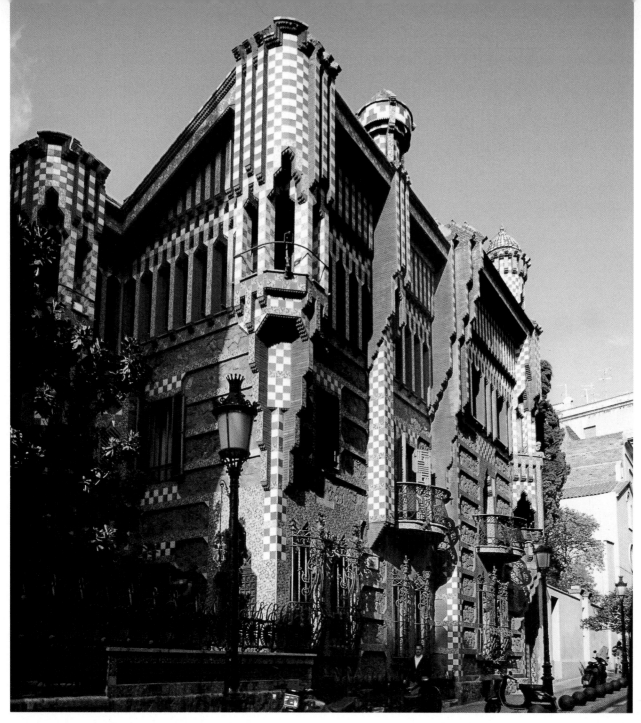

Casa Vicens: one of Gaudí's first works.

CASA VICENS

The result of the commission the entrepreneur Vicens gave to the young and inexperienced Gaudí in 1878 is the villa located at 24 Carrer de les Calorines. The building, begun in 1883 and terminated in 1888, was a brilliant debut for the young architect, for it was one of his first works. The facade displays a balanced combination of elements which, with their play of geometric forms, recall Islamic architecture, while the color of the ceramic decoration stands out against the rough texture of the natural stone and brick. Despite the simplicity of the materials employed, the walls, taken as a whole, are unexpectedly beautiful. When enlargements were carried out in 1925-26, some of the magnificent gardens which surrounded the villa were lost. Of particular note the wrought-iron railings, where palm leaves are the basic decorative motive. The equally fascinating interior of the house was also planned and designed by Gaudí in line with his unbridled fantasy.

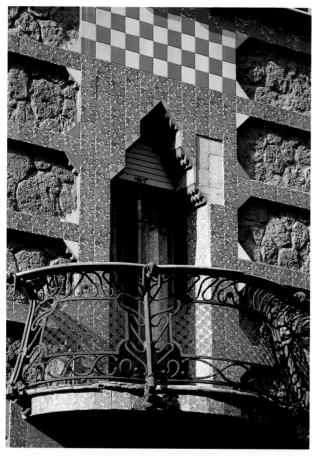
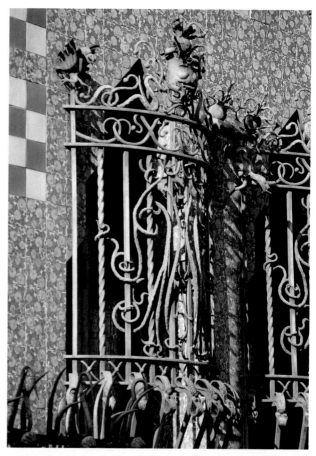
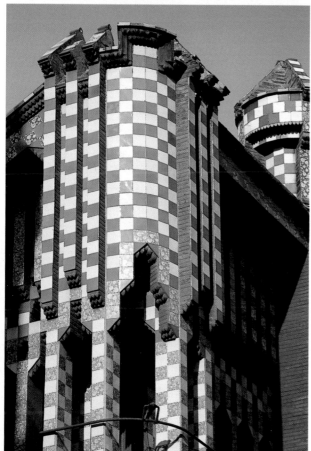
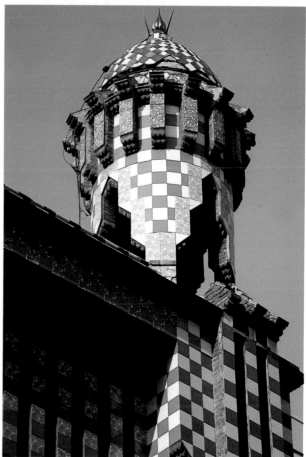

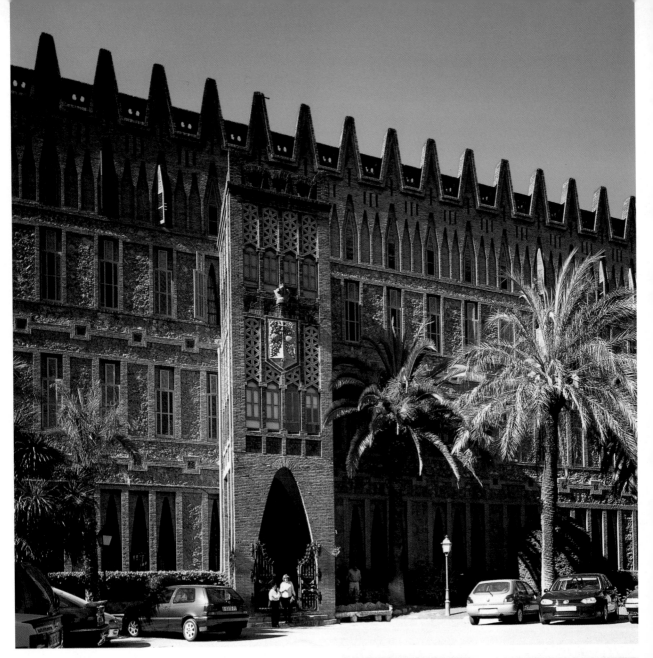

The Convent de les Teresianes.

CONVENT DE LES TERESIANES

Situated at number 85 of Carrer Gandurex, it constitutes the first phase in Gaudí's production. The nuns who live there and teach in the college housed in the convent belong to the Order of Saint Teresa of Avila. The rules of this order, poverty and parsimony, were kept in mind by the architect and dominate the entire building, which is, in effect, lacking in ornamental details.

The hand of Antoni Gaudí gives the complex a plastic value almost exclusively as a result of the structure itself. This, toghether with the parabolic brick arches and the iron grill at the entrance, is what characterize this work. Despite the unquestionable mark the Gothic philosophy of the Order and Gaudí's own interest in Gothic left on this building, it is considered an example of Modernist Art (Art Nouveau).

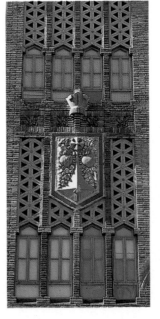

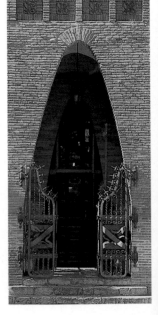

CASA CALVET

The house which now stands at number 48 of Calle de Casp was terminated between 1898 and 1899.

It is a house with a wealth of decorative detail: the facade, built of great blocks of stone, is enlivened by numerous balconies with wrought-iron railings, while at the top are two elegant curved pediments.

The lower floors of the building were to be used as shops and offices while the upper floors were to serve as dwellings.

Gaudí not only planned the outside of the house, but also designed the furniture which is still inside.

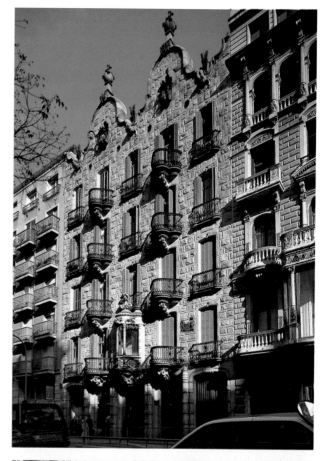

Casa Calvet.

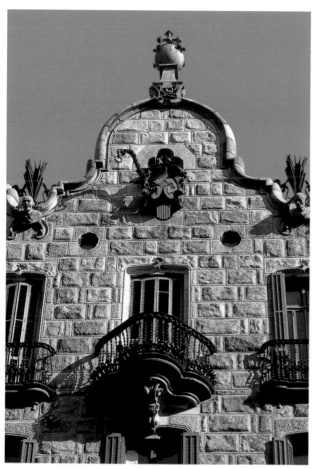

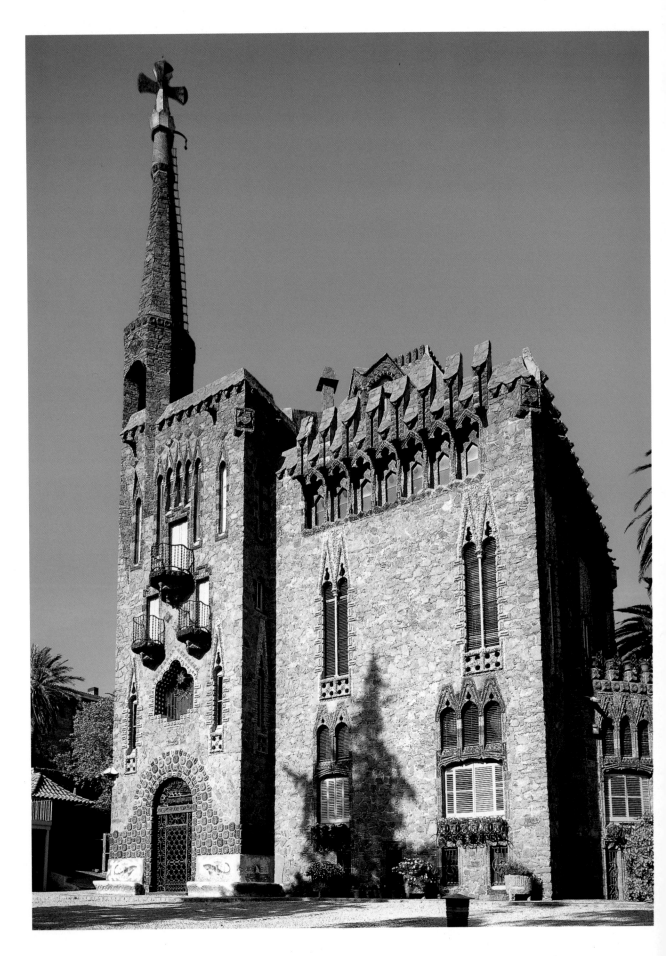

BELLESGUARD

In 1900 Doña Maria Sagués commissioned Gaudí to build a country house which was to reaffirm the historical and symbolic meaning of the site: it was indeed here that the last king of Aragon, Martin I, had a country house called « Bell Esguard » built in 1408, a name inspired by the truly magnificent panorama of the city to be had from here. The entire building was to recall one of the most felicitous periods for Catalonia, was to be a sort of medieval dream, a hymn to antiquity.

Antoni Gaudí, « the most Catalan of the Catalonians » as his friend Joquim Torres defined him, created a relatively simple plan almost perfectly square, onto which he grafted neo-Gothic elements of great elegance: the magnificent portal, protected by a highly decorated wrought-iron grill, the crenellation and the slender spire. The building however remained incomplete and was terminated by Domènec Sugrañes in 1917.

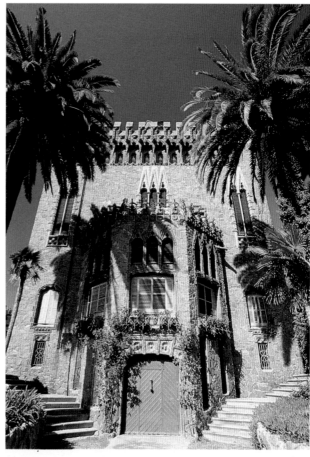

Bellesguard: two pictures of the villa and a detail of the superb portal.

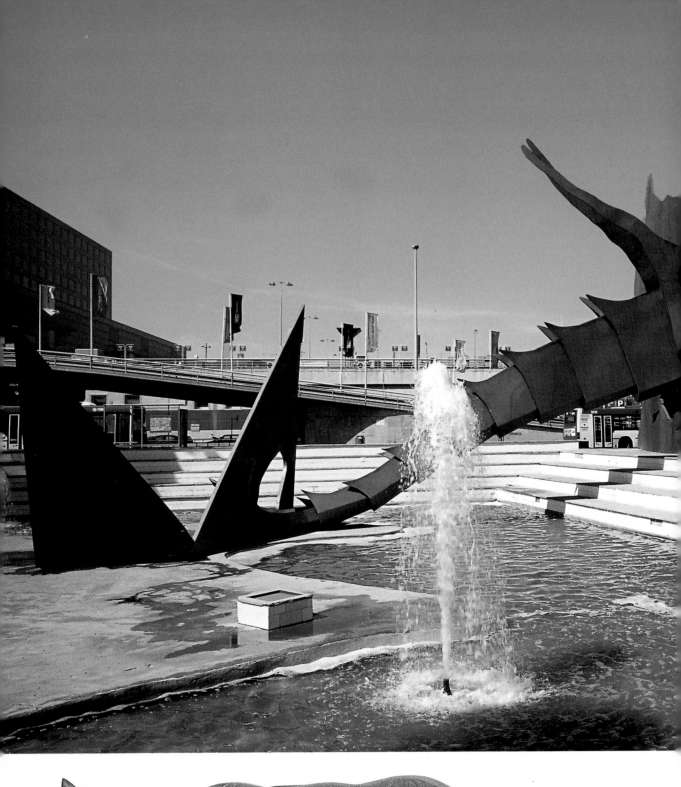

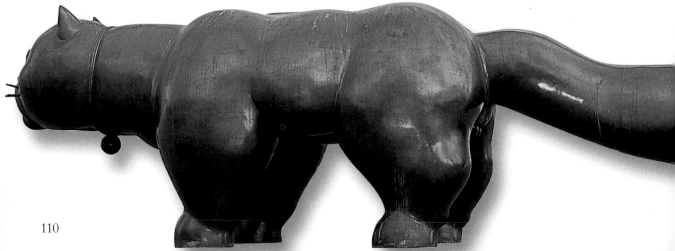

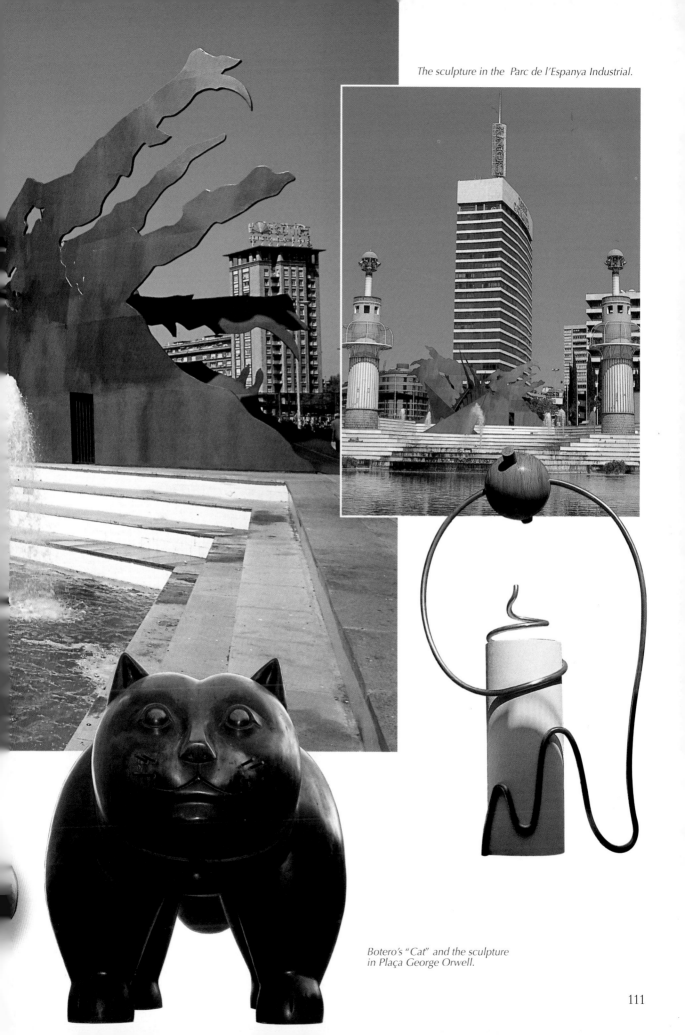

The sculpture in the Parc de l'Espanya Industrial.

*Botero's "Cat" and the sculpture
in Plaça George Orwell.*

111

Plaça El Escorxador, the monolith by Joan Miró , made of tiles by Llorens-Artigas.

Úrculo's sculpture in Parc Carles I.

Roy Lichtenstein's sculpture in Plaça d'Antoni Lopez.

MONTJUÏC

A speechless Don Quixote contemplated a battle between the Christian fleet and the Saracen fleet from these heights. A system of signals, quite sophisticated for the time (banners and bonfires), signalled the position of the enemy ships to the Catalan admirals from Montjuïc. This hill, 213 meters high above the harbor of Barcelona, maintained this function until 1401.

The hill of Montjuïc is one of the most interesting spots in the city. Laya, the ancient village of the Iberians who were the first inhabitants of Catalonia, rose here. The Romans built a road between the « Mons Taber » where their colony was situated and the hill which they may have called « Mons Jovis », Jupiter's Mountain. This was the first name of Montjuïc, later rebaptized « Mons Judaicus » probably because it was the site of a Hebrew cemetery. Montjuïc has always been a strategic link in the defenses of Barcelona, a key element in its system of lookouts and surveillance. In 1640, after the war « dels Segadors » against Philip IV, the city of Barcelona built a military fortification, the Citadel or **Castle**, on the top of Montjuïc. When the city surrendered to Philip V's Bourbon armies at the end of the unfortunate War of Succession to the Spanish throne, the Castle was transformed into a military prison. Not until the early 60s did the army turn the old Castle over to the city. Barcelona installed a *Museum of Military History* there, with antique weapons, mementos of the battle of Lepanto, relics of Catalan and Arab history and whole armies of lead soldiers. A marvelous panorama of Barcelona can be had from the bastions of the Castle.

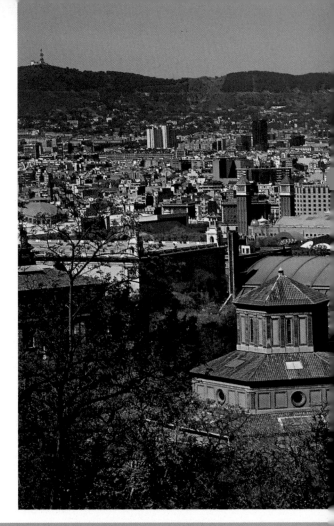

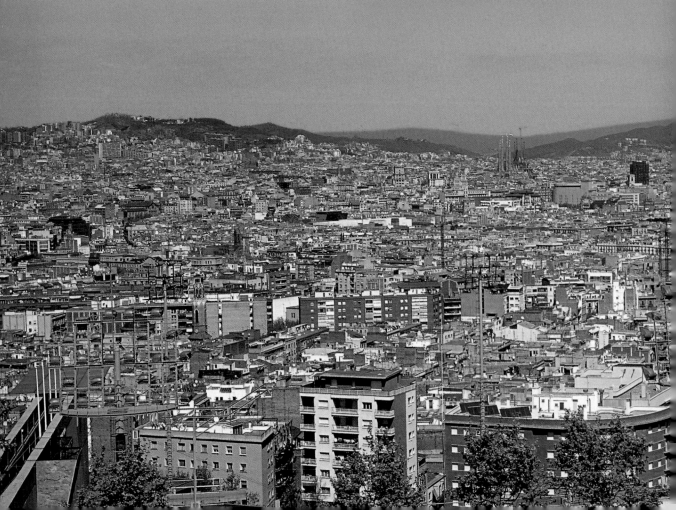

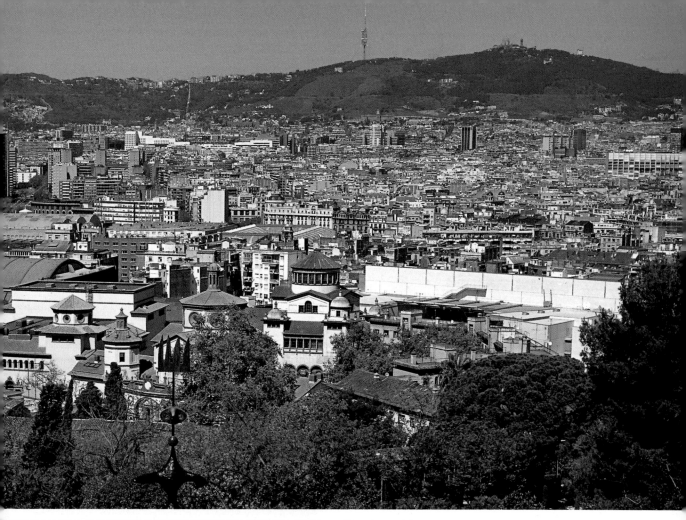

Two views of the city from Montjuïc.

The hill of Montjuïc which surrounds the Citadel is a real spectacle: gardens, monuments, an amusement park, museums and palaces make it an irresistible attraction for tourists and Barcelonians. Montjuïc owes its present splendor to the intuition of the architect Amargós and the French landscape architect Forestier and the work done to prepare for the 1929 Exposition. Along its avenues are the **Palau Nacional**, built expressly for the Fair, the **Pabellón de la Rosaleda** which houses the *Ethnological Museum*, the *Archaeological Museum*, a Greek theatre, the botanical gardens, the *Font del Gat*, the reconstructions of the Poble Espanyol, the *Fundació Joan Miró* and the *Miramar*, which dominates all of Barcelona.

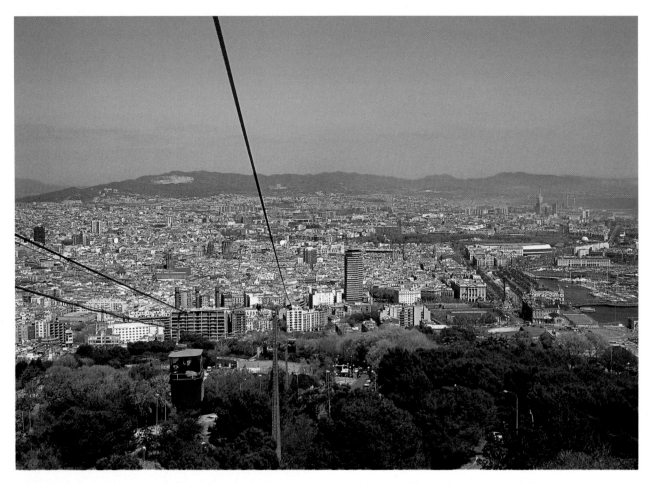

Montjuïc: the cable and the monument of the Sardana.

The entrance to the old castle and a piece of artillery housed in the Museum of Military History.

THE FUNICULAR OF MONTJUÏC

The cableway which connects the maritime district of Barceloneta to Montjuïc is the most spectacular of the various approaches to the hill which dominates the city. It was made famous by Michelangelo Antonioni's film, « Professione Reporter ». Rising from the port of Barcelona to the balcony of *Miramar* it touches two high metal towers, the *Tower of Saint Sebastian* and the *Tower of Jaime I*, from which the aerial trip over the harbor of Barcelona can be begun.

SARDANA

The choral dance of the Sardana is the expression of the Catalan people. On the hill of Montjuïc the sculptor José Cañas has placed his *monument to the Sardana*. No Sunday passes but one comes across great circles of people in the streets of Barcelona who, holding hands, with a proud and vaguely aristocratic air, are dancing the Sardana with its varied rhythms, calm or restless, of ever more rapid short steps.

POBLE ESPANYOL

The Poble Espanyol is a sort of amusing Spain-in-miniature spread out over two hectares on the hill of Montjuïc. The entire village can be visited. The streets, plazas, houses and buildings faithfully reproduce various important characteristic Gothic and Renaissance corners of cities or places in Catalonia, Aragon, Andalusia, Galicia, Castile, the Balearic Islands, Navarre and Estremadura. It was created for the 1929 World Fair by Xavier Nogués, Miquel Utrillo and Ramón Raventós. The replicas, realized and arranged with a truly surprising attention to detail, provide a complete anthology of Spanish architecture and of the extremely diverse architectural features of the regions of the north, the south, the mountains and the coast. Two impressive towers of the *Puerta de San Vicente* (or Puerta de Ávila) mark the entrance to the village. The circle of walls which encloses the village and which reproduces the walls of the city of Avila begins here. On the other side of the gate is « Plaza Castellana », to the right of which, in « Calle de la Conquista », stand the buildings inspired by the constructions of Cáceres. Passing under the portico of Sangüesa, we come to the *Plaza Mayor*, surrounded by buildings that are typical of Guadalajara, Madrid, Segovia, Santander, etc. The square also contains the reproduction of the city hall of Vall-de-roures. To the left of the Plaza Mayor, after « Calle del Alcalde de Zalamea »

Poble Espanyol: the Puerta de San Vicente and the so-called "steps of Santiago".

Plaza Mayor and the belltower of the church of Utebo.

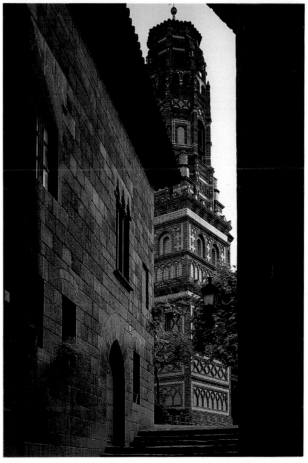

are the so-called *steps of Santiago* and other massive looking Galician buildings while further on, in Plaza Aragonesa, the bell tower of the church of Utebo in a picturesque Mudéjar style rises to the sky. The charming reconstruction of the candid Andalusian quarter begins here, followed by that of the Catalan quarter where an old pharmacy is also reproduced. On the other hand, retracing one's steps to Plaza Mayor and turning into « Calle de los Caballeros », the road leads to the quarter dedicated to the simple and austere rural buildings of Castile, beyond which are those that recall the Basque dwellings and those of Navarre.

Plaza Mayor is often an outstanding setting for exhibitions and folklore festivals. Casa Pallaresa on the plaza shelters one of the most important museums in the village, the **Museum of Folk Art and Industry**, dedicated to the habits, customs and traditions of Catalonia. In the environs the **Museum of the Graphic Arts** with an interesting survey of printing methods and graphic techniques is open to the public.

The village abounds in small shops specialized in the sale of typical regional products where, under the eyes of the visitor, craft objects in clay, glass, wrought iron and wood are made.

A visit to the Romanesque *Monastery* beyond the city walls is well worthwhile. Its frescoes repeat the typical pictorial decoration of the small Catalan churches in the Pyrenees.

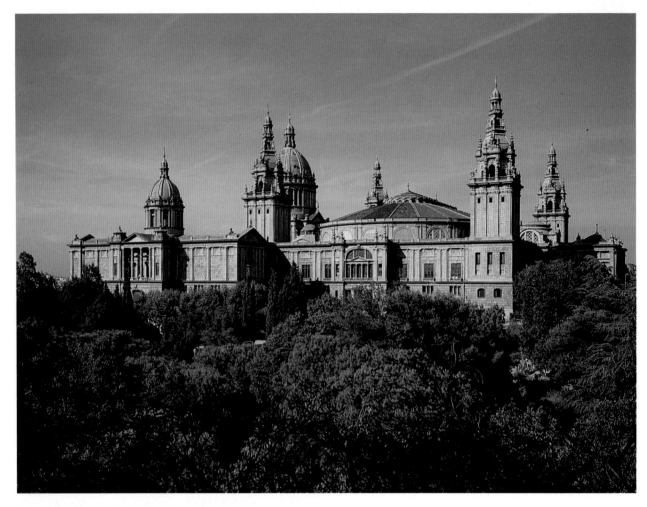

Palace of the International Exposition, where the Museu d'Art de Catalunya has its seat.

MUSEU D'ART DE CATALUNYA

Situated on the hill of Montjuïc, in a position which dominates the underlying *Plaça de Espanya*, the Palace of the World Exposition (1929) can be reached via a monumental staircase which departs from the main avenue of the park.

The Museu d'Art de Catalunya, housed on the ground floor of this palace, is probably the richest in the world as far as Romanesque Catalan art is concerned and is without doubt one of the most important for its collections of Gothic panel paintings and sculpture. Created by Josep Lluís, it was enlarged by his successor Joaquí Folch y Torres, who also enriched it with numerous frescoes from various religious buildings in northern Catalonia. The works of art exhibited in chronological order in some of the rooms in the museum, with the aid of photographic documentation, illustrate the technique used to remove the frescoes from their original sites.

The more important works preserved in the rooms dedicated to Romanesque art include the frescoes from the Church of Sant Joan de Bohí (*Martyrdom of St. Stephen*), the detached frescoes from the apse of the Church of San Clemente de Tahull, representing *Christ Pantokrator, the Virgin and the Apostles* (12th cent.), and those from the churches of Santa María de Tahull, Santa María de Aneu and San Ginestarre de Cardós (12th cent.). A group of

works attributed to the so-called Maestro de Pedret, datable to the 11th-12th century and characterized by motifs close to Byzantine art, are also of particular interest.

Noteworthy among the many wooden altar frontals in the museum are the one from Santa María de Tahull in polychrome relief (12th cent.) representing *God the Father in Majesty*, the one from Valltarga, and the one from Sorriguerola, which already marks the passage from the Romanesque to the Gothic. This later period is well represented by a fine series of retablos, including the one from Santa Coloma de Queralt attributed to Juan de Tarragona, and the *retablo de Sigena*, by the Serra brothers.

The most significant moments in Catalan art are represented by Luís Borrassá (*Resurrection*, first half of the 15th cent.), with whom Catalan art became receptive to various international influences; Lluís Dalmau, who was influenced by Flemish art (*Altarpiece of the Councilors*, 1445), and the famous Jaume Huguet (1436-1486), skilful interpreter of Flemish naturalism in the ambit of Catalan art at the end of the 15th century (*Consecration of St. Augustine*).

Spanish painting of the 16th and 17th centuries is also well represented, with works by Pedro Berruguete, Velázquez, El Greco, Ribera (*Martyrdom of St. Bartholomew*) and Zurbarán.

The Cambò Collection is also in this complex. Cambò was a French banker and statesman, who lived at the turn of

the 19th-20th centuries. Various works by famous artists, ranging from pre-Renaissance painting up to more recent times are on exhibit in the interesting picture gallery.

In *Room I* there are paintings by Neri di Bicci (*Madonna and Child*), Ambrogio Bergognone (*Christ on the Mount of Olives*), Bernardini Luini (*S. Agatha*) and works from the 14th-century school of Rimini and by followers of Angelico and Ghirlandaio. In *Room II* one can admire works by Botticelli (*St. John Baptist*), Jacopo da Velenza, Antonello da Messina (*A Monk*) and paintings attributed to Raphael, Filippo Lippi and artists of the circle of Piero della Francesca. In *Room III* are exhibited canvases by Titian (*Girl Combing Her Hair*), Tintoretto (*Portrait of a Venetian Dignitary*), Giovan Battista Tiepolo (*The Minuet*), Veronese (*Saint Catherine*), Sebastiano del Piombo (*Portrait of a Woman*), Correggio (*Eve*), Quentin de la Tour (*Portrait of a Dignitary*), Fragonard, Vigée-Lebrun, Zurbaran, J.-B. Pater. *Room IV* proposes pictures by Rubens (*The Countess d'Arundel*), Lucas Cranach (*Gallant Scene*), A. and B. Cuyp, F. Bol (*Portrait of a Young man*), G. Massys, Patinir (*Flight into Egypt*). The arrangement in *Room V* consists of works by artists of the Catalan school (unknown), works by Murillo (*Portrait of a Genoese Gentleman*), T. Gainsborough (*The Countess of Spencer*), Pantoja de la Cruz (*Philip III Infante*) and a picture attribuited to artists from the workshop of El Greco (*Saint John the Baptist and Saint Francis*).

The collections of the **Ceramic Museum** are also on exhibit in this complex, with pieces dating to Roman and early medieval times, while a place of honor is reserved for the national ceramic production, ranging from the 12th to the 18th century.

Museu d'Art de Catalunya: the fresco of Christ the Pantocrator, outstanding example of Catalan 12th-century wall painting, and the detail of a tomb fresco (ca. 11th century).

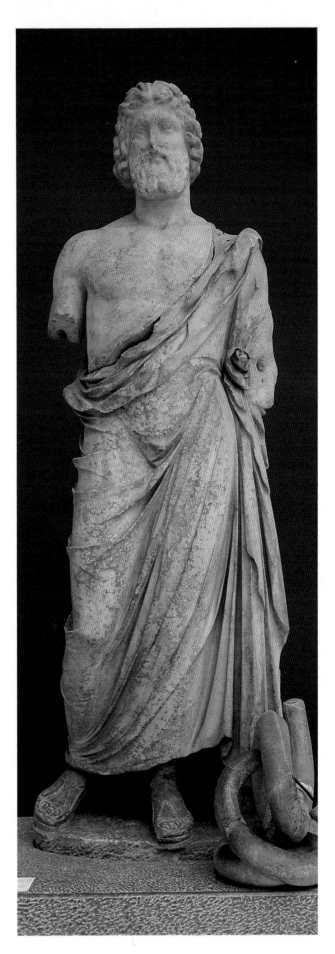

MUSEU ARQUEOLÒGIC

The collections of the Archaeological Museum are exhibited in the 1929 World Fair *Palace of Graphic Arts* situated in the park of Montjuïc.

The Museum is dedicated to the ancient civilizations of the Mediterranean, and its collections fill more than 30 rooms where the finds are chronologically arranged, ranging in time from prehistory to the 8th century. *Rooms I-X* contain prehistorical material dating to the stone age. Worthy of note are the examples of pottery from Guadix and the reconstructions of the most important dolmens to be found in Spain. *Rooms XI-XIII* contain Bronze age jewellery found in the Balearic Islands. *Room XIV* contains Greek, Punic and pre-Roman pottery. Of particular note is *Room XV*, which offers a survey of the finds that came to light during the excavations in Ampuries. Outstanding are the Greek statues of *Venus* and *Aesculapius*, as well as the Roman mosaic of *Iphigeneia*. *Rooms XVI-XVII* contain collections of pottery from the Mediterranean basin, in particular the Greek, Italiote and Etruscan areas. There are also examples of Roman and Hellenistic sculpture, as well as fragments of Etruscan and Roman fresco paintings. *Room XVIII* contains pottery of varied provenance, particularly Greek, Apulian and Campanian. These finds range from the 6th to the 4th centuries B.C. *Room XIX* houses interesting examples of Etruscan bucchero from the 7th and 6th centuries B.C. *Rooms XX-XXIII* are dedicated to finds from the Iberian and Roman areas (applied arts). *Rooms XXIV-XXVI* have on exhibit interesting examples of Roman mosaic art. Of particular note are the representations of the *Race in the Circus* and the *Three Graces*. *Rooms XXVII-XXXI* are to house the reconstruction of a Roman house. Various sarcophagi of early Christian date are to be found in *Room XXXIII* while fine examples of Visigothic goldsmith work are on view in the vestibule.

MUSEU ETNOLÒGIC I COLONIAL

The collections of the Ethnological Museum are housed in a modern building set in the middle of the gardens of the park of Montjuïc. The museum exhibits artifacts, objects of daily use, products of the crafts, and costumes from Oceania, various regions of Asia, Africa and the Americas, collected throughout the centuries in the course of the numerous Spanish expeditions. Of particular importance is material from pre-Columbian and post-Columbian cultures, while examples of aboriginal make (Australia) are also present. Of merit are the Japanese ceramics and the objects from Senegal and Morocco.

Museu Arqueològic: statue of Aesculapius and, above right, the main entrance.

Museu Etnològic: seen from the outside.

The modern complex of the Fundació Miró.

FUNDACIÓ MIRÓ

Someone said: « Joan Miró is the night, silence, music ». This definition appealed to one of the greatest artists of our century for in it Joan Miró recognized himself. He was born in Barcelona on the 20th of April 1893 in Passatge del Crédit, number 4. The capital of Catalonia and all of the Catalonian land left its mark. Chagall, the Russian painter in exile in Paris, one day wrote him: « You are lucky, my boy, you have a country ». But Joan Miró never tolerated the fact that art books or encyclopedias defined him as a « Spanish painter ». He sent unending letters of protest, demanded and succeeded in being called a « Catalan painter ».

Joan Miró began to paint at an early age. A friend of Picabia, Max Ernst and André Masson, impassioned habitué of the Dadaists, he knew Hemingway, Ezra Pound, Jacques Prévert, Henry Miller, and, above all, Breton, Éluard and Aragon. He exhibited for the first time in Barcelona in 1918. A year later he moved to Paris where he adhered to the cubist movement and then, in 1924, passed into the ranks of the surrealists. But it may not be possible to cata-

Works on exhibit at the Fundació Miró.

log Miró's art: Miró is unmistakeable, his hand moves in absolute freedom. Giulio Carlo Argan, the famous Italian art historian, defined him as « the nightingale of modern painting ». The artist always moved beyond the frontiers of the rational and the senses and created one of the richest and most fascinating languages of 20th-century art. On June 10, 1975, Joan Miró made Barcelona the best of all possible gifts: this was the day that the Foundation which bears his name, a cultural center which has raised Catalonia to the highest levels of world art, was inaugurated — the *Fundació Joan Miró, Centre d'Estudis d'Art Contemporani*.

The building which houses the Foundation is on the hill of Montjuïc and was built by Josep-Lluis Sert. The following year, a large exhibition of 475 drawings (covering the period 1901 to 1975) marked the formal inauguration.

In 1978 the European Council awarded the Miró Foundation with the « Special Prize for a Museum », an international acknowledgment of the imaginative work of the Catalan painter. « What is closest to my heart is Catalonia and the dignity of man » are what the artist said.

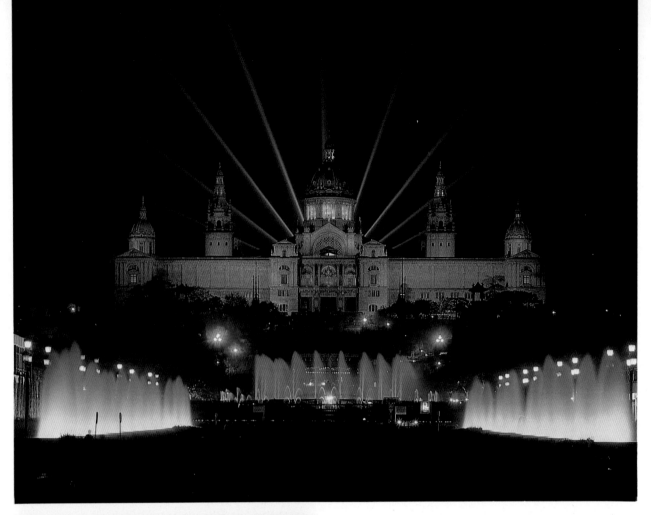

Palau Nacional: the main facade and the magic fountain.

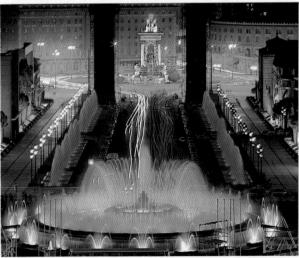

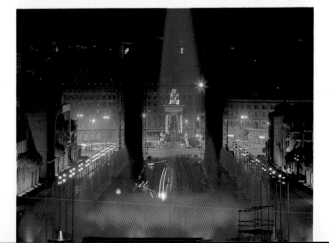

PALAU NACIONAL

Two unusual bell towers in pure Venetian style comprise the entrance to the old enclosure of the fair quarters of the 1929 World Exposition. The two towers lead to the wide *Avinguda de la Reina Maria Cristina*, an enormous avenue designed by the architect Raventós. The perspective of the boulevard is daring: the various buildings of the fair lead rapidly one after the other from *Plaça de Espanya* up to the extraordinary ornamental waterworks of the fountain by Carles Buigas. In the background on the slopes of the hill of Montjuïc, rises the austere mass of the Palau Nacional, (National Palace) which is faced in the distance by the mount on which the Sanctuary of Tibidabo rises.

The fountain, situated at the foot of the flight of stairs that leads to the Palau Nacional, is by an engineer, Carles Buigas. Known simply as «Luminous Fountain», it is also called *Magic Fountain* of Barcelona. And rightly so: on hot

summer nights its ornamental waterworks and lights illuminate the entire city with the kaleidoscope of its reflections. The number of variations and imaginative combinations possible come close to thirty: a chromatic mosaic, an unending rainbow.

The Magic Fountain is also the fountain of fantastic numbers: two concentric basins at different heights make up the main body; the water arrives at the fountain at the rate of 2430 liters a second; the jet of water touches on and at times exceeds fifty meters in height. Pumps and fans using 1413 horsepower and 4730 lamps employing 1445 kilowatts are an indication of the energy needed to set it in motion. In this personal version of « Sons et Lumière » Barcelona has outdone itself. From a cabin, a man using remote control directs the play of lights in the Magic Fountain all summer long.

At the top of the steps leading up from the enchantment of the fountain lies the Palau Nacional, whose rooms contain the collections of the *Museu d'Art de Catalunya*. The Palau Nacional was also designed by the engineer Buigas for the International Exposition of 1929. When the fair was held it housed the section dedicated to electricity.

PLAÇA DE ESPANYA

One of the most convulsive and noisy intersections in all of Barcelona, Plaça de Espanya is situated at the crossing of *Avinguda Gran Via de les Corts Catalanes* and *Avinguda del Paral-lel (Calle del Marqués del Duero)*. An immense, impressive square, overflowing with traffic, Plaça de Espanya was the monumental entrance to the old fair quarters in the World Fair of 1929.

The Catalan architect Jujol, one of Gaudí's best pupils, placed a monumental *fountain* at the center of the square. The three statues by Oslé which decorate it on three sides symbolically represent the waters of the three seas which bathe the coasts of Spain — *the Mediterranean*, the *Bay of Biscay* (or *Mar Cantabricum*) and the *Atlantic Ocean*.

The principal airlines have their headquarters in Plaça de Espanya and the second Plaça de toros in Barcelona, *Les Arenes*, is situated at the departure point of the Iberia terminal. Les Arenes was built in the latter part of the 19th century and seats up to 26,000 spectators. The three massive red brick buildings in the plaza were the hotels which housed the visitors to the 1929 Exposition.

Plaça de Espanya: the monumental fountain by Jujol.

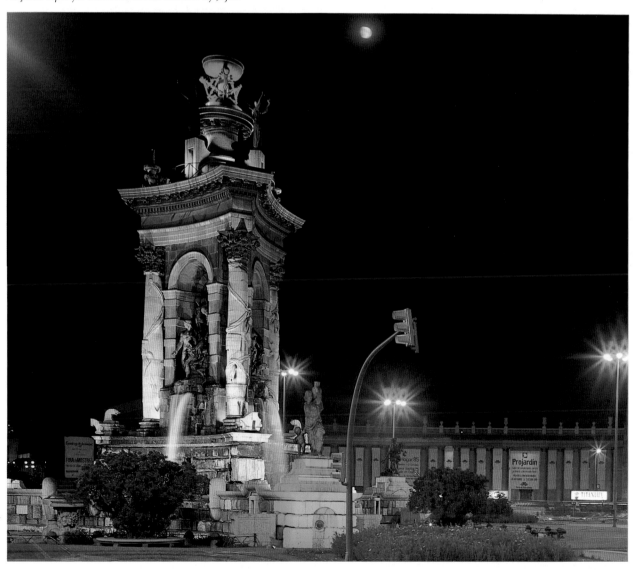

The modern Olympic Stadium.

BARCELONA OLYMPIC CITY

Thanks to the proclamation of Barcelona as the site of the 1992 Olympic Games, the metropolis, which for decades had lived off its ocean, has witnessed the achievement of great reforms and improvements. The communications network is a mirror of these important changes and openings: new tunnels such as that of Vallvidrera and Rovira, broad city streets, promenades such as the Paseo Picasso, boulevards such as the Avenida Gaudí; but also highways both for access and for circumvallation. Contact with the sea has been recuperated by eliminating industrial and port barriers. The city is now able to enjoy new beaches such as that of Mar Bella and new parks such as that of Collserola and Vall d'Hebron. The hill of Montjuïc has been reurbanized.

The railway network has been modified, the airport enlarged.

One of the most surprising results is undoubtedly the construction of the new district kown as Nova Icària. It takes its name from Etienne Cabet's Utopian idea of founding an ideal city. Set between the Park of the Citadel (Parc de la Ciutadella) and the Cemetery of Poblenou (Cementiri del Poblenou), this new district is part of one of the four Olympic areas, that of the Parc de Mar. For the entire duration of the Games, it hosted the Olympic Village where the participating athletes and their entourages were housed. The complex consists of lodgings, basic services such as cafeterias, a polyclinic, shops, meeting rooms, cultural structures, a press centre, a sports pavilion and an athletic track.

The Nautical Base of Nova Icària, situated on the other side of the Olympic Village, was the setting for the sailing events. The table-tennis competitions took place at the Northern Station (Estaciò del Nord) which completes the sports facilities in this privileged area. Instead, one of the demonstrator sports, hand-ball, could be watched at the Frontò Colom.

Undoubtedly, the nerve centre for the '92 Barcelona Olympic Games was the area of Montjuic. This mountain, that is so very representative for the Barcelonians, but not always in connnection with happy memories, was fully re-urbanized in order to house a major part of the sports facilities that were the theatre for the Olympic Games. ''Olympic Ring'' is the name given to the reurbanization of an extensive area of the cliffs that was integrated into the city. Thanks to the '92 appointment, the old stadium that dated back to the 1929 World's Fair was rebuilt and its capacity was extended to seat about 60,000 people, though its façade was preserved. Raised to the Olympic category, the Estadì witnessed the inauguration and closing of the '92 Games, as well as the athletic competitions and the finals of the individual jumping contest. The Sant Jordi Palace (Palau Sant Jordi), by the architect Arata Isozaki, is a marvel, both from an architectural and a technological point of view. With a capacity of 17,000 spectators, this pavilion, basically created for sport gymnastics and rhythmic dancing, and for the handball and volley ball finals of the Games, can also host an enormous variety of sport and exibition activities. New swimming pools were in fact built, one for the diving competitions and the other for water polo: these are located on the former sites of the municipal swimming pool, close to the Mirò Foundation, and of the Bernat Picornell swimming pools, where the water-polo, swimming and synchronized swimming finals were held. The Industrial Spain Pavilion (Pavellò de la Espanya Industrial), a new building that is situated within an urban park, was the location of the weight-lifting events. The fencing competitions were contended at the Metallurgy Palace (Palau de la Metallùrgica), that at present is part of the fairground complex. Also of recent construction is the Pavilion of the Institute of Physical Education of Catalonia (Pavellò de l'Institut Nacional d'Educaciò Fisica de Catalunya), where the Graeco-Roman-wrestling and all-in wrestling competitions were held. The Montjuic Area also includes the buildings of the fairground complex and the Municipal Sports Palace (Palau Municipal d'Esports), where several of the volley-

Unusual view of the Olympian Stadium.

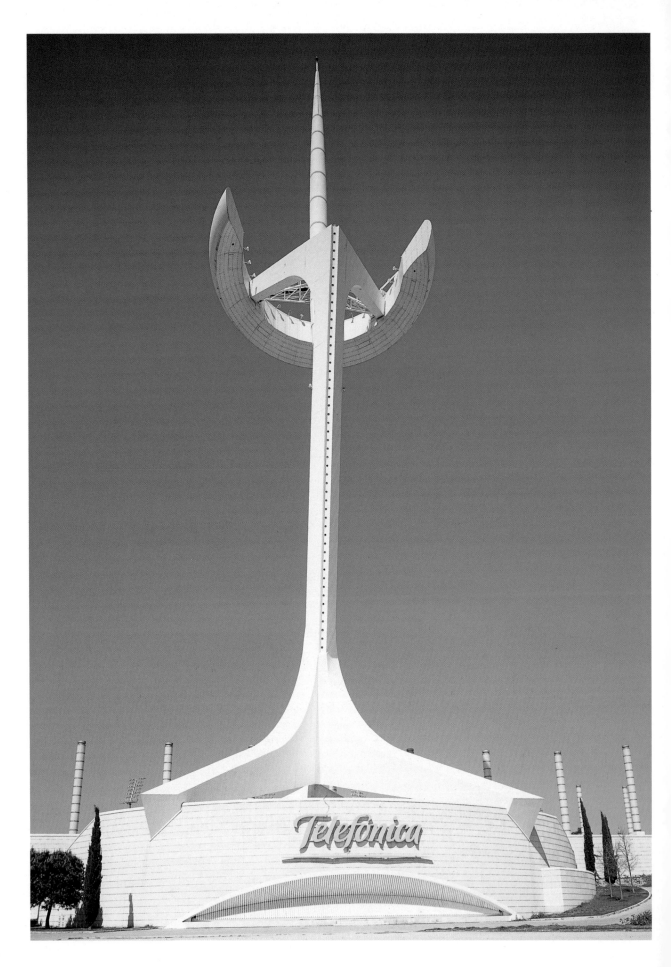

ball matches took place.

The facilities which make up part of the Area de La Diagonal are located in the high part of the city. The New Field (Campo Nou) and the Sarrià Stadium (Estadì de Sarrià) hosted some of the soccer matches. The hurdle races were held at the Ministadium (Miniestadì) of the Barcelona FC. The Polo RC was the site of the services connected with the Equestrian Centre.

The women's hand-ball tournaments were held at the Municipal Pavilion (Pavellò Municipal) of the CE Hospitalet del Nord. Judo events took place at the Blaugrana Palace (Palau Blaugrana): together with countless hotels and convention rooms of the Barcelona university campus, this site completes the structures of the Area de La Diagonal.

The fourth area chosen in the popular Vall d'Hebron zone has its central axis in the Municipal Velodrome (Velòdrom Municipal), where the cycling events and volley-ball matches were held. The archery competition took place at the Vall d'Hebron archery field (Camp de Tir amb Arc), and the tennis matches were held at the Teixonera Municipal Club.

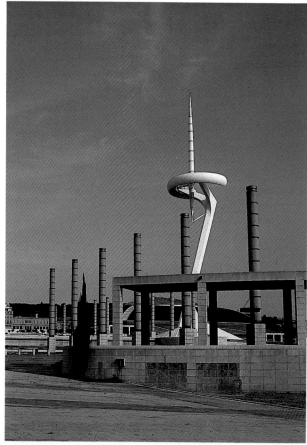

The Palau Sant Jordi by the architect Arata Isozaki and the futuristic Torre de Calatrava.

Gran Via de les Corts Catalanes.

Plaça Monumental: an all-over view of the famous arena and various details of the mosaic decoration.

PLAÇA DE BRAUS

There are two large arenas in Barcelona where the famous « corridas » take place — the **Plaça de Braus Les Arenes** and the **Plaça Monumental**, situated along the *Avinguda Gran Via de Les Corts Catalanes*. Built between 1913 and 1916, the latter can seat almost 20,000 spectators.

Even though it was built after Les Arenes (which dates to the second half of the last century) the Monumental is particularly prestigious, quite in keeping with the outstanding role Barcelona has achieved in the field of « corridas » throughout Spain. Every year more than 200 bulls are killed in the arenas of this city. Bull fighting, which was already known to ancient Greece and Rome, was practiced in Spain as early as the second century. Traditionally each corrida requires six bulls over four years old, and three « matadores », who each kill two bulls drawn by lot, with the help of three « cuadrillas », each of which consists of five or six men.

The other figures who take part in this picturesque spectacle include the « peones » or « banderilleros » who provoke the bull to arouse him, using the cape, and the « picadores » on horseback, who repeatedly strike him with the « puya » to weaken him. When the trumpet finally announces the « tercio de muerte », the last of the three stages into which the spectacle is divided, it is the turn of the « matador » or « espada », who exhibits himself in a series of figures and dangerous passages before killing the animal using a « muleta » (the red cape kept taut by a stick), quickly replacing the stick with a razor sharp sword with which to deal the fatal blow.

The bull, who drops dead in his tracks, is dragged out of the arena by gayly caparisoned horses, accompanied by the enthusiastic cheers of the crowd, which only a few seconds before (the final phase never lasts more than a quarter of an hour) was completely carried away by the exciting contemplation of the life and death struggle which has always fascinated, repelled and deeply moved man.

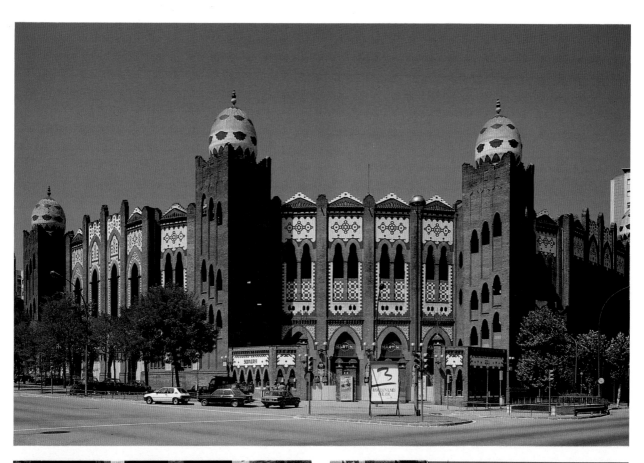

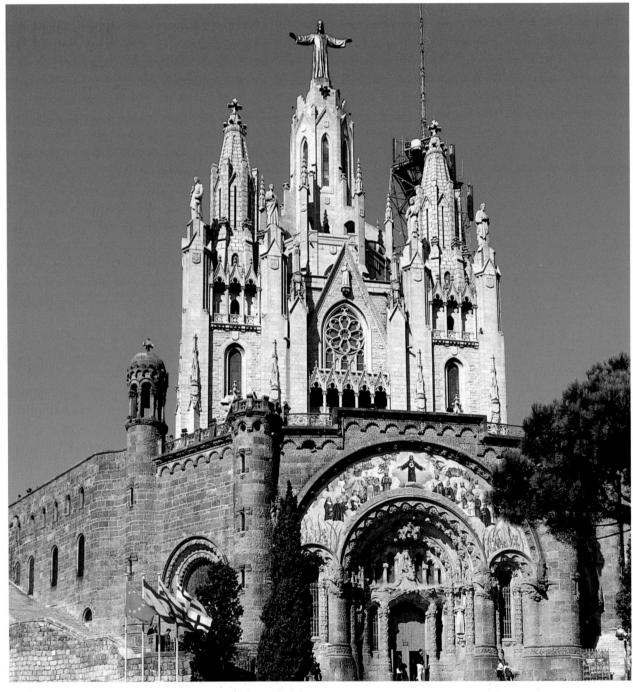

Tibidabo: Parroquia Sagrat Cor de Jesus del Tibidabo and two images of the Amusement Park.

TIBIDABO

The Tibidabo is the highest summit (over 500 meters) of Collcerola, or better of the hills surrounding the city and protecting it from the winds of the north.

An overall panorama can be had from this modest crest, which can be reached by bus or cable car or by car. It includes the entire city with the ocean in the background, the other summits of the chain (such as « La Arrabassada » and

« Sant Pere Mártir »), as well as Montserrat, and beyond, the Pyrenean summits. Halfway down its green slopes is the **Astronomical Observatory** and the **Museum of Physical Sciences**, which were created early in the 20th century thanks to Camillo Fabra, marquis of Alella. The crest of Tibidabo is crowned by the majestic Church of the Sacred Heart, built in Gothic style by the architect Enrique Sagnier. An elevator inside the church further amplifies the already vast panorama offered by Tibidabo. On the highest spire of

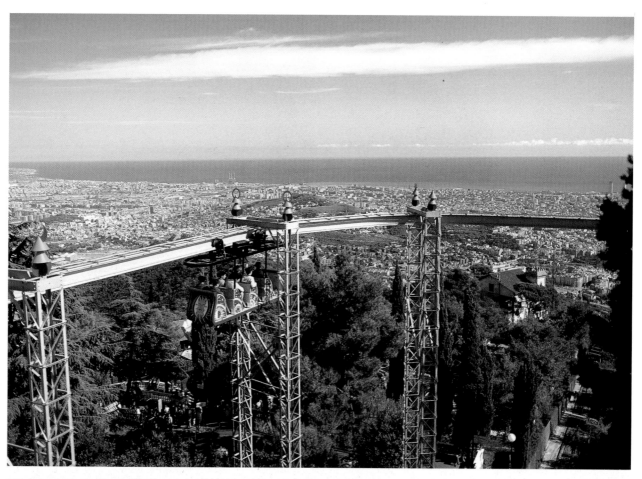

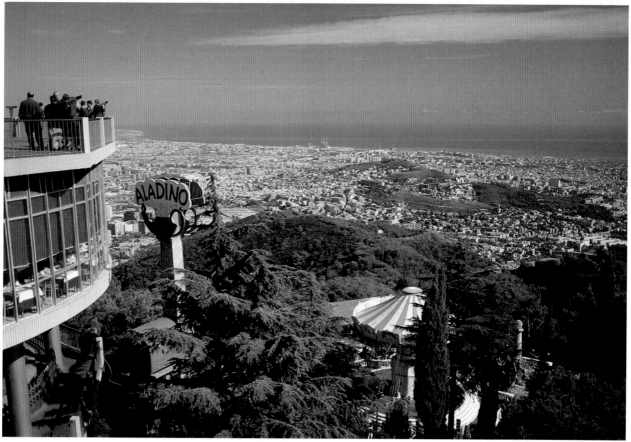

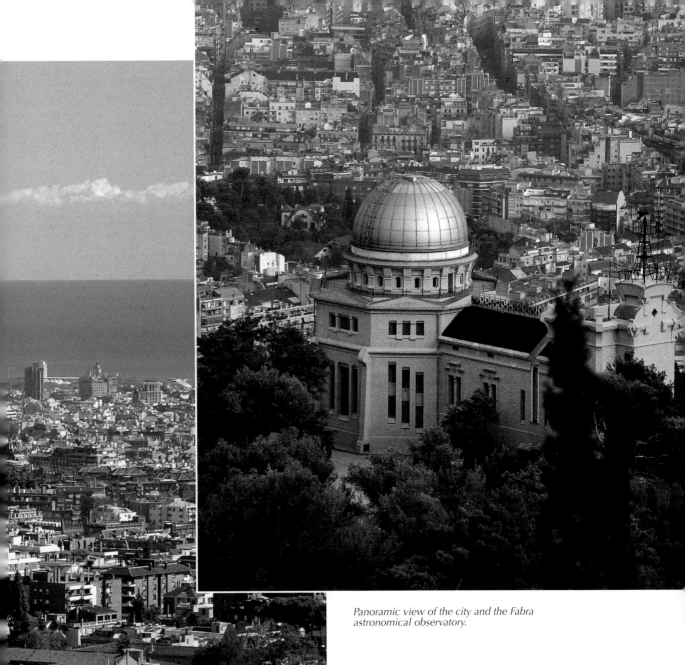

Panoramic view of the city and the Fabra
astronomical observatory.

the building a *Statue of Jesus* with widespread arms seems
to lean out over the underlying city. Tibidabo is a favorite
goal for tourists and natives, with an *Amusement Park* as
one of its attractions. Surrounded by terraces, avenues,
large squares, and charming gardens, the roller coaster, the
labyrinth, the haunted house, various meeting places and
characteristic bars and restaurants create an ideal at-
mosphere for relaxation and entertainment. Of the numer-
ous attractions Tibidabo offers particular mention must be
made of the unique **Museum of Automa** which contains a
large number of robots, automatized machines and automa
from every corner of the globe, dating to a wide variety of
periods. In the immediate vicinity of Tibidado, one of the
many interesting houses that merit mention is the *Villa
Joana*, which will be turned into the **Casa-Museu Ver-
daguer**, in homage to the contemporary Catalan poet M. J.
Verdaguer, who lived there until he died. The villa is sur-
rounded by the large green *Park of Vallvidrera*.

137

BARCELONA'S SURROUNDINGS

PALAU REIAL DE PEDRALBES

Pedralbes is one of the wealthiest residential districts in the city, where Art Nouveau buildings stand side by side with elegant villas and dignified constructions of more recent date. In any case the green of the hedges and gardens is the predominating note.

The Palau Reial de Pedralbes is in the University City, near the end of *Avinguda Diagonal* and was built between 1919 and 1929 as a residence for the heads of State or other important visitors. It is open to the public and sur-rounded by an enchanting park which also shelters an interesting *Coach Museum* and the **Museu d'Arts Decorativs** (period furnishings, embroidery, textiles, tapestries from Flanders, objects in glass from the pre-Roman period to the 18th century, porcelain).

A guided visit allows us to admire the rich decoration of the interiors (outstanding is the sumptuous *Throne room*, with its vault entirely covered with painted architectural structures), the furnishings, in part from Italy, and the valuable collections of porcelains, clocks, tapestries, fans and paintings (some by Luca Giordano), which are periodically renewed.

Palau Reial de Pedralbes: the garden entrance.

Palau Reial de Pedralbes: one of the bedrooms and the sumptuous Throne Room.

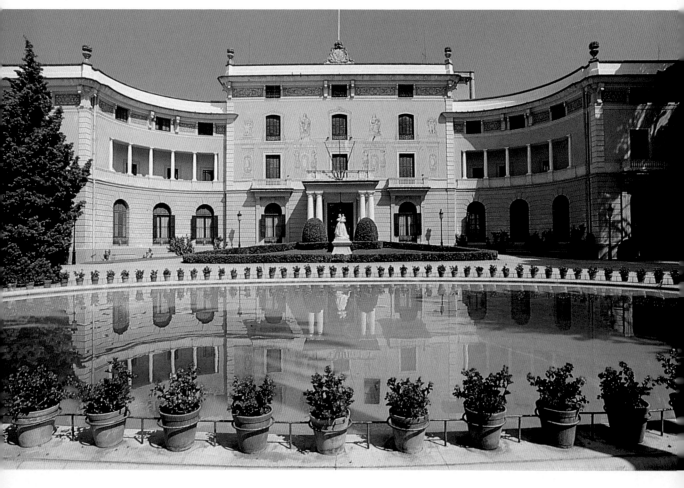

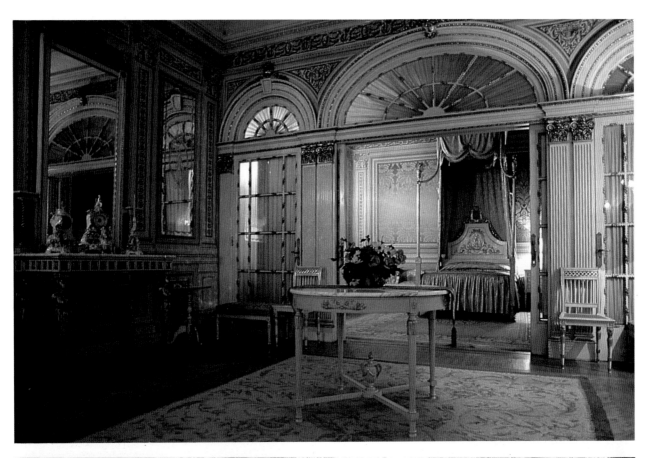

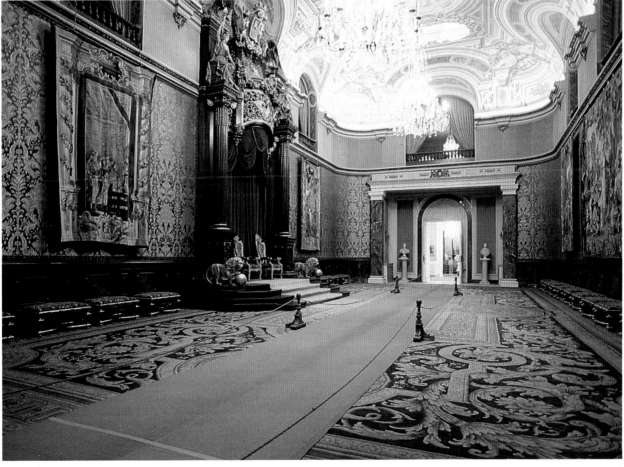

REIAL MONESTIR DE PEDRALBES

This monastery, one of the most evocative instances of ancient Barcelona, was founded by Queen Elisenda de Montcada, fourth and last wife of Jaime II. It was built between 1326 and 1419 by Ferrer Peiró and by Domènec Granyer and is one of the finest extant examples of Catalan Gothic. Only part of the monastery is open to the public for it is at present lived in by the nuns of Saint Claire. Noteworthy, on the exterior of the church, is the fine octagonal tower and, on the facade, the emblems of the Montcada family. Inside, the single majestic nave with 14th-century stained-glass windows contains the monumental *tomb of Queen Elisenda*.

The *Chapter House* is also fine, ornamented with a stained-glass window from the first half of the 15th century. The airy cloister, with three superposed orders of galleries supported by elegant small columns, leads to the *chapel of Sant Miquel*, with its splendid frescoes of the *Stories of the Life of the Virgin*, by Ferrer Bassa (1290-1348), one of the greatest Catalan painters and illuminators of the 14th century. Active also for some years in Italy, Bassa has endowed the ecstatic figures in the various scenes, dominated by a uniform blue ground, with various elements that come from contemporary Sienese and Giottesque painting. Dating to 1343, the paintings are well preserved. Part of the Von Thyssen collection is to be housed in the Monastery of Pedralbes.

Reial Monestir de Pedralbes: the octagonal tower and a view of the cloister with its garden.

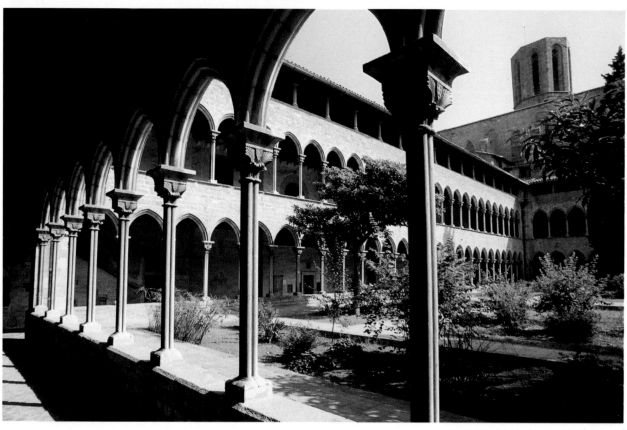

140

Montserrat: a view of the monastery.

MONTSERRAT

The mountain of Montserrat rises about 30 kilometers north of Barcelona. Its highest summit, known as S. Girolamo, is over a thousand meters high. The Catalan term « Montserrat », or *serrated mountain*, is a good name for the aspect of this massive ridge, with the stony conglomerate, prevalently sandstone, which erosion has modelled into extremely suggestive strange silhouettes and forms, to which the fantasy of man has given various names (the giant, the camel, cat's head, ball, etc.).

The wealth and variety of the local flora is also surprising. The goal of many trekkers, Montserrat also attracts many enthusiastic tourists.

As far back as the 8th century various unidentified hermitages existed on Montserrat. In later times these included the hermitage of S. María, converted by Bishop Oliva in the 11th century into a small monastery, the forerunner of the present sanctuary, which was to become famous throughout Catalonia thanks to the image of the miraculous Romanesque *Madonna* (12th century) still in the sanctuary today and called « *Moreneta* » by the Catalans for the dark color of her skin. According to legend she appeared in a cave in the mountain.

The monastery soon became known all over Europe, and religious buildings dedicated to the Madonna of Montserrat rose everywhere. Thanks to the hermit Bernardo Boil,

travelling companion of Christopher Columbus, the cult of the Madonna of Montserrat also reached the New World (an island in the Antilles received the name of Montserrat). Among the most famous personages connected with the monastery are Giuliano della Rovere (future Julius II), who was responsible for the building of the cloister in Gothic style (1476), the Emperor Ferdinand III, who donated generously to the Benedictine community, Francesco Borgia, Luigi Gonzaga, Saint Ignatius of Loyola, Goethe and Schiller, who immortalized the mountain in some of their works.

From the 16th century on, the church, numerous annexes of the monastery, and buildings for the pilgrims, who increased as the place became more famous, were added to the original hermitage.

In 1811 the monastery was sacked by the Napoleonic army and the successive revolutionary uprising reduced Montserrat to a pile of ruins abandoned by the monks.

The rapid rebirth of the sanctuary which began in the middle of the 19th century continued despite the last civil war (1936-1939) thanks to the intervention of the autonomous government of Barcelona.

The present monastery rises on a narrow ledge about 700 meters high. The large basilica was built between 1559 and 1592 and is more than 60 meters long and over 30 meters high. The facade, as we see it today, dates to the 1960s. The elegant ***interior***, with a single nave scanned

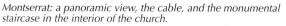

Montserrat: a panoramic view, the cable, and the monumental staircase in the interior of the church.

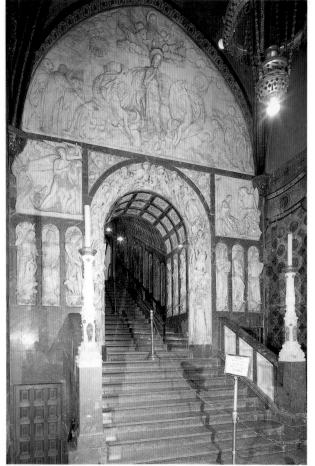

by Gothic arches and flanked by side chapels, ends in a richly decorated apse, which dates to the second half of the 19th century. From here a marble staircase leads to the chapel which houses the wooden polychrome statue of the *Madonna of Montserrat* (patron saint of Catalonia ever since 1881). The Madonna and Child are seated on a throne decorated in gold and silver reliefs by famous Catalan artists: behind her is a finely storied retablo (1947). Besides the *Escolania* (the old school for the preparation of young choirboys), the large *library* (containing over 200,000 volumes) and the old *typography*, founded in the 15th century, the **Museu** is particularly noteworthy. Here important examples of European painting and archaeological material of varying provenance are to be found. The paintings are exhibited on the *ground floor* and include works by Iberian, Italian, Flemish and French artists. Of note El Greco (Dominico Theotokópuli), Zurbarán, P. Berruguete (*Death of the Virgin*), L. Giordano, Caravaggio,

Matteo di Giovanni (*Madonna*), Solimena, F. Guardi (*Landscapes*), Guercino, I. Bassano, Velvet Brueghel (*St. Benito in the Thornbushes*), De Cles, Mignard, Rigaud, I. M. van Loo. On the *first floor* are the collections of the *Museum of the Biblical East*. The archaeological material includes finds from prehistoric, Roman-Byzantine times and from the Hebrew and Palestinian cultures. Some of the most interesting are examples of pottery found in Cyprus (14th-16th cent. B.C.) and objects of Egyptian, Syrian and Mesopotamian art.

The *Chapel of Santa Cueva* can be reached by a path or by cable car. It was built by Gaudí in the place on which the Virgin is said to have appeared in 880.

Sant Juan also provides a fine view of the monastery, while the *belvedere* near the Chapel of Sant Jeroni, reached by cable car, offers a splendid panorama which, when the weather is fine, reaches all the way to the Pyrenees.

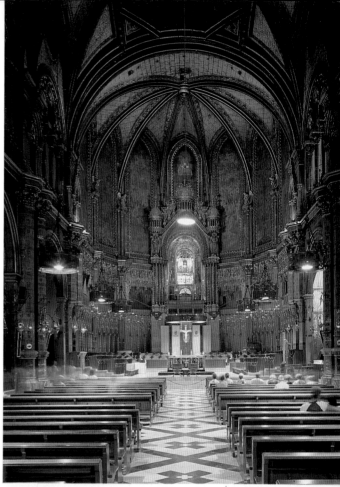

Inside view of the church and the famous "Moreneta".

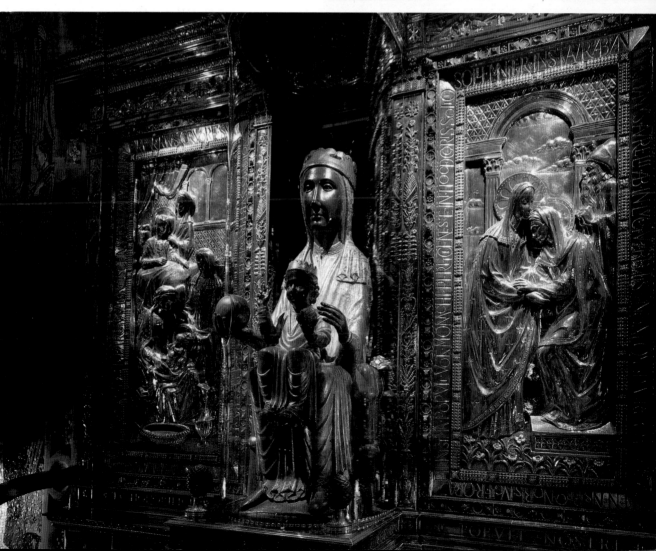

CONTENTS